# Greek and Roman Art
## in the British Museum

*If you regard works of art more highly than mere
antiquities, these are the things for you to look at.*

Pausanias *Description of Greece* I.24.3

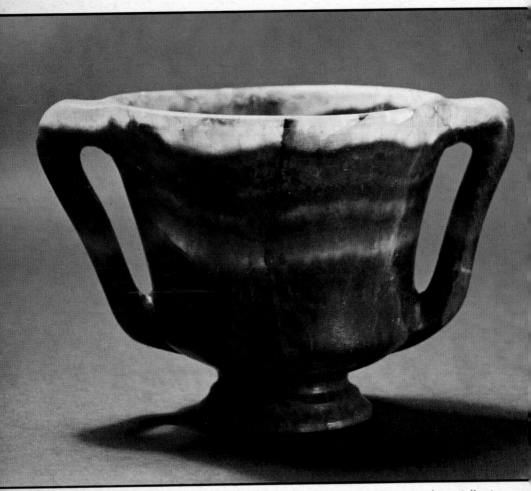

**The Crawford Cup.** A Roman drinking cup of fluorspar given by the National Art-Collections Fund to commemorate the 25 years (1945–1970) that the Earl of Crawford and Balcarres devoted to the Fund as its Chairman. 1971.4–19.1, ht 9.7 cm.

# Greek and Roman Art
## in the British Museum
B. F. Cook

Published for
The Trustees of the British Museum
by
British Museum Publications Limited

All photographs are by the British Museum
Photographic Studio except for illustrations
6, 14, Peter Clayton; 67, 75, Alison Frantz;
82, Deutsches Archäologisches Institut,
Athens; and 97 (left-hand fragment),
Professor P. Demargne.

ISBN 0 7141 1248 8 *paper*
ISBN 0 7141 1249 6 *cased*
Published by British Museum Publications Ltd.,
6 Bedford Square, London WC1B 3RA

Designed by Harry Green
Set in 11 on 12pt Monophoto Apollo
by Filmtype Services, Scarborough
Printed in Great Britain by
Cox and Wyman Ltd, London and Fakenham

# Contents

| | |
|---|---|
| 2 | |
| 3 | |
| 4 | |
| 5 | |
| 1 | |
| 6 | |

1 Cycladic Room
2 Bronze Age Room
3 Early Greek Room
4 Room of the Kouroi
5 Room of the Harpy Tomb
6 Bassae Room
7 Nereid Room
8 Duveen Gallery
9 Room of the Caryatid
10 Payava Room
12 Mausoleum Room
13 Hellenistic Room
14 First Roman Room
15 Second Roman Room

8

7

9

10

To Room 11

15

14

13

12

Architecture Room ▶

# Introduction
# Prehistoric Greece

European civilization was born in Greece about 5000 years ago. That was when a gradual but widespread rise in the level of material culture began to bring Greece to a point where it could stand comparison with the older and more sophisticated civilizations of Egypt and the Near East. An important factor in this change was metal. At first copper was used alone, but later it was alloyed with tin to produce a tougher material, bronze. This gradually replaced stone as the principal material of tools and weapons, so that it has become customary to describe this period as the Bronze Age, distinguishing it both from the Stone Age that preceded it and from the Iron Age that was to follow. Broad distinctions such as these must be used since in Greece this was still the 'prehistoric' period, when men had not yet begun to keep written historical records. Occasionally we can glean information on Greek lands from contemporary Egyptian and Hittite documents and from vague memories of the past embedded in later Greek legends, but our knowledge of this period is derived chiefly from the material remains excavated and interpreted by the archaeologist.

### Greece in the Stone Age
Greece had already been inhabited for several thousand years. Traces have been found of itinerant hunters and food-gatherers of the Early and Middle Stone Ages, but the earliest known settled community has been dated by carbon-14 analysis to about 6000 BC. During the following 3000 years simple communities of shepherds, farmers and fishermen established themselves at various sites on the mainland and in the islands. These Neolithic (Late Stone Age) peoples perhaps came mainly from Asia Minor. They already knew how to make pottery and they traded items such as obsidian (natural volcanic glass, sharp fragments of which served as tools and weapons). The difficulties of travel, however, left their small communities rather isolated and led to a vast variety of local cultures. Their material remains consist principally of pottery and implements of stone and bone.

### The Bronze Age (Rooms 1 and 2)
During the Bronze Age the two main cultural centres in the Aegean were the island of Crete and, on the mainland of Greece, the north-eastern part

of the Peloponnese (the Argolid), the latter becoming dominant after about 1400 BC. The civilization of Crete is conventionally termed Minoan, after Minos, the legendary ruler of Knossos, while the mainland culture is known as Helladic, from Hellas, the Greek name for the land of Greece. Local artistic styles may be distinguished and their development traced through Early, Middle and Late periods, each period being subject to finer subdivisions.

The Early Bronze Age (*c.* 3000–2000 BC) may be considered a transitional phase between the Neolithic period and the Bronze Age proper. Tools of stone and obsidian were still being used, but metalworking began both on the mainland and in Crete, perhaps introduced by new peoples from Asia Minor. Communities were still small, often widely scattered, and communications between them were difficult and slow. It was therefore at this period that the culture of the Cycladic Islands was at its most distinctive, since it had not yet come under the influence either of Crete or of the mainland.

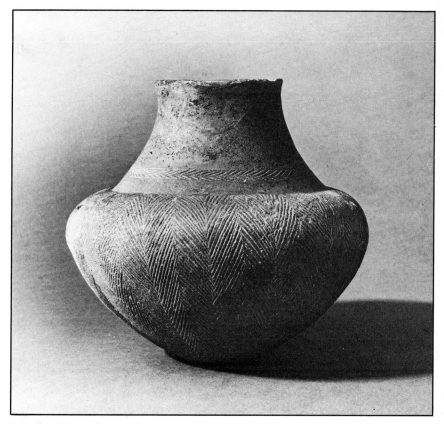

1 Unglazed jar with incised decoration. Early Cycladic, *c.*2800–2500 BC. Vase A 301, ht 18 cm.

Room 2

# Room 1
# Cycladic Antiquities

The potter's wheel came late to the Cycladic Islands, so that the pottery of both the Early Cycladic (*c.* 3000–2000 BC) and Middle Cycladic (*c.* 2000–1550 BC) periods was made entirely by hand. A jar of coarse texture with an incised herringbone design (Vase A 301) is typical of the first phase of Early Cycladic (before 2500 BC). Later than this is a spouted bowl (Vase A 263), sometimes called a 'sauce-boat', although its actual function is not known for certain. This has a finer texture and is coated with a wash of primitive glaze. Matt paint, introduced around 2000 BC, increased the range of decorative possibilities for pottery: the multiple vase (Vase A 343), probably used for the simultaneous presentation of various offerings to the dead or to some deity, is decorated with a painted zigzag design, its straight lines recalling the patterns on Early Cycladic incised ware. Later vases have patterns with curving lines and pictorial designs that show Minoan influence. In shape, however, the jugs with beak-like spouts, tilted backwards so that they are almost vertical, remain typically Cycladic (Vases A 341, A 342).

The best-known products of the Cycladic culture are the marble figurines, the so-called 'Cycladic idols', whose simple form and austere style appeal strongly to the modern taste for primitive art (Cases 2–3). Almost all of the known examples are female, and while they have sometimes been thought to be representations of a mother-goddess, it must be noted that they have been found in graves rather than in shrines. A very schematic form, with only the faintest indication of head and limbs, distinguishes the earliest examples (Sculpture A 5, A 6). These are normally found with Early Cycladic incised pottery and may be dated about 2800–2500 BC. Towards the end of this phase figurines of a more naturalistic style make their appearance (Sculpture A 27). Their arms are held in front of the body with the hands meeting at the waist, and for the first time fingers, toes and facial features are indicated. Such figurines are found not with pottery but with marble vessels: bowls with high tapering lips and conical bases (e.g. 1843.5–7.76), or tumbler-shaped jars (e.g. 1889.12–12.1), both types having long thin lugs with horizontally pierced holes.

Schematic figurines were still made after 2500 BC (Sculpture A 7), but they now show the influence of a new naturalistic type that was introduced around this date and continued until about 2000 BC or a little later

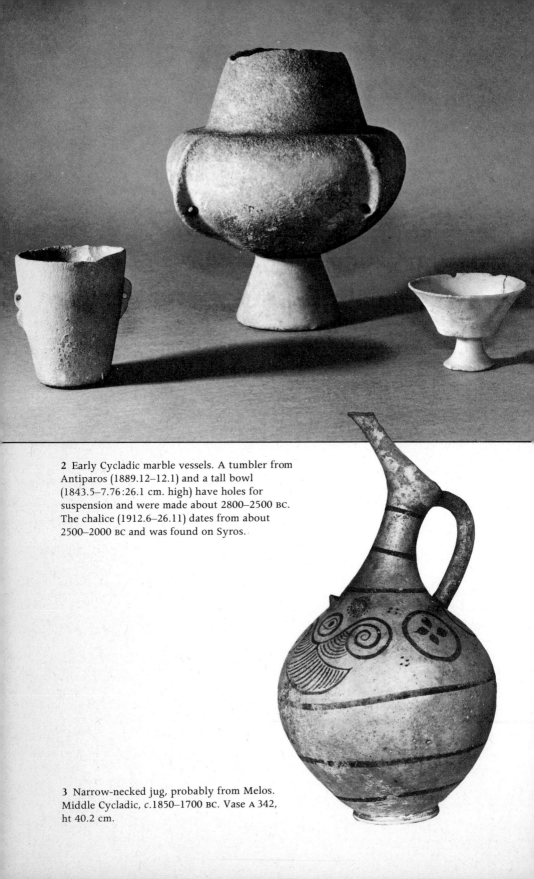

2 Early Cycladic marble vessels. A tumbler from
Antiparos (1889.12–12.1) and a tall bowl
(1843.5–7.76:26.1 cm. high) have holes for
suspension and were made about 2800–2500 BC.
The chalice (1912.6–26.11) dates from about
2500–2000 BC and was found on Syros.

3 Narrow-necked jug, probably from Melos.
Middle Cycladic, c.1850–1700 BC. Vase A 342,
ht 40.2 cm.

(1932.10–18.1 and Sculpture A 23 in Case 2; Sculpture A 15, A 17 and A 25 in Case 3). The arms of this new type are folded across the chest, the head is usually tilted back, the nose is prominently modelled, the knees are bent slightly, and the feet are outstretched. Fingers and toes are indicated by incision. A particularly large example (1971.5–21.1) still retains traces of its original paint, in particular a headband represented by a double row of red dots. The eyes were also added with paint. The severe style of these figurines is not necessarily produced by a conscious striving for abstract form but is to some extent the natural result of the physical properties of the marble itself and of the difficulties of working it without the aid of metal tools.

4

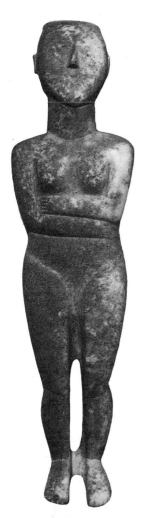

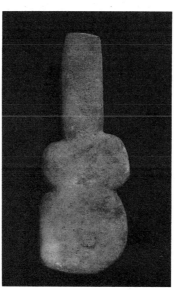

5 Marble 'fiddle idol' from Antiparos, representing a woman in a simplified form. Early Cycladic, c.2800–2500 BC. Sculpture A 6, ht 12.6 cm.

4 Marble figurine of woman with folded arms. Early Cycladic, c.2500–2000 BC. 1971.5–21.1, ht 76.8 cm.

# Room 2
# Minoans and Mycenaeans

**Minoan Antiquities (Room 2, Case 1)**
In the Early Minoan period (*c.* 3000–2000 BC) the population of Crete was scattered among small rural communities, chiefly in the central and eastern parts of the island. Few vases made of metal have survived from this period, but their influence is clearly seen in the imitation rivets and long spout of a mottled-ware jug from the Isthmus of Hierapetra (Vase A 425). Minoan love of colour is already evident in the elegant stone vessels that they begin to produce in this period (e.g. 1907.1–19.227). The technique of making them with drills and abrasives was probably learned from the Egyptians, whose contact with the Minoans over a long period is proved by finds in both Egypt and Crete.

Shortly after 2000 BC the beginning of the Middle Minoan period saw the scattered villages of Early Minoan times replaced by larger communities that were dominated by palaces, including those at Knossos, Phaistos, Mallia and Zakro. The Bronze Age had now begun in earnest, and it was the introduction of bronze tools that made possible the ashlar masonry of the great palaces. They are characterized by careful planning; they have good drainage; and their plaster walls invited the fresco decoration that was later to rise to great heights. Western Asia may well have been the source of these new architectural techniques, as it was of the potter's wheel, an indispensable instrument for the production of the fine pottery of this period, some so thin that it merits the description 'egg-shell'. Middle Minoan pottery is rich in different types, of which few are represented here. (Minoan antiquities in general are rare outside of Crete itself; the Archaeological Museum at Heraklion has an incomparable collection; in England the best collection is in the Ashmolean Museum, Oxford.) A cup from Knossos (Vase A 477) with decoration in light colours, cream and pink, on a dark background hints at the Minoan tendency to turn even simple linear decoration into a spiral form. Minoan religion at this period manifests itself in worship at natural features of the landscape, especially mountain-tops and caves. Among the offerings dedicated in a mountain sanctuary at Petsofa in eastern Crete were simple terracotta statuettes of men and animals (1907.1– 19.1, 31, 33, and 34).

Like other ancient peoples, the Minoans used seals to identify and protect their property. Early Minoan sealstones were made of fairly soft and easily

7

6

8

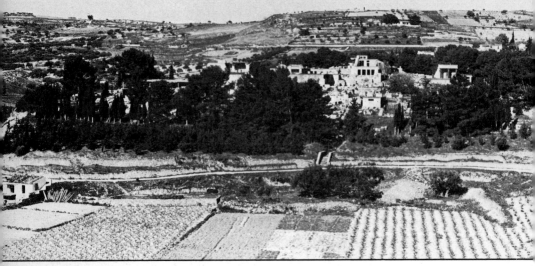

6 The Palace of Minos at Knossos from the east.

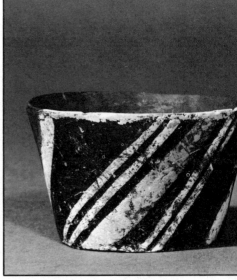

**7, 8** *Left*: jar of black Cretan marble with white veins, found at Palaikastro. Small stone jars of this kind were usually made for funerary use. Early Minoan, *c.*2500–2000 BC. 1907.1–19.227, ht 6.7 cm. *Right*: small cup of matt-painted pottery, with red and creamy white stripes on a dark ground, from Knossos. Middle Minoan I, *c.*2000–1900 BC. Vase A 477, ht 4.4 cm.

worked materials such as ivory and steatite, but in the Middle Minoan period various quartzes and other semi-precious stones came into use. These were worked with a cutting wheel and tubular drills together with an abrasive powder. Popular subjects in this period were animals, such as the ibex on a flattened cylinder of banded agate (Gem 3; Case 5, no. 13), and hieroglyphic signs like those on the other side of the same sealstone.

Some three hundred years after their foundation the palaces were destroyed, perhaps by one of the violent earthquakes to which Crete is periodically subject. New and more splendid palaces rose in their place, but Knossos was now predominant. Its wealth was based on trade, and commercial settlements were founded in various parts of the Aegean. To record their transactions the Minoans used a form of writing in which individual signs represented whole syllables. This is known as a 'linear' script to distinguish it from the 'hieroglyphic' script that survives chiefly on the sealstones. An example of Linear 'A', the script in use at this period, may be seen on a bronze axe-head (1954.10–20.1).

In the general turmoil that accompanied the destruction of the early palaces, the quality of pottery declined: egg-shell ware was no longer produced and the paint used for decorating pottery with a dark background became a rather dull white (Vase A 579). As in the preceding period, some vessels were simply decorated with a haphazard trickle of glaze on the front (1938.11–19.1). The walls of the new palaces were gay with frescoes (many of which are now preserved in the Archaeological Museum at Heraklion) but the Minoans did not produce any sculpture on a large scale. Their skill in small sculpture, however, is evident in the copper statuette of     9
a worshipper with his right hand raised to his forehead (1918.1–1.114), and
in the group portraying an acrobat taking part in the dangerous Minoan     10
sport of bull-leaping (1966.3–28.1). Having grasped the bull's horns, he has turned a somersault to land on its back, and from there he hopes to leap to safety.

Something of the graceful and lively style of Minoan art in this period may be seen in miniature on the sealstones. A goat, a deer and a lion appear on the three faces of a dark green jasper prism that may be dated about 1600–1550 BC (Gem 5; Case 5, no. 2). By about 1500–1450 BC a more realistic style may be observed on an almond-shaped (amygdaloid) sealstone of cornelian with a chariot drawn by two mules (Gem 39; Case 5, no. 10).

The wealth of some individual Minoans in the period of the new palaces is suggested by the jewellery of the 'Aegina Treasure', so called because it is said to have been found in a Mycenaean tomb on the island of Aegina. Its stylistic affinities, however, are Cretan, and point to a date around 1600 BC. Among the most striking items from the treasure is a gold ornament with a 'Master of Animals' in relief (Jewellery 762). He wears an elaborate     11
head-dress and is holding a goose by the neck in each hand; lotus buds spring from the base on which he stands. Other ornaments are decorated

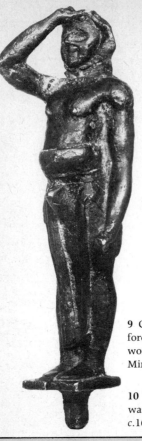

**11** Gold ornament (enlarged) from the 'Aegina Treasure' showing a 'Master of Animals', a nature god whose Cretan name is not known. He wears a typically Cretan belt and loin-cloth, and holds a goose in each hand. Middle Minoan, *c.* 1600 BC. Jewellery 762, ht 6 cm.

**9** Copper statuette of a man raising his right hand to his forehead in a gesture of adoration. Similar statuettes of worshippers have been found in Cretan sanctuaries. Middle Minoan, *c.*1600 BC. 1918.1–1.114, ht 19.5 cm.

**10** Bronze acrobat vaulting on a bull. This dangerous sport was probably religious in character. Middle Minoan, *c.*1600 BC. 1966.3–28.1, length 15.5 cm.

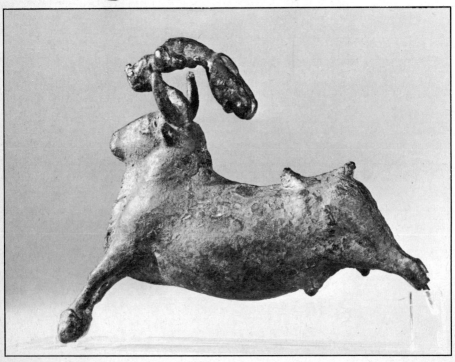

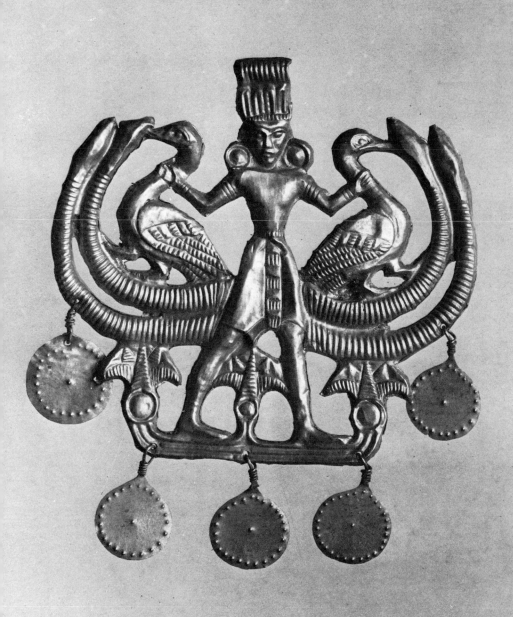

with confronted hounds that rest their front paws on the heads of monkeys sitting back to back (Jewellery 764, 765); the circular frame is in the form of a two-headed snake. More items from the Aegina Treasure are exhibited in the Greek and Roman Life Room on the first floor.

The manufacture of stone vessels continued, a favourite shape of this period being the 'blossom-bowl' with petals in low relief on the outside (1914.3–21.1). Slightly later stone vessels include a conical alabaster vase (rhyton), which probably had a ritual function (1874.8–5.121). This dates from the first phase of the Late Minoan period, when a new technique of vase-painting had been introduced. Dark glaze is now used against a light background for naturalistic designs, especially of floral and marine subjects, such as the octopus on a slender, round-bottomed jug from Palaikastro (Vase A 650).

About 1450 BC the Cretan palaces were again destroyed, probably as a result of the catastrophic eruption of the volcanic island of Thera (Santorini). Knossos was subsequently reoccupied, but it was now under the control of new rulers who added the Throne Room, introduced pottery, weapons and jewellery of mainland type, and had their accounts kept in a new script, Linear 'B'. Tablets like that from Knossos exhibited here (1910.4–23.1) have been found at several mainland sites, and the decipherment of its syllabary has revealed the language as an early form of Greek. All the evidence points to the capture of Knossos by Greeks from the mainland. That the new rulers continued to trade overseas is shown by a large two-handled flask with decoration in the form of a wheel, which is judged on stylistic grounds to have been made in Crete about this time but was found in a tomb on the island of Cyprus (Vase C 563). It is of a rare shape that is

12

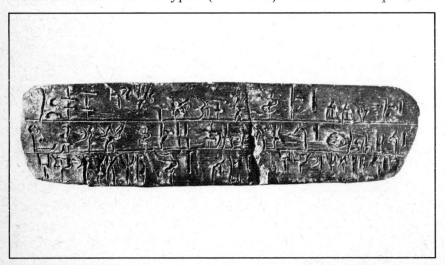

12 Clay tablet with Linear 'B' inscription. Late Minoan, c.1400 BC. 1910.4–23.1, length 15.7 cm.

thought to have been used only for special gifts. Among the vases found in the West Magazines of the palace at Knossos, before Sir Arthur Evans began his excavations there, was a large storage jar decorated with raised bands incised to imitate ropes (Vase A 739; second open shelf).

Sealstones of high quality have survived in large numbers from this period. Bulls are popular subjects: resting peacefully (1938.11–15.1; Case 5, No. 14), quietly led by an attendant (Gem 79; Case 5, no.16), or by contrast, taking part in the sports that were so hazardous for the human participants (Gem 78; Case 5, no. 1). Pairs of animals in balanced, almost heraldic postures are a new feature, perhaps reflecting the taste of the new rulers (Gem 61; Case 5, no. 6).

13

The evidence of the final destruction of the palace at Knossos is difficult to interpret and highly controversial, but many archaeologists believe that the sudden catastrophe that left the Throne Room in disorder and the palace in ruins took place about 1375 BC. The great days of Knossos were over, and it was now the turn of Mycenae to dominate the Aegean World. Although the destruction of the palaces marked the end of Cretan political independence and of the period when·Minoan art reached its greatest heights, life went on in the towns and villages, its standard now less luxurious. Small sculptures, such as the bronze statuettes of bulls (1930.6–17.3 etc.), are far less accomplished than the masterpieces of the previous era, although retaining a certain charm and vigour of their own. Animals appear in the vase-painter's repertory too, and ceramic techniques are employed in the decoration of large bath-tubs that also served as coffins (Vase A 744; first open shelf). Artistic leadership, however, had passed, with political power, to the Mycenaeans.

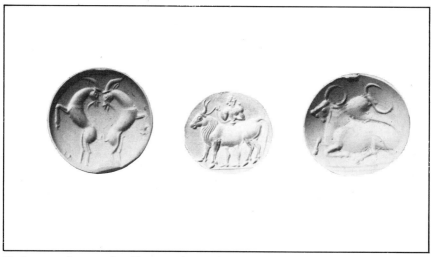

13 Cretan seal stones: heraldic goats (Gem 61); man leading a bull (Gem 79); bulls resting (1938.11–15.1).

## Mycenaean Antiquities

During most of the Early Bronze Age life on the mainland was rather like
that of Early Minoan Crete, but in the Middle Bronze Age the mainlanders
lagged behind their Minoan contemporaries, having nothing to compare
with their palaces and highly developed civilization. Towards the end of
the Early Bronze Age a new kind of pottery and new burial customs appeared
on the mainland, and some scholars interpret these as evidence for a new
wave of immigrants who brought with them a new language: Greek. This
theory implies that the Middle Helladic and Middle Minoan peoples dif-
fered not only in material culture but also in language and perhaps in
ethnic origin.

More changes are evident in the archaeological record around 1550–
1500 BC, marking the transition from Middle to Late Helladic. Important
though they were, these changes do not imply the immigration of new
peoples on a large scale. It is possible that there was an invasion by relatively
small groups, who were related in language and blood to the existing
inhabitants but better armed and equipped. On the other hand, the burial
ground of the rulers of Mycenae at this period (Grave Circle B) was in use
before the end of Middle Helladic and continued into Late Helladic. This
continuity suggests that the change from Middle to Late Helladic took
place without a dynastic break and was a cultural development caused by
increasing contact with Crete. This new period of Helladic culture is
frequently called 'Mycenaean' rather than 'Late Helladic', because Mycenae
became the chief centre of a trading empire whose power was to spread far
beyond the confines of the Greek mainland.

The city of Mycenae is still remarkable for its monumental architecture,
in particular for its impressive fortifications with the Lion Gate, and for a
series of huge, stone-lined tombs. These are frequently called Tholos
tombs, from the Greek word for a circular building, or alternatively
Beehive tombs, since their conical shape is reminiscent of an old-fashioned
beehive. One of the largest, dating from about 1300 BC, has been known
since the nineteenth century as the 'Treasury of Atreus'. This misnomer is
derived from a passage in the *Description of Greece* by the Greek writer
Pausanias, who, in the second century AD, mentioned among the sights of
Mycenae 'the underground chambers of Atreus and his children where
they kept their treasures'. Its main chamber, more than 13 metres high
and nearly 15 metres in diameter, is lined throughout with circular courses
of cut stone, each course slightly smaller in diameter than the one below,
so that the walls converge towards the top where they are crowned by a
single cap-stone. There is in addition a small side-chamber to the right of the
entrance. The tomb is approached through an open passage (the *dromos*),
6 metres wide and 36 metres long, cut into the hillside and lined with
masonry. At the end of the dromos the façade of the tomb was richly
decorated with architectural reliefs, including engaged half-columns in

14

14  The entrance to the 'Treasury of Atreus' at Mycenae (see also *Ill.* 15).

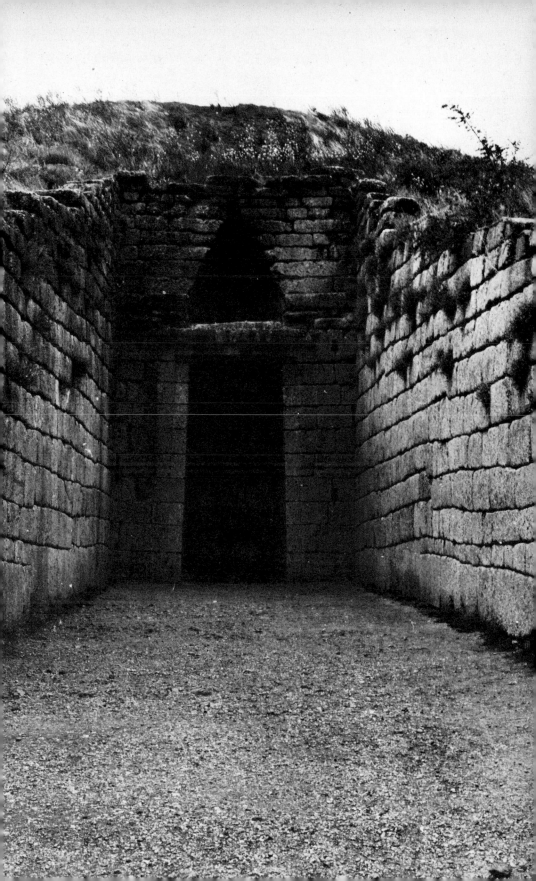

two tiers flanking the huge doorway and the triangular space left empty above it to relieve the weight on the lintel. The columns are of green marble and have shafts that taper from top to bottom. They are embellished with bands of chevrons with hatched borders, alternate chevrons being filled with running spirals. Fragments of them are incorporated into the restoration of the doorway exhibited at the entrance to Room 1 (Sculpture A 51 and A 52). In Room 2 are other fragments from the façade of the tomb:

15 part of a slab decorated with running spirals, shown by its sloping edge to come from the facing of the relieving triangle over the lintel (Sculpture A 53), another fragment (Sculpture A 55) with pairs of opposed half-rosettes (both of these made of a kind of red marble known as rosso antico, quarried at Kyprianon in the southern Peloponnese), and a slab of green marble with a running spiral over a row of discs representing the ends of beams (Sculpture A 54). Two fragmentary gypsum reliefs of bulls may have formed part of the decoration of the side-chamber (Sculpture A 56–57).

The earliest expression of the Mycenaean style, around 1550–1500 BC, first became known in the contents of a group of rich tombs, the so-called Shaft Graves of Grave Circle A, excavated at Mycenae by H. Schliemann in 1876. The treasures found in these graves, now preserved in the National Museum of Antiquities in Athens, brought new meaning to Homer's phrase 'golden Mycenae', which finds an echo here in a gold cup dated about 1500 BC or a little later (Jewellery 820). At first the influence of Minoan art was strong at Mycenae. Mycenaean palaces, although built on the Helladic plan, were decorated with frescoes in the Minoan manner. Minoan shapes were added to the range of Helladic pottery, and Minoan decorative motifs were used even on shapes seldom found in Crete, as on a shallow perfume vase (alabastron) decorated with a very naturalistic representation of nautilus, closely imitating the Late Minoan marine style (Vase A 651). The difficulty of distinguishing some Mycenaean products from their Minoan prototypes is well illustrated by a copper

16 pitcher of about 1400 BC, made from four separate pieces of sheet metal

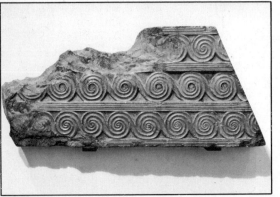

15 Red marble slab from the triangular space over the lintel of the 'Treasury of Atreus' at Mycenae (see *Ill.* 14), c.1300 BC. Sculpture A 53, length 97 cm.

16 Copper jug, manufactured either in Crete or on the mainland c.1400 BC, when Minoan influence on Mycenaean culture was particularly strong. 1963.7–5.1, ht 54 cm.

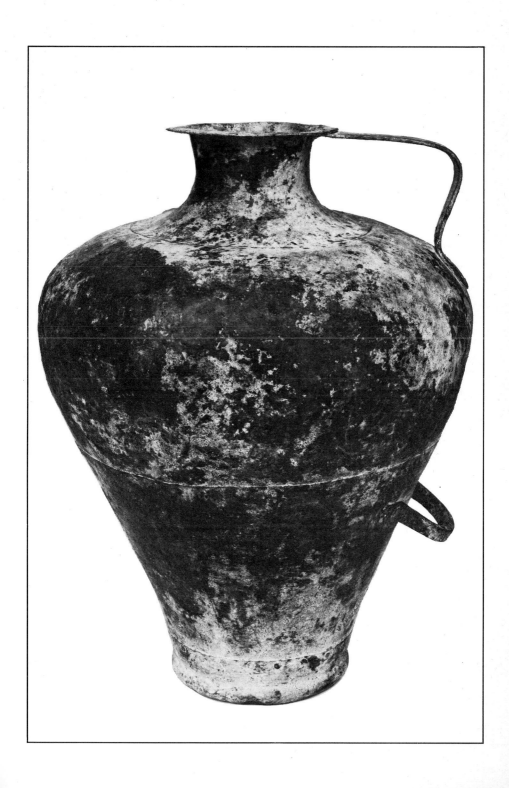

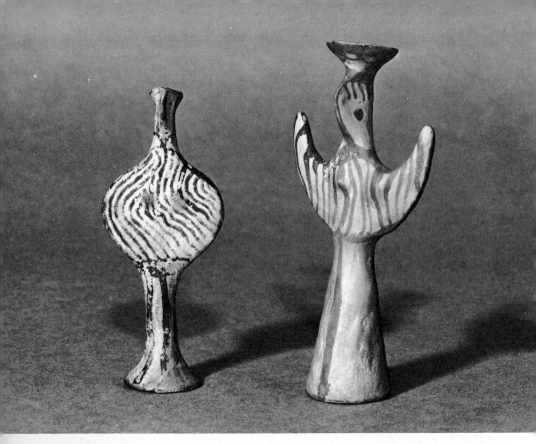

**17** Two Mycenaean
terracotta statuettes of
women of rather stylized
form, made about 1400–1300
BC. The figures were
modelled freehand and the
details of anatomy and
drapery were added in glaze,
using the techniques of the
vase painter. *Left*: Phi-type
(Terracotta B 12; ht 9.2 cm.)
*Right*: Psi-type (Terracotta
B 5, ht 10.9 cm.)

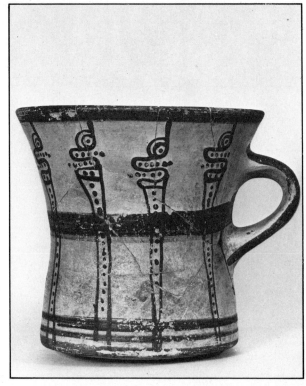

**18** Mycenaean tankard
found in a tomb at Ialysos on
the island of Rhodes. The
decoration, which consists of
stylized murex shells, was
painted on before the vase
was fired, using a thick
solution of clay. Late
Mycenaean IIIB, *c*.1300–1200
BC. Vase A 848, ht 15.9 cm.

riveted together (1963.7–5.1). The technique is Cretan, but this example is said to have been found on the mainland, and it is impossible to say for certain whether it was an import or the locally made product of a metal-worker trained in Crete. The bronze sword from near Mount Olympos, however, is a typically Mycenaean weapon (1930.12–15.10), very similar in shape to some of the swords from the Shaft Graves. Also characteristically Mycenaean are the small female figurines made of terracotta, one raising her hands (Terracotta B 5), another with her arms concealed by her drapery (Terracotta B 12). These are known respectively as the Psi-type and the Phi-type from their resemblance to the Greek letters Ψ (psi) and Φ (phi), and are dated about 1400–1300 BC.

    17

During the century that followed the destruction of Knossos, Mycenae rose to heights of wealth and power hitherto undreamed of in Greece. A series of local kingdoms spread throughout the mainland, their centres including Athens, Thebes, Sparta and Pylos. They were apparently autonomous locally but owed allegiance to the ruler of Mycenae, whose standing was such that he was treated as an equal by the Hittite kings. In their records he appears as the King of the Ahhiyawa (Achaeans). The enormous wealth of the Mycenaeans was generated by trade, the extent of which can be gauged by the wide distribution of their pottery, found as far afield as Cyprus, Syria and Egypt in the east, and Lipari off the north coast of Sicily in the west. Some of the vases were exported as luxury objects, but many served primarily as containers for the perfume that was an important commodity of the export trade. Mycenaean imports probably included gold from Egypt, ivory, spices and perhaps textiles from Syria, and copper from Cyprus.

As Mycenaean power grew, colonies were established at various points overseas. One such was at Ialysos on the island of Rhodes, where several of the objects exhibited here were excavated in 1868 and 1870. These include a terracotta statuette of a bull (Terracotta B 3) and a model of a man driving a two-horse chariot (Terracotta B 2). Two large three-handled jars, one with lilies in the shoulder panels (Vase A 828), the other decorated with scale-pattern (1959.11–4.7), are of a Minoan shape taken over by Mycenaean potters. As direct Minoan influence waned after about 1400 BC, Mycenaean vase-painting gradually became less naturalistic in style and more linear. This tendency towards the abstraction of marine subjects such as murex shells may be observed on a stemmed goblet of about 1400–1300 BC (Vase A 868), where it has already begun, and on a tankard of about 1300–

    18

1200 BC (Vase A 848), where it has become much more pronounced. On a stemmed goblet of this later period, taller and more slender than the earlier example, is a thoroughly stylized representation of a cuttle-fish (Vase A 1008). Of about the same period is a ritual vessel in the form of a bull's head from the island of Kalymnos (Vase A 971). The mouth of the vessel is on top of the head, behind the horns, and a small pouring-hole is pierced

**19**  Mycenaean stemmed goblet found at Enkomi in Cyprus. Late Mycenaean IIIA,
*c.*1400 BC. Vase c 616, ht 11.5 cm.

through the muzzle. The graves at Ialysos also contained items of jewellery and other trinkets, including a gold finger-ring with the bezel set at right angles to the hoop (Ring 873), as is usual on Minoan and Mycenaean rings; beads of gold (Jewellery 793–4), blue glass (1870.10–8.50) and semi-precious stones (1870.10–8.61); and engraved sealstones (Gems 64 and 154; Case 5, nos 15 and 18).

In the decades following 1300 BC the Mycenaean empire reached its greatest extent, but already there were signs of trouble. The massive fortifications of Mycenae and other mainland sites date from this period, and overseas there was a breakdown in the friendly relations with the Hittites that had been maintained in the previous century. Symptomatic of this breakdown was the Mycenaean expedition to north-western Asia Minor, mentioned in the Hittite records and remembered in later Greek traditions as the Trojan War. Its true cause was doubtless less romantic than the Abduction of Helen: more likely it was concerned with expanding markets and the control of trade routes. But the destruction of Troy brought little benefit to the Mycenaeans. The vast expedition seems to have left their forces at home weakened and vulnerable to attack from the north. Several mainland sites, including Mycenae itself, were assaulted around this time. Fortifications were strengthened and rebuilt, but further incursions around 1200 BC left Tiryns and Pylos in ruins. Many parts of the country were largely depopulated as refugees fled to safer areas, including Rhodes and Cyprus, which remained prosperous for several generations. The complex system of trade and government, however, had been disrupted, and Mycenae was no longer in overall control of the Aegean world. Its decline is reflected in the disappearance of a unified style of Mycenaean pottery and the emergence of local schools. A bowl of this period from Ialysos, its painted decoration consisting simply of horizontal bands, is enlivened by four statuettes of women standing on the rim (Vase A 950).

## The Mycenaeans on Cyprus

Cyprus lies remote from the Aegean world, and before about 1400 BC it looked more to the east for its overseas contacts. There was never a Minoan colony on the island, as there had been on Rhodes, and Minoan imports are relatively rare. With the rise of Mycenae, trade increased between the Aegean and Cyprus, and has left its mark in the vast quantities of Mycenaean pottery discovered on the island. Among the early examples, around 1400 BC, are a goblet of typical Mycenaean shape found at Enkomi on the east coast (Vase C 616), and a perfume vase (alabastron) from Hala Sultan Tekke near Larnaca on the south coast, an area where much of the Mycenaean trade was concentrated (Vase C 493). During the next hundred years this trade continued steadily. Among the vases found at Maroni, another site on the south coast, are two mixing bowls (*kraters*) of a shape characteristic of this period: a pear-shaped body with an offset neck and with strap-like

19

handles connecting the lip with the shoulder. One of these is decorated with chariots in the usual technique of dark glaze on a light background (1925.11–1.3); the other (Vase C 332) has a frieze of birds drawn in a light colour superposed on a dark background of glaze, an uncommon technique at this period. Enkomi had some particularly prosperous inhabitants at this time, and their tombs have yielded silver vessels, including a bowl (1897.4–1.300) and a one-handled cup (Jewellery 821), both of such typically Mycenaean form that they also must be imports. Other finds at Enkomi that suggest a certain luxury by their lack of a strictly utilitarian purpose include small sculptures of terracotta: the chariot (Terracotta A 22) and the statuette of an ox (Terracotta A 23) in Case 3 are to be dated about 1300 BC.

During the following century the quantity of Mycenaean vases found in Cyprus increases. Typical of the period is a stemmed goblet with a highly stylized representation of a cuttle-fish (Vase C 608); more unusual is the ritual vessel in the form of a bull's head (Vase C 607). At the same time new varieties of familiar shapes appear, including tall-necked jugs with

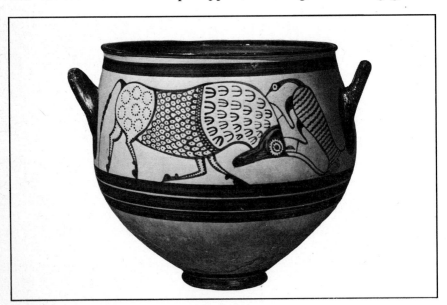

20 Imported wine-bowl, found at Enkomi in Cyprus. Late Mycenaean IIIB, c.1300–1200 BC. Vase C 416, ht 27.2 cm.

tapering bodies and convex shoulders. A jug of this type exhibited in Case 4 is decorated on the shoulder with the foreparts of bulls (Vase C 575). Kraters too have undergone a change; the new variety has a more rounded bowl, lacks a neck, and has two loop handles placed high on the body. Chariot scenes or rows of animals or birds form the usual decoration of such kraters, but a more imaginative scene shows a bull being groomed by

a cattle-egret (Vase C 416). Vases of these particular forms have scarcely
been found outside of Cyprus, and it was once thought that they were
made locally by Mycenaeans who had established colonies on the island.
The sites where they have been found, however, all have a long history of
settlement and a cultural background that is clearly Cypriot. It was only
after the destruction of mainland sites that Mycenaean colonists actually
settled in Cyprus, probably about 1200 BC. Earlier Mycenaean vases found
in Cyprus must have been imported, either from the mainland or perhaps
from Rhodes. They may well have been manufactured principally for
export and with the Cypriot market in mind, just as in later times many
Attic vases were made specifically for export to Etruria or to the Greek
cities in Italy. After 1200 BC vases of Mycenaean type were actually made
on Cyprus itself by the new colonists, and other Mycenaean crafts survived
there, including that of ivory carving. The ivory mirror-handles decorated
with reliefs of a warrior fighting a griffin (1897.4–1.872) and a lion attack-
ing a bull (1897.4–1.402) date from this period of Mycenaean colonization
in Cyprus.

22

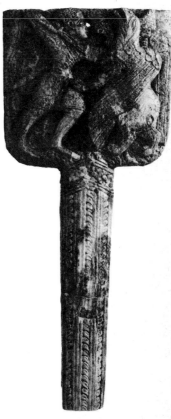

21  Silver cup found in a tomb at Enkomi in Cyprus. In shape
it is like the famous gold cups from Vaphio in the National
Museum, Athens. Mycenaean, c.1400–1300 BC. Jewellery
821, ht 6.9 cm.

22  Ivory mirror-handle with warrior fighting griffin.
Probably made on Cyprus, c.1200–1100 BC. 1897.4–1.872,
ht 20.2 cm.

44
43

30

45        41
                40
      42

35

36        31
39
                38

29   31
   28   32      26
27

34

33

◁ Room 4                                          Room 2 ▷

37

㉕   23  24

# Room 3
# The Geometric, Orientalizing and Archaic Periods

**The Dark Ages**

With the collapse of Mycenaean civilization and its system of communication and trade (c. 1100 BC), Greece was plunged into the 'Dark Ages', which were to last for more than three centuries. For many this was a time of poverty and hardship. Some free peoples were reduced to serfdom by the invading Dorians, others were driven from their lands and forced to migrate across the Aegean. Some indication of the course of the migration can be gleaned from later traditions and from the distribution of Greek dialects in Classical times. The archaeological record confirms the reoccupation of many coastal sites in Asia Minor that had been abandoned at the end of the Mycenaean period, but of actual events and personalities we remain ignorant. In their new homes the various Greek tribes maintained their common ties, in particular their religion, which pervaded the whole of life, and their common tongue – their non-Greek neighbours being characterized as 'foreign-speakers' (*barbaroi*). The political unity of the Late Bronze Age, however, had vanished, and in its place we see a multiplicity of small city-states, whose isolation and jealously guarded autonomy are reflected in the variety of local artistic styles.

**Geometric Art**

The absence of large-scale architecture in the Dark Ages and the resulting lack of wall-painting left vase-painting as one of the major arts, a position it was to hold for several centuries. In Attica the stylistic development of painted pottery can be traced without a break from Mycenaean times through the Protogeometric style of the tenth century to the Geometric of the ninth and eighth centuries. This continuity lends credence to the tradition that Attica resisted the incursions of the Dorians. For much of this period Attic pottery set the pace of development, and Athens was the centre from which ceramic techniques and new decorative idioms were disseminated.

**Vase-painting Technique**

The basic technique of decorating vases was a legacy from the Bronze Age. Its effect is derived from the contrast between the black or brownish 'glaze' and the lighter ground formed by the body of the vase itself.

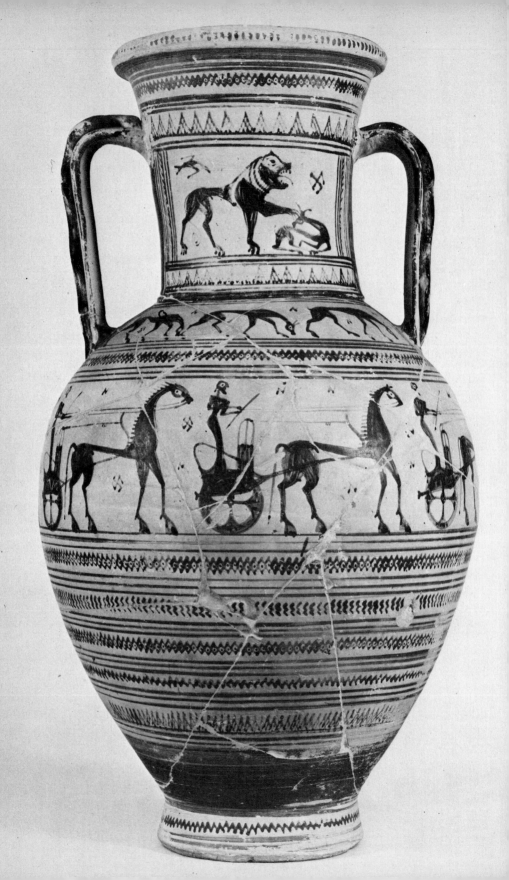

Strictly speaking 'glaze' is incorrect, as is its common alternative, 'paint'. The correct term is 'slip': a solution of fine particles of clay, the same clay in fact as the body of the vase, perhaps with a little potash added to help maintain a proper consistency. Many Greek clays contain traces of iron, and the contrasting colours of the finished vase are caused by a natural variation in the colour of different oxides of iron. In practice the different colours of the body of the vase and the slip were produced by twice changing the oxygen content of the kiln during firing. The process itself remained unchanged for hundreds of years, but successive generations of Greek potters learned to control it with ever greater precision until the technique reached its peak in the fifth century BC.

## Protogeometric and Geometric Art

Protogeometric art is represented in Case 2 by an amphora from Athens decorated with a characteristic zone of wavy lines between the handles (Vase A 1123). Patternwork based on straight lines becomes the norm in the Geometric period, the most frequent design being the meander. From small panels set into a dark background the patternwork gradually spread until it occupied almost the whole of the surface. Animals appear rarely at first, but are seen more frequently towards 800 BC, both in the painted decoration and modelled in the round. A cosmetic-box *(pyxis)* in Case 2 belongs to a class of vase found only in women's graves (1910.11–12.1). Its painted decoration includes chariot-wheels, and the four horses that stand on the lid probably represent the chariot-team.

After about 800 BC scenes with human figures play an increasingly important role in vase-painting, especially representations of funeral rites and processions. An amphora in Case 4, of a type found only in men's graves, has a funeral procession of chariots around the body (1936.10– 17.1). Horses, chariots and drivers are drawn in silhouette and in order to avoid an excess of complicated detail the artist has shown only one horse with each chariot, although in fact there would have been two or four.

A large bowl (krater) from Thebes (1899.2–19.1) shows a ship, the treatment of which exemplifies both the difficulties inherent in the silhouette technique, confined as it is to a two-dimensional view of the world, and the Geometric artist's compensating freedom from formal perspective and the restrictions of a single viewpoint. To draw the rows of oarsmen one behind the other would reduce the scene to a chaotic mass of overlapping forms; the artist therefore shows the ship from the side but adopts a bird's-eye view for the oarsmen. The man and woman seen boarding the ship may be Theseus and Ariadne. Other representations of mythological themes from this period include the Trojan Horse and Herakles killing the Hydra on a Boeotian bronze brooch *(fibula)* in Case 3 (Bronze 3205).

23

23 Amphora with figures drawn mainly in silhouette. Made in Athens, c.720–700 BC. 1936.10–17.1, ht 61.5 cm.

Bronze was also used for small statuettes, cast solid by the 'lost wax' technique. In the simplest form of this technique, the statuette to be cast was first modelled in wax and then covered with a substantial layer of clay, which was then fired in a kiln. The cavity left by melting out the wax was filled with molten metal, and when this had cooled the mould was broken away. Since the broken mould could not be used again, every statuette made in this way is unique. Favourite subjects include warriors and animals, especially horses (1905.10–24.5; 1925.4–22.1), some of which stand on openwork bases. Their forms are schematic – cylinders and convex plates serve as bodies and limbs, knobs are sometimes added to indicate the joints – but their taut contours remind us of the two-dimensional horses on the vases, and in spite of their rigid stance they appear lively and alert.

24

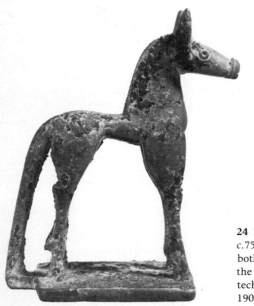

24 Bronze statuette of a horse made c.750–700 BC. Its simplified form reflects both limited knowledge of anatomy and the relatively primitive modelling techniques of this early period. 1905.10–24.5, ht 9.8 cm.

### The Orientalizing Period
With the picture on a Rhodian plate of about 600 BC we are in a different world (1860.4–4.1; Case 5). New designs, largely derived from floral motifs, have replaced the old geometric patternwork, but they have been reduced to the status of subsidiary ornament. The most important element of the decoration is now the figured scene: Menelaos and Hector fighting over the body of Euphorbos. They are no longer mere silhouettes, but are drawn in a brownish black outline on a pale yellow background with a dark red added on areas of exposed flesh. Many details of dress and armour are clearly shown, and the names are inscribed.

25

These changes were not accomplished overnight, but were the product of a century of innovation and experiment. The process began towards the end of the eighth century. Contact with the non-Greek world had been sporadic before this, but from about 750 BC expanding population drove the enterprising Greeks to seek new territories and new commercial outlets. New communities, retaining ties of language, religion and affection with the homeland but politically independent, were founded first in southern Italy.and Sicily, later on the shores of the Black Sea. Trading stations were established on the Syrian coast and in Egypt. Ever quick to learn, the Greeks took full advantages of their revived contact with the peoples of the Near East. From the Phoenicians they learned to write, adapting the Semitic alphabet to the various dialects of the Greek language.

In the arts too they had much to learn. A bronze handle-attachment in the form of a siren (1914.4–11.1), said to have been found at Olympia and

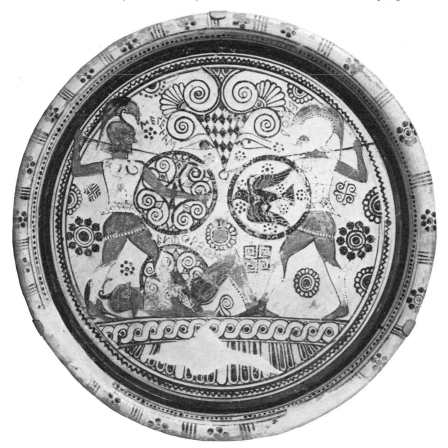

25 Rhodian plate with Menelaos and Hector fighting over the fallen Euphorbos. c.600 BC. 1860.4–4.1, diameter 38 cm.

dated about 725 BC, is of a type that had a long history in North Syria and Asia Minor. Oriental monsters like the sphinx and the griffin had been known in Greece in Mycenaean times. Now they reappear and take their place in the Greek decorative repertoire along with wild goats and deer of oriental types, lions (which few Greeks can have seen in the flesh), and eastern floral motifs based principally on the lotus and the palm. The griffin may be seen here in a variety of media: in pottery as the spout of a jug made in one of the Cycladic islands (1873.8–20.385), in bronze as a decorative attachment from a cauldron (1870.3–15.16, also in Case 6), and in gold on items of jewellery (Jewellery 1234 and 1235; Case 9, nos 15–16). Some oriental motifs came to Greece on imported merchandise, including bronzes, ivories, and in all probability also textiles, although these have not survived; others were no doubt introduced by immigrant craftsmen, especially goldsmiths and ivory-carvers. All were rapidly assimilated and naturalized: the Greek artist was prepared to learn and to adopt, but he was not a mere copyist.

27

26

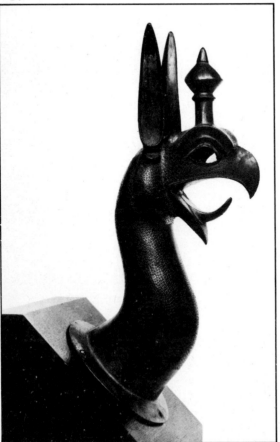

26 Bronze griffin from the sloping shoulder of a cauldron. The head and neck were cast hollow, one of the earliest examples of the technique from Greece. c.650 BC. 1870.3–15.16, ht 23.4 cm.

27 Earthenware jug with griffin-head spout. c.675 BC. 1873.8–20.385, ht 41.5 cm.

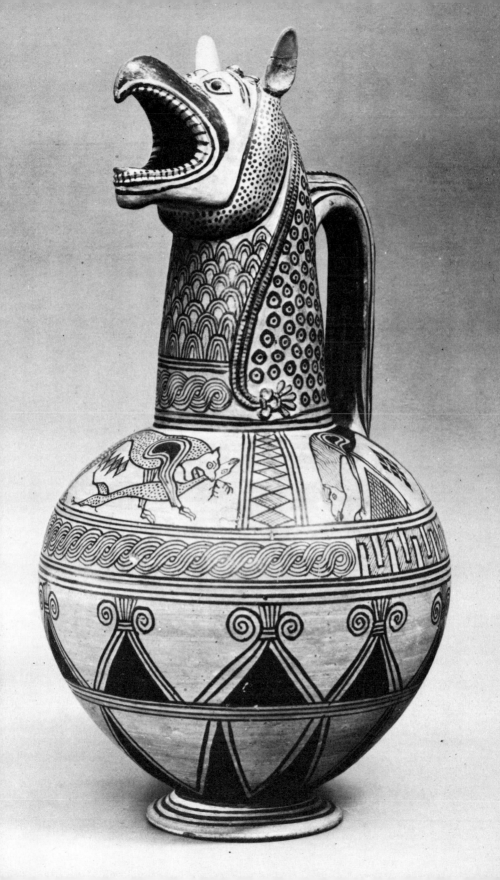

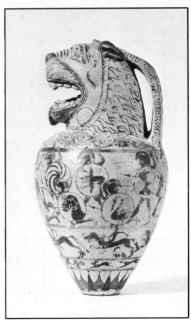

28, 29 Two Protocorinthian aryballoi. *Left*: with two hunters. *c.*700 BC. 1969.12–15.1, ht 6.8 cm. *Right*: with a lion-head spout. *c.*640 BC. 1889.4–18.1, ht 6.8 cm.
30 Gold plaques with Artemis. *c.*650 BC. Jewellery 1128–1130, ht 4.2 cm.

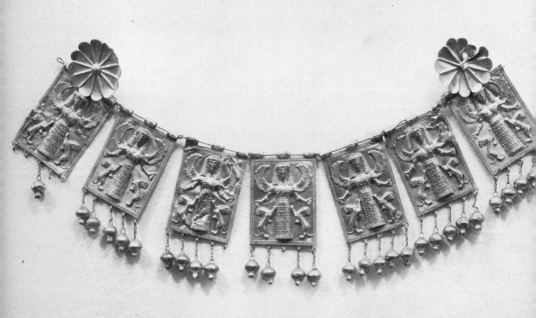

Prominent among Greek cities at this period was the thriving commercial centre of Corinth. Aided by its geographical position, which gave convenient access to both eastern and western trade routes, Corinth exported its products, especially pottery, far and wide. The first phase of its orientalizing pottery, the so-called Protocorinthian, is especially remarkable for its miniature style. An Early Protocorinthian scent-bottle (aryballos) has its decoration arranged in two friezes (1969.12–15.1) The floral ornament in the centre of each is derived from the oriental 'tree of life', but the Greek artist is already asserting his greater interest in figurework and narrative: the main frieze shows two men, one armed, the other on horseback, pursuing a deer. These figures are still drawn mainly in outline, but around 690 BC the 'black-figure' technique of vase-painting was introduced: the figures are drawn as solid silhouettes, and details are indicated by incised lines and by areas of added colour, chiefly a purplish red. An aryballos with a lion-head spout (1889.4–18.1) shows how successfully the Protocorinthian artist exploited the possibilities of this new technique in miniature: in a zone scarcely three centimetres high it has three friezes representing a battle, a horse race and a hare hunt. The technique was used with equal success on a larger scale, and Corinthian vases not only found a ready market in the western colonies and Etruria but were even able to compete with locally made wares in East Greece. From Camirus in Rhodes comes a Corinthian *olpe* (jug) with two friezes of animals and monsters, the central figures antithetically arranged in the oriental manner (1860.2–1.18). The cock was itself an oriental newcomer to the Greek farmyard, the lions are based on Assyrian models, but the twin-bodied panther-bird is a Greek invention.

The prosperity of Camirus in the seventh century can be gauged by the rich jewellery exhibited in Case 11. Particularly impressive are the oblong plaques that were strung side by side and worn on the breast. Their relief decoration includes such monsters as centaurs and winged sphinxes (Jewellery 1108 and 1109, nos 4–5). The centaurs (Jewellery 1115–1117, nos 6–8) are of the early type, having an entire human body with the barrel and hindquarters of a horse attached behind. A winged goddess, perhaps Artemis, appears as a 'Mistress of Animals' with a panther on either side (Jewellery 1107, no. 10: Jewellery 1128–1130, no. 11).

East Greek pottery was slow to adopt the black-figure technique, clinging instead to the outline drawing we saw on the Euphorbos plate. A small bowl on a high foot in Case 6 is decorated with a lively pair of wild goats, their bodies in solid black, their heads drawn in outline (1860.2–1.16). This too was found at Camirus and is probably of Rhodian manufacture. Other products of the Rhodian potteries included small scent-bottles of various shapes decorated with ceramic glaze. Some, such as the ram (Terracotta 1605) and the siren (Terracotta 1602), had bodies made on the potter's wheel, the other parts being moulded or made free-

28

29

30

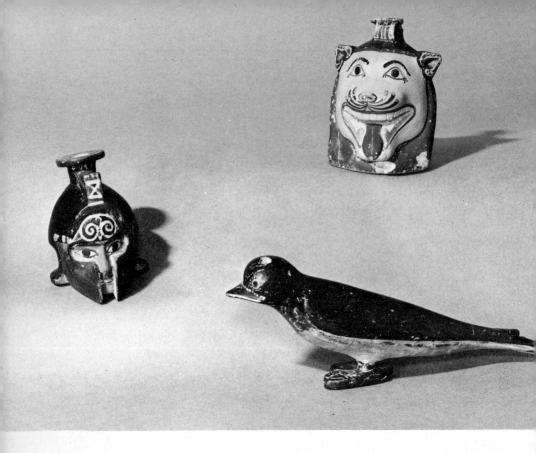

**31** Three Rhodian perfume
vases: a head of a warrior,
c.600 BC (Terracotta 1621,
ht 6.5 cm.); a swallow,
c.600 BC (Terracotta 1646,
ht 6.5 cm.); and a lion head,
c.620 BC (Terracotta 1633,
ht 8 cm.)

**32** Terracotta group of
Demeter and Kore seated in a
cart, made in Corinth c.620
BC. Terracotta 897,
ht 16.5 cm.

hand; others, like the slightly later woman's head (Terracotta 1601) and
the swallow (Terracotta 1646), were made chiefly in moulds, with a few
parts added freehand. The same mixture of techniques was commonly
practised in workshops that produced terracotta figurines. In the group
of Demeter and Kore seated in a cart (Terracotta 897), which was made in
Corinth, moulded heads have been added to handmade bodies.

31

32

## Sculpture and Architecture in the Archaic Period

Around the middle of the seventh century political unrest in many Greek
cities led to the overthrow of the old aristocratic regimes and the seizure
of control by powerful individuals. These new rulers were known as
Tyrants *(tyrannoi)*, although the word did not at that period imply unjust
or cruel rule. Many Tyrants encouraged commerce and patronized the
arts, so that for the first time since the fall of Mycenae the necessary funds,
talent and labour were available for large-scale building programmes.
Instead of palaces and tombs, however, the emphasis was now on public
buildings such as temples and fountain-houses. The inspiration for large
stone-built temples probably came from Egypt, which was reopened to
Greek trade about this time. Egyptian influence may also be discerned
in the stone sculpture of the second half of the seventh century.

Much of the archaic sculpture in the British Museum is East Greek,
the fruit of nineteenth-century expeditions to Xanthos in Lycia (by
Charles Fellows in 1842), to Miletus (by C. T. Newton in 1858) and to
Ephesus (by J. T. Wood from 1863 to 1874).

The Lycians were not themselves Greek, but although many of their
monuments conform to their own architectural tradition, they are
decorated with relief sculptures that are Greek in style and presumably
the work of Greek artists. An early example is the so-called Lion Tomb
(about 600–575 BC), a sepulchral chest originally supported by a rectangular

33

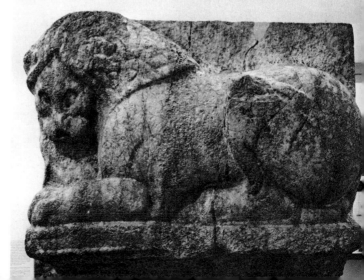

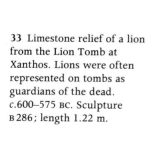

33 Limestone relief of a lion
from the Lion Tomb at
Xanthos. Lions were often
represented on tombs as
guardians of the dead.
*c.*600–575 BC. Sculpture
B 286; length 1.22 m.

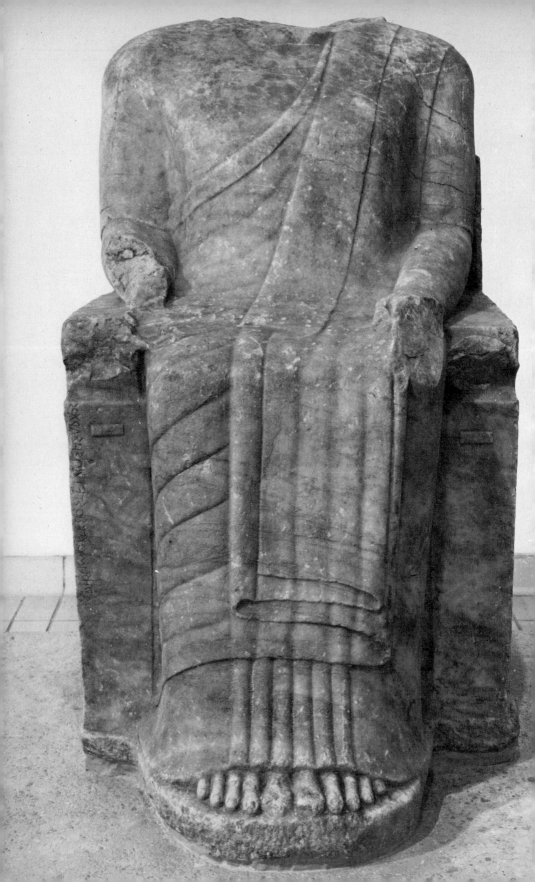

pillar about three metres high cut from the same block of stone (Sculpture B 286). Its name is derived from the lion holding a bull's head between its paws, which is carved in high relief on one of the narrow ends. The entrance was in one of the longest sides, flanked by low-relief panels, of which only one is well preserved. It shows a man stabbing a lion with a sword. A relief of a lioness and her cubs, which was found nearby and perhaps belongs to the other end of the Lion Tomb, is now exhibited separately.

At Didyma, a few miles south of Miletus, there was an oracle of Apollo that enjoyed particular renown in the sixth century. A Sacred Way led to the temple from a small harbour about a mile and a half away, and many statues dedicated to the god were placed alongside the route. These included a series of seated figures and two recumbent lions, one of which bears an inscription stating that it was dedicated to Apollo by the sons of a magistrate called Orion (Sculpture B 281). The seated figures, both male and female, wear an ankle-length tunic *(chiton)* of fine texture and a heavier mantle draped diagonally across the body. The sculptor's emphasis on a pleasing surface texture rather than on the underlying structure is characteristic of East Greek work. One of the figures is identified by its inscription as Chares, the ruler of nearby Teichioussa (Sculpture B 278).

<span style="float:right">34</span>

Very little survives of the archaic temple of Artemis at Ephesus because it was burnt down in 356 BC and many of the stones were reworked for the temple that replaced it. It was an Ionic building of great size, about 115m. long and 55m. wide, with a double row of columns all round. Part of the cost of the temple was defrayed by Croesus, King of Lydia, and his generosity was recorded in inscriptions on the column bases (Sculpture B 16). Some of the drums of the columns were decorated with relief sculptures, of which a few fragments have survived. A woman's head (Sculpture B 91) retains traces of the brightly coloured paint that the Greeks used to apply to their stone sculpture. The red on her hair is particularly noticeable. The drapery over the legs of a man walking to right provides another example of the archaic tendency to use folds to create a pleasing surface texture (Sculpture B 121). A highly stylized head of a woman, which must also have had its details emphasized with paint, perhaps also comes from one of the sculptured columns (Sculpture B 89). Two restored capitals and other fragments are exhibited in the Architecture Room; gold jewellery from the Foundation Deposit of an earlier temple on the same site is exhibited in Case 9 (nos 1–14).

<span style="float:right">35</span>

34 'I am Chares, son of Kleisis, ruler of Teichioussa, the statue is Apollo's' is inscribed on this marble statue from Didyma, c.560 BC. Sculpture B 278, ht 1.49 m.

### Archaic Vases, Terracottas and Bronzes

The manufacture of moulded scent-bottles continued in Rhodes during the first half of the sixth century (Case 7). Popular shapes during this period include a bust of a woman (Terracotta 1612) and a head of a warrior wearing a helmet (Terracotta 1621). Their counterparts made in Corinth tend to lack the conspicuous wheel-made spout of the Rhodian types and their suspension holes may be concealed, as they are in the hair of the sphinx (Terracotta 1670) and in the mane of the lion (Terracotta 1671). In Boeotia at this period terracotta figurines were made chiefly for local use rather than for export. A statuette of a standing woman has a decorated chiton with an elaborate floral pattern on the breast (Terracotta 768).

36

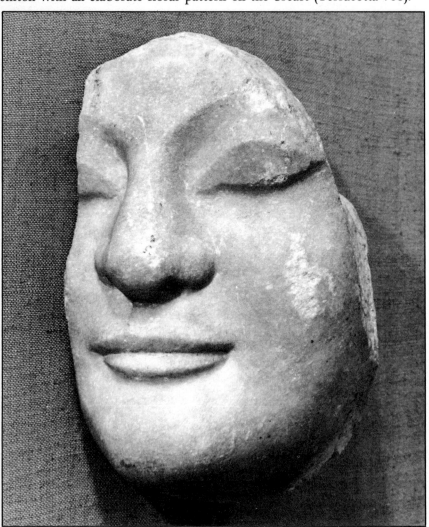

Athenian vase-painters had adopted the black-figure technique from Corinth towards the end of the seventh century, and during the first half of the sixth they took advantage of the fine quality of Attic clay to produce pottery of a superior quality that gradually drove Corinthian wares from the overseas market. The foundations of Athenian prosperity were laid by the liberal reforms of Solon at the beginning of the sixth century, and her economic expansion was fostered by the tyrant Pisistratus in the years following 561 BC. Many Attic vases of the early sixth century are decorated simply with zones of animals and monsters, conventionally drawn in the manner that the Athenian vase-painters had learned from the Corinthians. An interest in the human figure, however, already evident

**35** Marble head of a woman from the archaic temple of Artemis at Ephesus. The rounded forms and soft contours are characteristic of East Greek sculpture. c.530 BC. Sculpture B 89, ht 19 cm.

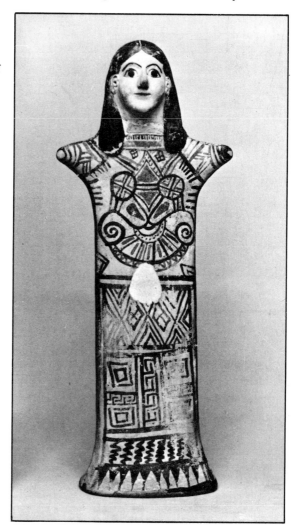

**36** Boeotian statuette of a woman. The head was made in a mould and attached to the body, which had been made by hand with very simplified forms. c.575 BC. Terracotta 768, ht 28 cm.

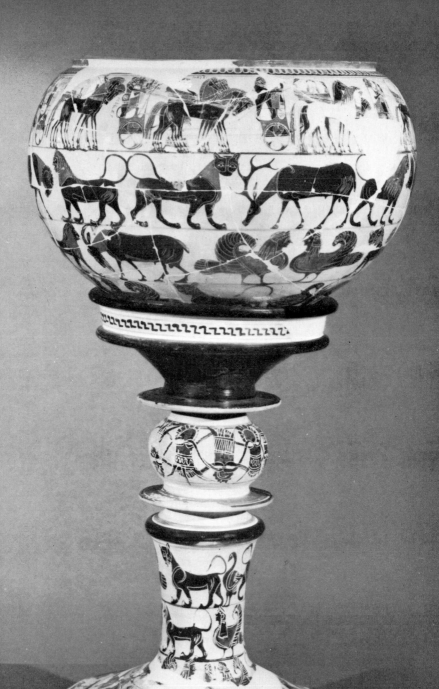

in Athenian art from the Late Geometric period, gradually asserted itself.

Among several artists of this period with recognizably individual styles, the first to be known to us by name is Sophilos, who signed a number of his vases, including the large round-bottomed bowl *(dinos)*    37 with a separate stand in Case 12 (1971.11–1.1). Its zones are filled for the most part with various wild and domesticated animals, but the principal frieze contains an elaborate mythological scene, the wedding of Peleus and Thetis. Sophilos has not tried to tell the whole story, but has picked one significant moment, the arrival of the guests. The gods and goddesses have come in procession from Mount Olympos, some of them in chariots and others on foot, and they are accompanied by various minor divinities like the Nymphs and the Muses. Peleus welcomes them at the door of his house; Thetis is nowhere to be seen and is presumably indoors.

Since the rest of the story was familiar to the Greeks, Sophilos could leave it to their imagination, adding just a few hints of it. The presence of Eileithyia, goddess of childbirth, foreshadows the birth of a son to Peleus and Thetis: Achilles, who would be educated by the wise centaur Chiron (also present), and who was destined to outshine his father and to die a hero of the Trojan War. This choice of a significant moment in the story is characteristic of archaic art. Equally characteristic is the composition of the scene, with its main movement from left to right, and with its many distortions of scale and posture to bring the heads of all the figures up to the same level.

On a black-figured water-jar *(hydria)* of about 575–550 BC the frieze of panthers and goats has only a minor decorative function (Vase B 76). The principal picture area on the shoulder of the vase shows the departure of a chariot manned by Hector and his charioteer Kebriones, both identified by their inscribed names. Other vases have been attributed to the same painter, but since none of them is signed a nickname has been given to him: 'The Painter of London B 76', after this vase. Some vases are signed not by the painter but by the potter; a few are signed by both. A drinking cup with a picture of a successful huntsman inside (Vase B 421) has on the outside the potter-signature of Tleson, whose father Nearchos was himself a distinguished potter.

Exekias, one of the greatest of the black-figure painters, states that he made a neck-amphora (see Glossary, under Amphora), which has Achilles and Penthesilea on one side and Dionysos and Oinopion on the other (Vase    38 B 210). His statement here might be interpreted as referring only to the potting, but since he signed other vases as painter, the figurework too can be attributed to his hand. Added white is used for Penthesilea's exposed flesh, in accord with the usual convention in black-figure,

37 Black-figured wine bowl and stand made in Athens about 570 BC and signed 'Sophilos painted me'. The main frieze shows the wedding of Peleus and Thetis. 1971.11–1.1, ht 71 cm.

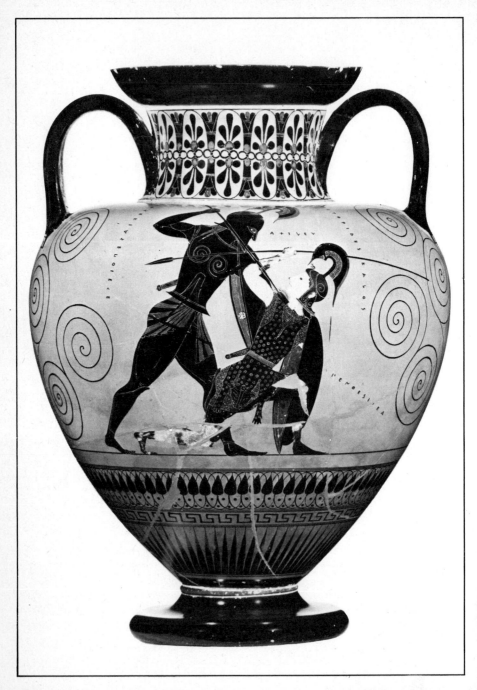

**38** Black-figured neck-amphora: Achilles slays the Amazon Penthesileia. Their names were inscribed by Exekias, who also signed the vase. Attic, about 540 BC. Vase B 210, ht 41.5 cm.

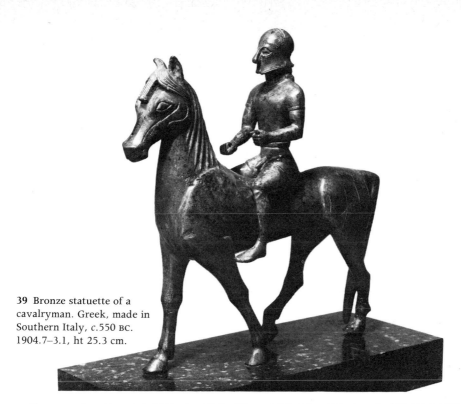

**39** Bronze statuette of a cavalryman. Greek, made in Southern Italy, *c.*550 BC. 1904.7–3.1, ht 25.3 cm.

reflecting the fact that Greek women avoided exposure to the sun and were in consequence pale-skinned in comparison with their well-bronzed menfolk. Achilles, as victor in the duel, is shown moving from left to right. The eyes of both figures are drawn as if seen from the front, although the heads are in profile. Two jugs, an *oinochoe* with a chariot (Vase B 524) and an olpe showing a hunter returning with his catch (Vase B 52), are not signed but have been attributed to a contemporary of Exekias, whose mannered style is very distinctive. He is known as the 'Amasis Painter' since he decorated several vases signed by the potter Amasis.

The Dorian city of Sparta is chiefly remembered in history for the strictness of its military discipline and for the unflinching courage of its warriors. It was also the home of a splendid series of bronzes and of a distinctive style of pottery that owed something to Corinthian influence but was far from being entirely derivative. The tall-stemmed drinking-cup *(kylix)* with a horseman and a rather enigmatic winged figure is a characteristic example of the ware (Vase B 1). As usual, the principal subject is on the inside, but in contrast to Attic practice little effort is made to fit the composition to the circular frame; this is often divided into two segments by an exergue that serves also as a ground line.

Although the now prosperous western colonies imported a great deal of pottery from cities in the Greek homeland, they were not without an artistic production of their own. Among the finest Greek bronzes of about 550 BC is a statuette of a mounted warrior (1904.7–3.1), which was found at Grumentum in Lucania and probably made somewhere in that

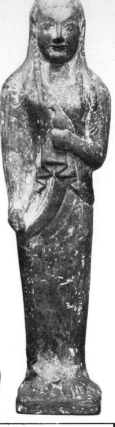

**41** Woman holding a dove, one of many identical figures made from the same mould. East Greek, *c.*540 BC. Terracotta 58, ht 25.5 cm.

**40** Bronze banqueter, cast by the 'lost-wax' technique. Probably Peloponnesian, *c.*520 BC. 1954.10–18.1, length 10.2 cm.

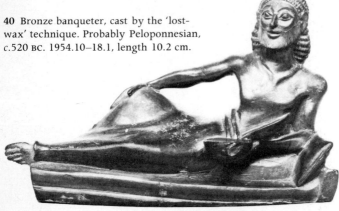

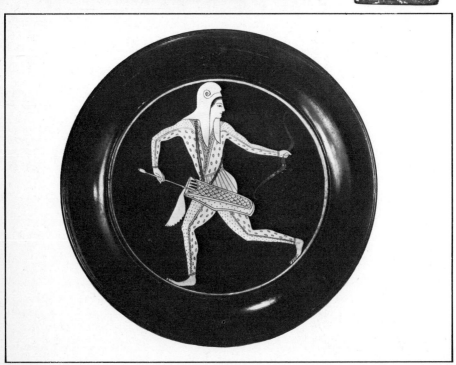

part of southern Italy. From Ruvo, also in south-eastern Italy, come a pair of bronze greaves (shin-guards) in Case 8 (Bronze 249). They are decorated with figures of running gorgons, their heads partly in relief, other details incised; the teeth and projecting tongue were of ivory, and the eyes were originally inlaid.

Among the bronze statuettes in Case 8 is a small figure of a naked youth *(kouros)*, standing upright with his hands by his sides, a miniature representative of a sculptural type that was ultimately derived from Egyptian models but became characteristic of Greek sculpture in the archaic period (1905.6–10.1). Another statuette of a youth bears an inscription stating that it was dedicated to Apollo, and is perhaps meant to represent the god himself (1908.4–13.1). A statuette of a reclining banqueter, said to have been found in the sanctuary of Zeus at Dodona, is probably of Peloponnesian workmanship (1954.10–18.1). This too may represent the god to whom it was dedicated, since the vessel in his hand is a shallow bowl of a special kind known as a *phiale*. Its use as a drinking-cup is normally restricted to the gods, while mere mortals use it only to pour libations, or drink-offerings.

40

Another sculptural type characteristic of the archaic period is the standing draped female figure, the so-called *kore* or maiden, best known from the series of marble statues in the Acropolis Museum in Athens. They were found on the Acropolis, where they had been buried after the city was sacked by the Persians in 480 BC. Here the type is represented by hollow-moulded terracotta figurines (Terracotta 58 and 49), one of which was modified to serve as a scent-bottle by the addition of a spout on top of the head. Few traces remain of the bright colours that originally decorated them, since they were applied after firing and tend to fade, unlike the ceramic glazes of the earlier aryballoi.

41

## New Techniques of Vase-Painting

Around 530 BC the 'red-figure' technique of vase-painting was invented in Athens. As the name implies, the figures are now left in the reddish colour of the vase itself, and it is the background that is filled in with black glaze. Incision was still used for a while to mark the outline of the hair, as on a water-jar (hydria) signed by the painter Phintias (Vase E 159), but for inner details it was replaced by lines drawn with glaze. This technical advance was of enormous stylistic importance, for it made possible a new fluidity of line that was invaluable to the vase-painters of the period in their search for more realistic ways of drawing the human figure. The glaze was used in two ways: a thick solution produced a bold

**42** Red-figured plate, with an archer; signed by the painter Epiktetos. *c.*520 BC. Vase E 135, diameter 19.3 cm.

line of black, often raised slightly above the surface and therefore sometimes called 'relief line'; a more dilute solution gave a fainter line of golden brown, or was sometimes applied as a wash.

Black-figured vases continued to be made for many years, but from now on the more enterprising vase-painters worked predominantly in the new technique. One of the most prolific red-figure painters of the sixth century was Epiktetos. More than a hundred of his vases have survived, of which about forty have his signature. They include a plate with an
42      archer wearing oriental costume, skilfully drawn to fit the circular frame (Vase E 135), and a cup, signed also by Hischylos as potter, with armed satyrs in red-figure on the outside and a horseman still in black-figure on the inside (Vase E 3). Two more plates and a cup signed by Epiktetos are shown in Room 5.

Another new technique introduced into Attic vase-painting around 530 BC entailed the application to the surface of the vase of a thin layer of white clay to serve as a ground for the figurework. A perfume-vase
45      *(alabastron)* in this technique, signed by Pasiades as potter, is decorated with a pair of maenads (female devotees of the wine-god Dionysos), drawn in outline with a yellow wash of dilute glaze on some of the drapery (Vase B 668).

Towards the end of the sixth century and in the early part of the fifth, vase-painting techniques were used to decorate a series of terracotta coffins, probably made at Clazomenae in Asia Minor. Some feature animals and monsters, drawn in outline and reminiscent of those on earlier East Greek vases (1902.10–12.1). Battles are also favourite subjects, and for these a sort of imitation black-figure is used, the details being indicated not by incisions but by painted white lines (1896.6–15.1).

## Sealstones (Case 10)

The art of carving sealstones was lost in Greece during the Dark Ages, and its revival in the seventh century BC was perhaps stimulated by chance finds of Bronze Age seals. At first only soft stones were used, serpentine or steatite, and seals were made chiefly in the islands. The repertory of subjects included animals and monsters like the lion (1936.7–
43      21.7; no. 13) and the centaur (Gem 173; no. 5), and many of the stones were almond-shaped (amygdaloid).

During the sixth century BC the scarab or beetle-shape became popular, in imitation of Phoenician seals of that shape that were themselves derived from Egyptian scarabs. The reintroduction of the cutting-wheel and the drill brought hard stones like chalcedony back into use. A wide variety of subject matter was important so that a man's seal might be unique. To discourage fraud Solon forbade seal-engravers by law to keep impressions of their work.

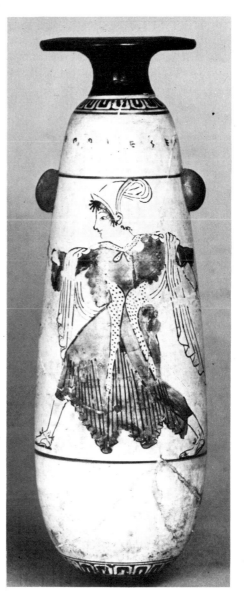

**43, 44** *Above*: an amygdaloid (almond-shaped) seal stone showing a centaur. 700–600 BC. (Gem 173, length 2.4 cm.); *right*: seal-impression with Herakles, Acheloos and Deianeira. *c.*550 BC (Gem 489, length 1.8 cm.)

**45** White-ground alabastron made in Athens by Pasiades towards 500 BC. Vase B 668, ht 14.4 cm.

Sealstones reflect in miniature the trends of large-scale Greek art. Their subjects include mythological scenes, such as the fight between Herakles **44** and Acheloos (Gem 489; no. 6), and figures from everyday life like the athlete with his oil-flask and strigil, or scraper (Gem 490; no. 8). An increasing knowledge of anatomy and a corresponding skill in representing it may be seen in the athlete and also in a satyr on an agate scarab (Gem 465; no. 7).

Room 5

Room 3

46

# Room 4
# Kouroi

The Greek *kouros*, the standing youth of which we have already seen a small example in bronze, resembles its Egyptian counterpart in several respects. The stance is upright and frontal, one foot (usually the left) is advanced, the arms hang by the sides, the hands are clenched. There are, however, two essential differences: the Egyptian figures wear a kilt and are supported by a pillar at the back, while the Greek youths are nude and freestanding.

Statues of this type served a variety of purposes. A few may have represented Apollo, but many that once stood in sanctuaries must simply have been meant as worshippers. Some are known to have been commemorative statues of famous men such as victors in the games, and others served as grave monuments.

The earliest *kouroi*, made shortly before 600 BC, are very schematic in form, less realistic than the corresponding Egyptian statues. They are seen to best advantage from a strictly frontal or profile viewpoint, the transitions between the front and side views being at first awkwardly managed. As the sculptors' skill and knowledge of anatomy increased during the sixth century, there is a perceptible development from stylization towards naturalism. The two *kouroi* exhibited in Room 4 exemplify the trend.

The earlier of the two (Sculpture B 474) may be dated about 460 BC. 46
The pose is stiff, the limbs angular in shape. The lower edge of the rib-cage is indicated by shallow curved grooves. The other *kouros* (Sculpture B 325), which was found in a tomb in Cyprus, is some forty years later in date. Even without the head the differences are readily apparent: the limbs are rounder, the muscles more skilfully modelled, and the surface planes of the body run into one another without grooves to mark the transitions.

A further development is evident in one of the latest of the archaic *kouroi*, which formerly belonged to the sixth Viscount Strangford and is 47
now exhibited in Room 5 (Sculpture B 475). Many elements are still stylized, such as the formal row of spiral curls across the forehead, but there is now apparent a more confident treatment of the anatomical structure, of the musculature, and of such smaller details as the form of the ear. Small holes are drilled on either side of the head and at the back

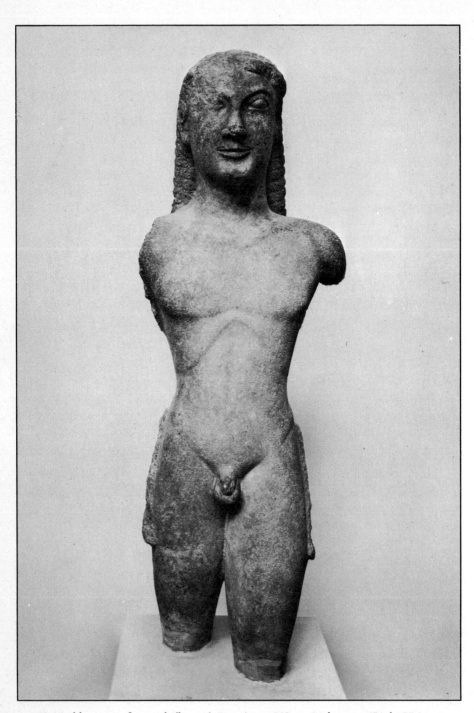

**46** Marble statue of a youth *(kouros)*. Boeotian, *c.*560 BC. Sculpture B 474, ht 77.3 cm.

for the attachment of a wreath or fillet (headband), probably made of bronze.

The development of the *kouros* exemplifies one of the characteristic features of Greek art: the adherence to a particular type and its gradual perfection. The Greeks did not share the modern obsession for 'originality'. The Greek approach to artistic progress may be observed not only in sculpture but also in other arts, for example in pottery and especially in architecture. While the basic design of the Doric temple was fixed about 700 BC, the gradual refinement of details and proportions took two and a half centuries to reach its culmination in the Parthenon.

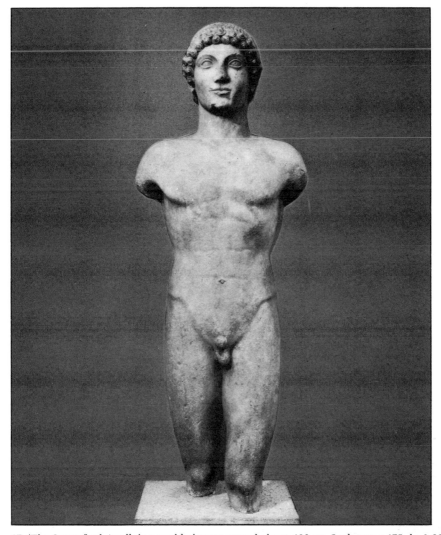

47 'The Strangford Apollo'; a marble *kouros* carved about 490 BC. Sculpture B 475, ht 1.02 m.

# Room 5
# Greek Art, 500~440 BC

## Greece in the Early Fifth Century

For some thirty years after 500 BC the history of Greece is dominated by the menace of Persia. In their abortive revolt against Persian rule at the beginning of the fifth century the Greek cities of Ionia had been aided by the Athenians, and it was primarily against Athens that the Persian King Darius launched a punitive expedition in 490 BC. This the Athenians repulsed at Marathon. Ten years later Xerxes, the son and successor of Darius, mounted a full-scale invasion of Greece. He was defeated by the concerted action of most of the major Greek cities under the leadership of Sparta, but only after the Athenian acropolis had been sacked. A turning-point in the war was a sea-battle off the island of Salamis, in which the Athenian navy played an important part. After the war Sparta remained the most influential city on the mainland, while Athens established her leadership of the maritime states.

The fifth century also saw fundamental changes in the Athenian constitution. Towards the end of the sixth century constitutional reforms had been introduced by Kleisthenes to secure the rights of the Athenian citizens. These paved the way for the full democracy that developed in Athens after the Persian Wars.

## Sculpture in the Early Fifth Century (Case 2)

When the Persians sacked the Acropolis in 480 BC the archaic period had almost run its course. The increasing mastery of anatomy that we have seen in the *kouroi* may also be observed in the late archaic period in small-scale sculpture, but the traditional poses are still in use, and in the representation of drapery there is still much emphasis on the surface texture. A bronze statuette of a girl holding a flower, found on the island of Melos, retains the frontal stance of the traditional *kore* (Bronze 194). The equally traditional posture of the running or flying figure – legs in profile, forward knee raised, chest frontal – is maintained by a girl runner, perhaps made in Laconia (Bronze 208), and by a winged figure from the collection of Richard Payne Knight, bequeathed to the Museum in 1824 (Bronze 491). All these date from around 500 BC or a little later. Roughly contemporary with them is a group of Boeotian terracotta statuettes, probably toys, which are said to have been found at Tanagra (Terracottas

48

49

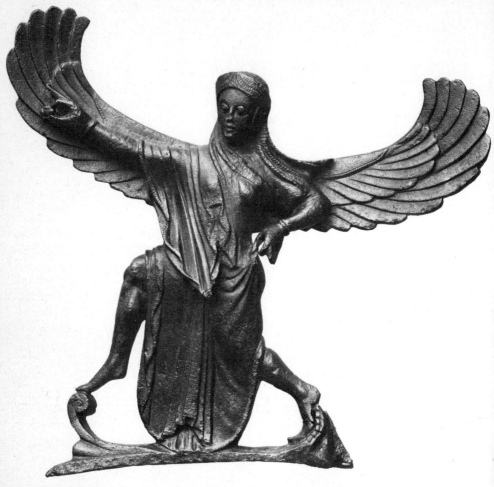

**48** Winged female, perhaps Nike or Iris, made soon after 500 BC. Bronze 491, ht 15.6 cm.

804–808). Solidly made and modelled freehand in the traditional manner, they were all originally brightly coloured like the man riding a goose (Terracotta 806).

## Late Archaic Vase-painting (Cases 3–5)

The early decades of the fifth century found many artists of high ability practising the red-figure technique of vase painting. Prominent among them was the 'Berlin Painter', so-called after a splendid amphora now in the Berlin Museum. He also painted the scenes from the Trojan War on the neck of a large volute-krater in Case 3 (Vase E468). (A volute-krater is a bowl for mixing wine and water, which is embellished with volutes above the handles; vases of this rather flamboyant shape were made

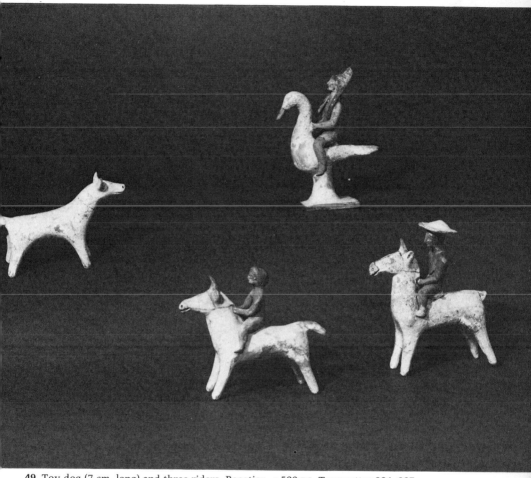

49 Toy dog (7 cm. long) and three riders. Boeotian, c.500 BC. Terracottas 804–807

largely for export and were popular in Etruria, this example having been found at Cervetri north of Rome.) On one side Athena encourages Achilles 51 as he overcomes Hector, who sinks to the ground with blood pouring from his wound, while his patron Apollo leaves him to his fate. On the other side Achilles and Memnon engage in combat, watched not by divine patrons but by their mothers, Thetis and Eos. In both duels Achilles, as victor, moves from left to right. All the names are inscribed. Musculature and drapery are still stylized into patterns, but clothing is beginning to accommodate itself to the shape and movement of the body, and a growing mastery of anatomy is evident in the three-quarter views of the body and especially of the abdominal muscles, which form a transition between the legs, seen in profile, and the frontally placed shoulders. Black relief lines are used for the most important details, dilute glaze for the rest.

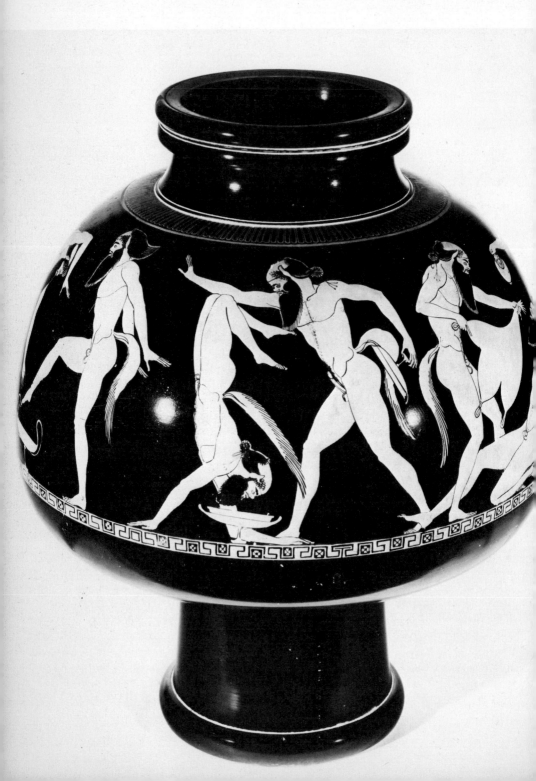

Among the many vases signed by Douris, whose long career as a vase-painter runs from about 500 to 470 BC, is a *psykter* (a wine-cooler designed to float in a large bowl of water) decorated with a merry band of satyrs, drinking and cavorting (Vase E768; Case 5). Satyrs are the rather boisterous companions of the wine-god Dionysos. They are usually represented with human bodies but with horses' tails and ears. Their bodies tend to be particularly hairy and they have shaggy beards. On a wine-jug (oinochoe)

50

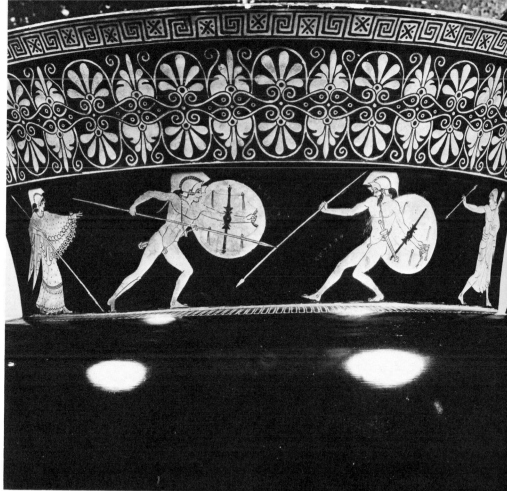

**51** Fight between Achilles and Hector before the walls of Troy. Detail of a red-figured volute-krater attributed to the 'Berlin Painter'. Attic, *c*.490 BC. Vase E468, ht of figures 7.5 cm.

**50** Wine cooler *(psykter)*, with satyrs; signed by the vase-painter Douris. 490–480 BC. Vase E768, ht 28 cm.

in Case 4 a rather more sedate satyr is bringing a jug of wine to his master
Dionysos (Vase E511). A large drinking-cup *(skyphos)* that shows Demeter
sending Triptolemos in his winged car to bring the gift of grain to mankind
(Vase E140) is signed on the handle by the potter Hieron and has been
attributed to the vase-painter Makron. These two men frequently
collaborated. The richness of the goddess's clothing is one of the character-
istics of Makron's style.

A two-handled jar *(stamnos)* in Case 5 has been attributed to the
Kleophrades Painter, who usually decorated fairly large vases. It illustrates
two episodes from the life of Theseus: the slaying of Procrustes and of the
Minotaur (Vase E441). The deeds of this legendary king of Athens were
popular subjects in Attic art, in wall-painting and vase-painting alike,
especially after the Battle of Marathon when he was believed to have
appeared on the Athenian side. The Brygos Painter, so named because
several vases signed by the potter Brygos have been attributed to him,
was like Douris a painter of the smaller vases, especially of cups. Of
those exhibited in Case 4, one is decorated with scenes of drinking parties;
on the inside a reclining youth watches a girl dancing (Vase E68). The
other cup, more elaborately decorated with some of the details gilded, is
signed on the foot by Brygos as potter (Vase E65). The exterior scenes
show Iris and Hera attacked by wild bands of satyrs. Inside, a woman
brings wine for a warrior to pour a libation before his departure for battle.
Their names, Zeuxo and Chrysippos, are inscribed beside them.

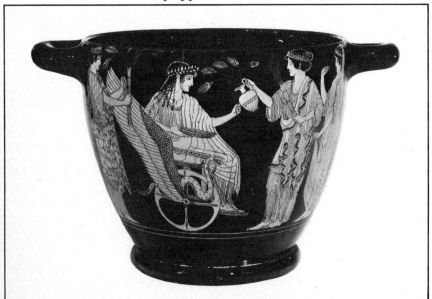

**52** Skyphos with Demeter, Triptolemos and Persephone. 490–480 BC.
Vase E140, ht 21.2 cm.

**53, 54** *Left*: seated woman. *c.*475 BC. Terracotta 1202, ht 25 cm. *Right*: Eileithyia. 490–480 BC. Bronze 188, ht 12.3 cm.

## Late Archaic Terracotta Statuettes (Case 4)

After about 500 BC terracotta statuettes were mass-produced in many areas. Stylistic development follows that of large scale sculpture, but tends to lag behind it, especially in the provinces. Thus a large statuette of a seated woman from Locri (preserved only above the waist) still has the archaic smile, but her lank hair suggests a date after 480 BC (Terracotta 1202). Thin wavy incisions indicate the fine texture of her chiton. On an earlier statuette of a seated goddess, which was made in Athens, extra details are added only in paint (1966.3–28.20). The bright colours that originally enlivened all of these statuettes are seen to advantage on a small figure of Hermes squatting (1956.2–13.1).

53

## Bronzes of the Late Archaic Period (Case 4)

Statuettes in bronze as well as in terracotta were frequently dedicated in Greek sanctuaries. Among those that bear votive inscriptions are a statuette of a hare dedicated to Apollo at Priene by Hephaistion, no doubt in recognition of his hunting success (Bronze 237), and Aristomacha's dedication to Eleuthia (i.e. Eileithyia, goddess of childbirth). This statuette (Bronze 188) probably represents Eileithyia herself, since she wears the tall head-dress *(polos)* of a goddess.

54

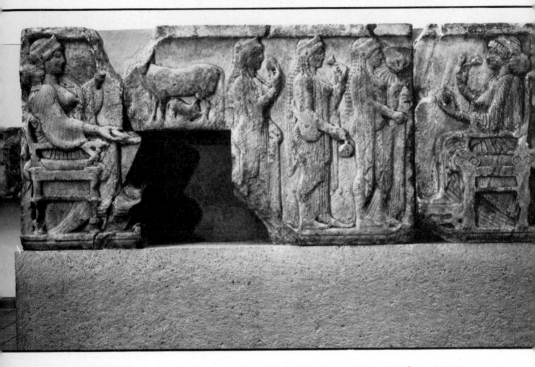

**55** Marble relief from the Harpy Tomb from Xanthos. *c*.480 BC. Sculpture B 287, ht 1.02 m.

A type of hand-mirror that was fashionable in the fifth century consisted of a polished disc attached to a statuette, usually of a woman, which served as a support as well as a handle. Some elaborate examples have additional figures attached to the disc. One from Athens, dated about 490 BC, has a pair of *erotes* hovering above the woman's shoulders (Bronze 241). The woman herself wears the Ionic dress of chiton and himation, and is still in the tradition of the archaic *korai*. Statuettes also served as handles for utensils: a shallow bowl *(patera)* from the Blacas collection has a handle in the form of a youth with his arms raised (Bronze 564).

### Sculptures from Xanthos
Towards the end of the sixth century a new phase of sculpture began in Xanthos following a break around the middle of the century, perhaps connected with the sack of the city by Harpagus in 545 BC. The limestone friezes mounted on the walls of Room 5, many of them in a fragmentary or damaged state, were recovered by Charles Fellows from a wall built around the acropolis of Xanthos in Byzantine times. The sphinxes came originally from the gables of Lycian tombs with steeply pitched roofs

and other details imitated from wooden prototypes (Sculpture B 290–1). (A later but more complete example of this type, the Tomb of Payava, is exhibited in Room 10.) Other buildings on the acropolis were decorated with continuous friezes in low relief, one of satyrs and animals (Sculpture B 292–8), the other with cocks fighting while hens look on (Sculpture B 299–306). The feathers of their wings and tails are represented by a series of receding surfaces, the edges cut sharply back to produce crisp shadows in the sunlight.

The 'Harpy Tomb' (Sculpture B 287), with its marble reliefs raised on a limestone pillar some five metres high, was discovered more or less intact in its original position near what later proved to be the civic centre *(agora)* of Xanthos. At first the winged figures at either end of the north and south sides were interpreted as harpies snatching away the daughters of the Lycian King Pandareos. They are now seen as sirens, death-demons bearing off the souls of the dead. Various interpretations of the scenes have been proposed, but it seems most likely that the seated figures represent the deceased members of the family whose tomb this was, while the offerings made to them form part of the funeral cult. The important location of the tomb and the scene on the east side, which reflects the court ritual of nearby Persia, perhaps indicate that the tomb belonged to the ruling family of Xanthos. 55

A marble statue of a standing woman (Sculpture B 318) wearing the Doric peplos (which came back into fashion about 480 BC, replacing the Ionic chiton and himation) still has the traditional pose of an archaic *kore*. With the right hand she pulls the lower part of her peplos sideways, setting up a pattern of shallow curving folds across her legs. The peplos is folded over at shoulder level, and the surplus hangs down loosely over the breast. Its edges form a series of stepped folds, no longer stiffly arranged in the formal archaic 'stack' but still flattened against the body, almost as if they were carved in relief.

## Sculpture of the Early Classical Period

The Persian Wars had been a conflict not merely between men of different language and culture but between incompatible political systems. The successful defence of their freedom and independence by the Greek city-states represented the triumph of democracy over oriental despotism, and it led to an age of buoyant self-confidence and of intellectual and artistic advances. Philosophers probed the nature of the universe and of man. Poets preached a gospel of order, justice and restraint. Sculptors, having mastered the complexities of anatomy by the end of the archaic period, did not move at once towards complete realism, but developed an idealistic concept of physical perfection expressed in dignity and grandeur, consciously remote from everyday life. Characteristic of the period is the Chatsworth Head, a bronze head from a statue found in Cyprus in 1836, 56

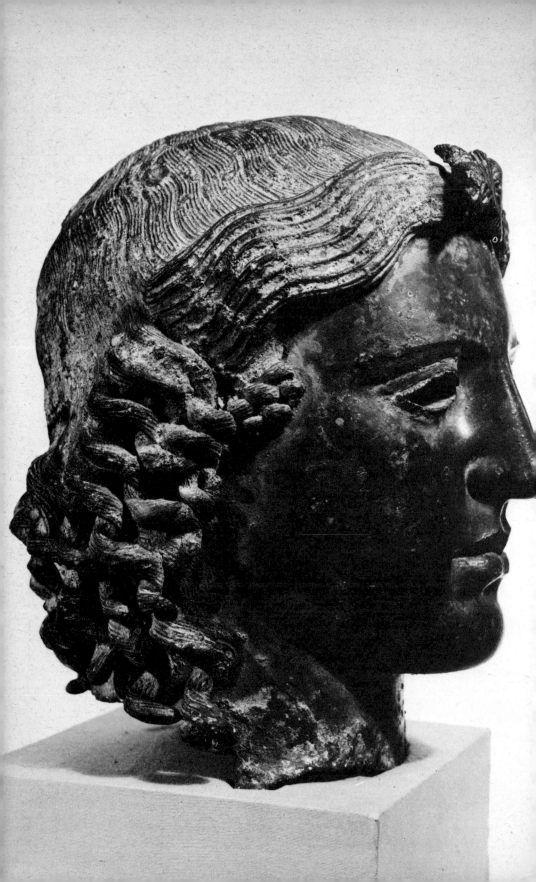

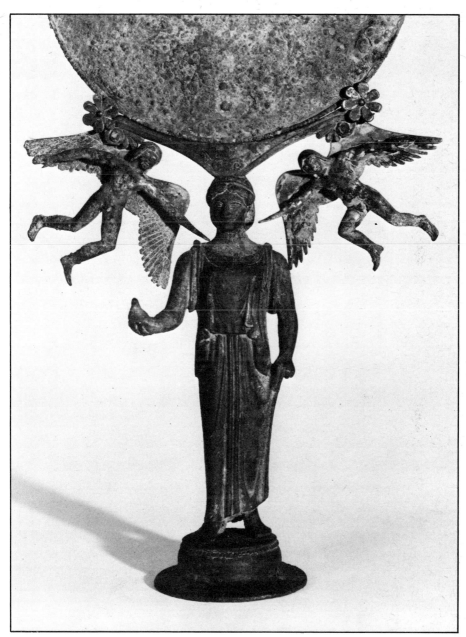

57 Bronze mirror with a statuette, perhaps of Aphrodite, serving as both handle and support. *c*.460 BC. Bronze 242, ht 32.5 cm.

56 'The Chatsworth Head' from a bronze statue, slightly over life size, which was found in Cyprus. 470–460 BC. 1958.4–18.1, ht 31.6 cm.

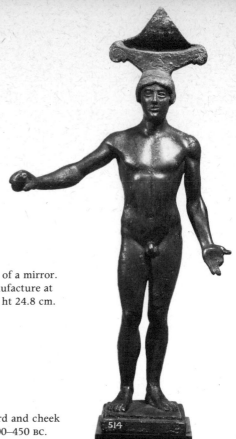

**58** Statuette of a youth, originally the handle of a mirror. The simple palmette attachment suggests manufacture at Locri in Southern Italy. *c.*460 BC. Bronze 514, ht 24.8 cm.

**59** Helmet of Corinthian type, with nose-guard and cheek pieces, made from a single sheet of bronze. 500–450 BC. Bronze 2836, ht 20.8 cm.

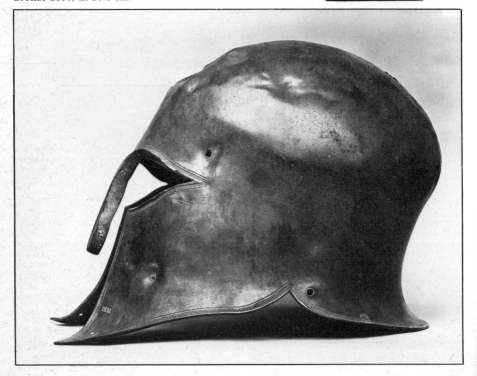

which was preserved for many years at Chatsworth House (1958.4–18.1). The eyes were originally inlaid, probably in glass and marble, and the eyelashes projected from the ends of the small bronze plates that still line the eye sockets. The curly locks of hair were cast separately and then attached to the head.

Few large bronzes of this period have survived, the rest having been melted down. Many marble statues have been destroyed too, broken up or burnt for lime. Fortunately many of the more celebrated sculptures were copied in Roman times, and we can learn much about classical sculpture from Roman copies and from descriptions in ancient literature. Roman marble copies of lost bronze statues are exhibited in Room 15 (see pages 184–5).

Small bronzes, privately owned and either consigned to the grave or dedicated in sanctuaries, have survived in greater numbers. Those in Case 7 include a mirror supported by a statuette of a woman, perhaps the goddess Aphrodite, who wears a Doric peplos, fastened at the shoulders with pins (Bronze 242); erotes hover around her head. A figure of a youth may be recognised as a mirror-support by the palmette attachment on top of his head (Bronze 514). Like the larger statues, these figurines were cast, using the 'lost wax' method. The bronze helmet (Bronze 2836), however, was made in a different technique, hammered out of a single sheet of bronze. It has protective flanges around the eye-holes and on the nose-piece. The same technique was used for the bodies of the bronze bowl (dinos, 1816.6–10.12) and water-jar (hydria, 1917.7–13.1) in Case 8, but the rims and the hydria-handles were cast separately and soldered in place.

57

58

59

## Early Classic Painting

The large-scale painting of the fifth century, whether on walls or on panels of wood or marble, has been irretrievably lost. Unlike sculpture, it did not lend itself to copying in more durable materials, but we know from the descriptions of ancient writers that its characteristics included grandiose compositions with figures on different levels, the representation of emotion, and a general nobility of expression such as we have seen in sculpture. Since wall- and panel-painting increasingly absorbed the talents of the abler artists, vase-painting tended to retreat to the position of a minor art. Consequently the vases of this and succeeding periods seldom stand comparison with the major arts. Nonetheless, the advances made in the larger medium may sometimes be observed in vase-painting, especially in the works of such artists as the Niobid Painter, who seems to have been particularly influenced by the wall-paintings of Mikon and Polygnotos. On a storage-jar *(pelike)* in Case 7 is one of the Niobid Painter's less ambitious compositions (Vase E 381). A king, identified by his sceptre, pours an offering of wine from a libation-bowl *(phiale)* on to a burning altar,

while a woman pours her offering from a wine jug (oinochoe). Their posture is dignified, their expressions calm; their drapery falls in simple lines. The eyes are now correctly represented in profile.

The most significant technical development in vase painting at this time took place on white-ground vases. We have already seen that from about the end of the sixth century some Attic vases were given a coating of white clay on which figures were drawn with lines of glaze. A perfume-bottle (alabastron) of about 470 BC in Case 6 shows a youth and a dog drawn in black 'relief' outlines with brownish lines of dilute glaze for the inner details, especially for the dog's coat (Vase D 15). One of the finest surviving examples of the improved technique is a drinking cup **60** (kylix) showing Aphrodite riding with serene dignity on the back of a large goose (Vase D 2). The outline is now drawn in lines of dilute glaze, and a flat wash of red is used for her cloak and the hem of her dress. A white background was particularly appropriate for *alabastra* and *pyxides*, since it recalled the alabaster or marble from which such vases were frequently made (examples are exhibited in Room 9; see page 112). A white-ground *pyxis* (a cylindrical box for cosmetics, trinkets and so on)

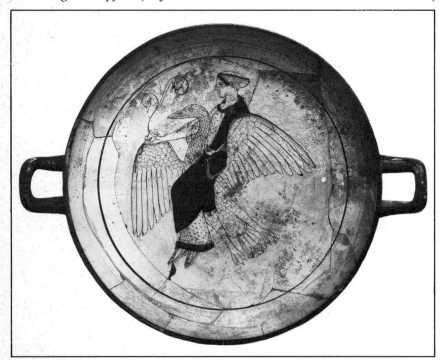

**60** Aphrodite on a white-ground cup attributed to the 'Pistoxenos Painter'. c.460 BC. Vase D 2, diameter 24.4 cm.
**61** Death of Medusa, on a hydria attributed to the 'Pan Painter'. c.460 BC. Vase E 181, ht of picture 14 cm.

shows women with balls of wool and skeins in baskets (Vase D 12). That the scene is indoors is indicated by a column and by various items hanging on the walls, including a pair of sandals. Another white-ground pyxis in Case 7 shows a wedding procession (Vase D 11). These vases were intended for women's use, and the choice of subject matter reflects their particular interests.

Somewhat outside the main trends of development but possessing a charm of their own are the Pan Painter and the Sotades Painter. The Pan Painter, so called from the subject of a krater in Boston, worked primarily in red-figure. A hydria with the death of Medusa (Vase E 181) exhibits the mannered gestures, the studied contrasts in movement and the consciously archaic style that are typical of his work. Perseus makes off with the gorgon's head in a satchel, still clutching the sickle with which he severed it, but finds time to look back towards her body as it falls lifeless: lifeless indeed, but with fingers delicately outstretched to break her fall. Meanwhile Athena follows swiftly behind, helmeted and armed with an enormous spear, but at the same time daintily holding a fold of her skirt. The Sotades Painter's miniature style is often displayed on vases of unusual

61

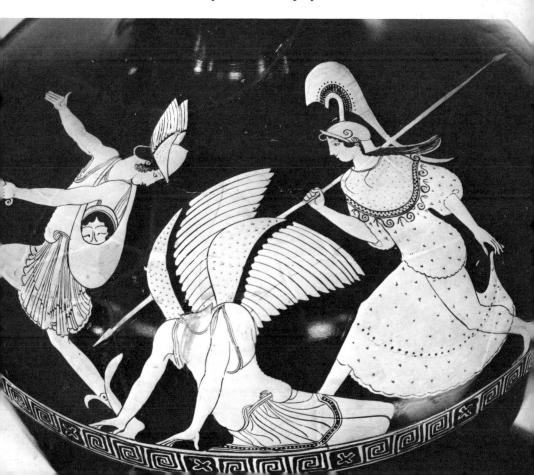

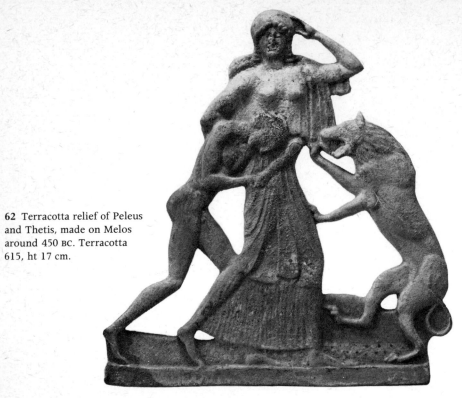

**62** Terracotta relief of Peleus
and Thetis, made on Melos
around 450 BC. Terracotta
615, ht 17 cm.

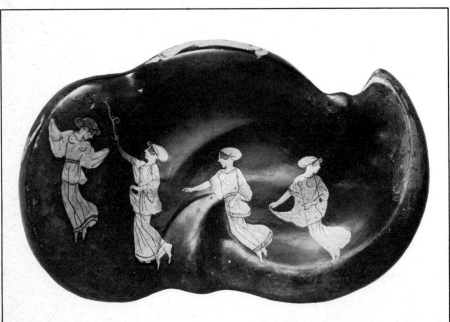

**63** Sheep's knuckle-bone in pottery, decorated by the 'Sotades Painter'. *c.*460 BC. Vase E 804,
length 17.2 cm.

shape, small cups of delicate make with wishbone handles or drinking-horns *(rhyta)* of various types. A white-ground cup (Vase D 5) showing Polyidos and Glaukos in the tomb, their names inscribed, bears the signature of the potter Sotades, from whom the painter's conventional name is derived. A red-figured vase shaped like a sheep's knucklebone may have served as a whimsical container for actual knucklebones, which were used as dice (Vase E 804). The figures of dancing and floating girls that decorate it have been variously interpreted as Clouds, directed by Aeolos, King of the Winds, or as Breezes *(Aurai).*

<div style="text-align:right">63</div>

## Melian Reliefs

A group of terracotta plaques made on the island of Melos around the middle of the fifth century have figures moulded in low relief. The subjects are chiefly mythological, and the plaques were apparently used to decorate wooden chests. Many have been found on Melos itself, but others were exported. Two plaques found in the same tomb at Camirus show Eos, the winged goddess of the Dawn, abducting Kephalos (Terracotta 614) and Peleus wrestling with his future bride, the sea-nymph Thetis (Terracotta 615). Thetis at first resisted the advances of Peleus by taking on various non-human forms. The lion alludes to one of her transformations.

<div style="text-align:right">62</div>

## The Delian League

During the invasion of Greece by Xerxes the Greeks fought under Spartan leadership by sea as well as by land, but shortly afterwards a group of maritime states made an alliance with Athens to continue the struggle against Persia. At first the allies were on equal terms with the Athenians, having their own assembly and treasury on the island of Delos and retaining their local independence. The Persian threat was removed by the Greek victory at the Eurymedon about 467, but under the leadership of Pericles Athens herself soon initiated a policy of imperialism. She subjugated much of central Greece and gradually deprived the allies of their independent status. By the time that the treasury was transferred to Athens in 454, the Delian league had become the Athenian Empire, and Athens herself was the wealthiest and most powerful state in Greece. The Thirty Years' Peace, concluded by Athens with Sparta in 445, inaugurated a period of peaceful development throughout Greece.

## Classical Sculpture

The classical style of Greek sculpture now reached its zenith. Among the leading sculptors of the day were the Athenian Pheidias and Polykleitos of Argos. None of their original works survives and we are again chiefly dependent on Roman copies and ancient descriptions for an assessment of their style. For Pheidias we also have the sculptures of the Parthenon (Room 8), which were made under his supervision. They represent the

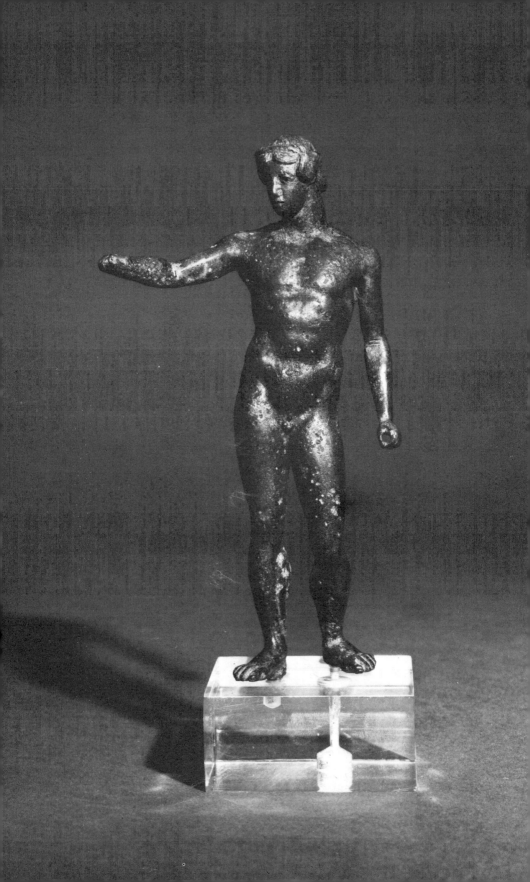

culmination of the idealistic trend we have observed in early classical sculpture, and display the 'combination of grandeur and precision' for which Pheidias's works were famous. While the masterpieces of Pheidias were statues of the gods, Polykleitos concentrated on human subjects. His athletes are well developed and at the peak of physical fitness. They maintain attitudes of dignified repose, all their strength carefully controlled.

Sculpture on a smaller scale continues to follow the advances made in larger works, although terracotta statuettes as usual display a certain conservatism. This is in part dictated by their manufacture in moulds, which tends to preserve particular types and which favours the compact stance of traditional figures over the more fluid gestures that were possible in stronger materials. A bronze statuette of a youth, found at Armento (Bronze 270, Case 9), stands in a relaxed posture, left leg slightly bent, right leg straight and supporting the weight of the body, right arm outstretched. The vogue continued for bronze mirrors supported by statuettes. A particularly ornate example stands on a base supported by a pair of winged horses in place of the more usual lions' feet (Bronze 3209). Another has a siren perched atop the disk and a fox pursuing two hares around the rim as well as erotes hovering below (Bronze 243; Case 10). This was found in Corinth and like the one with winged horses has been conjectured to be of Corinthian manufacture.

64

## Vase-Painting of the Classical Period

Few vase-painters can now be counted as artists of the first rank. Limitations of technique and scale preclude their competition with sculptors and wall-painters, but they follow the trends of the major arts and share the classical spirit with quiet compositions of dignified figures. A characteristic scene decorates a neck-amphora with twisted handles attributed to the Peleus Painter, who worked in the tradition of the Niobid Painter (Vase E 271; for the modern distinction between a neck-amphora and an ordinary amphora, see the Glossary under Amphora). Melousa and the mythical singer and healer Musaios stand and listen as Terpsichore, the Muse of lyric poetry, plays a harp. Melousa holds a pair of pipes (auloi) and Musaios a lyre with a tortoise-shell sounding box. Terpsichore's head is drawn in three-quarter view, no longer as a tour de force, but as a simple achievement of competent and confident draughtsmanship.

66

The finest vase-painter of the period is without doubt a pupil of the Berlin Painter who has been named the Achilles Painter after the subject of an amphora in the Vatican. He was a prolific artist, and often worked in the white-ground technique on slender oil-bottles (lekythoi), which furnish a particularly suitable field for compositions of one or two figures. A further advance in the white-ground technique was the rendering of drapery by flat washes of colour applied to the vase after firing. Unlike the fired colours, these washes tend to fade, and their disappearance often

**64** Statuette of a youth found at Armento (Southern Italy). c.450 BC. Bronze 270, ht 14.6 cm.

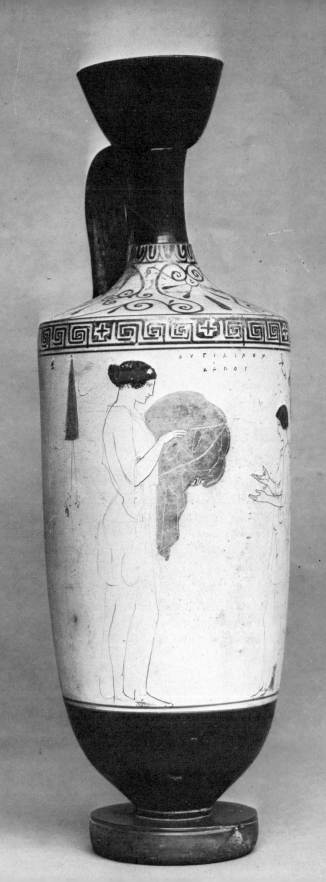

leaves figures apparently naked or dressed in transparent clothing. Although not suitable for vases in daily use the technique was freely employed on lekythoi intended for the tomb. Their subjects are chiefly drawn from daily life, and the two in Case 9 are typical: two women (a maid and her mistress) with a rolled up garment (Vase D 48), and a warrior bidding farewell to his wife (Vase D 51). The quiet poise of the figures lends them a certain grandeur in which the classical ideal of dignity and restraint finds a true expression.

65

Not all of Greek life was serious. The comedies of Aristophanes found their place on the Attic stage as well as the tragedies of Sophocles and Euripides. Vase-painters too sometimes display a touch of sly humour, and on a group of black-figured vases manufactured in Boeotia around the middle of the fifth century the element of sheer farce is unmistakable. Many of these vases were dedicated in the sanctuary of the Cabiri near Thebes, and the type is therefore known as Cabiran. A *skyphos* (drinking-cup) in Case 10 is characteristic: two grotesquely deformed men dance to the music of the pipes *(auloi)* played by an equally grotesque musician (Vase B 78).

**65** A woman holding a rolled-up garment; detail of an Attic white-ground lekythos attributed to the 'Achilles Painter'. 450–440 BC. Vase D 48, ht of picture 15.5 cm.

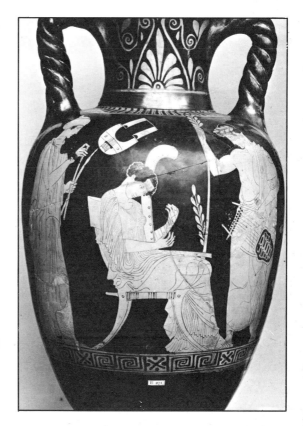

**66** Melousa and Musaios listen to Terpsichore playing the harp: detail of an Attic red-figured neck-amphora attributed to the 'Peleus Painter'. *c.*440 BC. Vase E 271, ht of picture 24 cm.

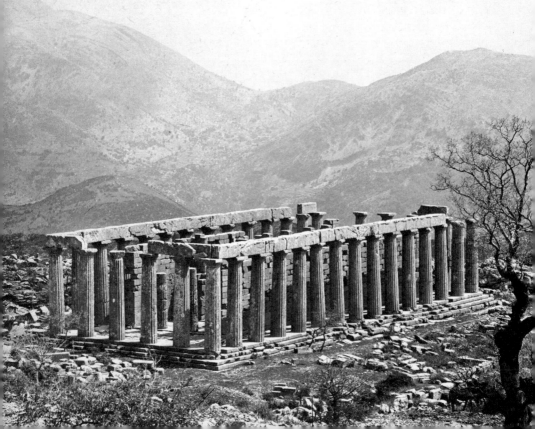

**67** The temple of Apollo at Bassae

# Room 6
# The Temple of Apollo at Bassae

At Bassae, on a rocky spur of Mount Cotylion a few miles from Phigaleia in south-western Arcadia, stands the temple of Apollo Epikourios ('The Helper'). According to Pausanias, who wrote his *Description of Greece* in the second century AD, Apollo received this title because he saved the Phigaleians from the plague at the time of the Peloponnesian War. Pausanias also informs us that the temple was designed by Ictinus, one of the architects of the Parthenon, that it was built entirely of stone, and that among the temples of the Peloponnese it was considered second in beauty only to the temple of Tegea. Local limestone was in fact used for most of the structure, but the sculpture and the finer architectural details were of marble.

The site of the temple was discovered in 1765 by the French architect Bocher, but few travellers reached the remote spot before 1811, when an expedition that included C. R. Cockerell and Haller von Hallerstein discovered the frieze. Excavations continued in the following year, and in 1814 the frieze and other sculptural and architectural fragments were auctioned at Zante. They were then acquired on behalf of the British Government.

The temple is of the Doric order, but it has many unusual features. Unlike most Greek temples, its longer axis runs from north to south instead of from east to west. Its main doorway faces north, and there is a secondary door in the east wall that gives access to a small room at the end of the cella. Here the cult-image perhaps stood, facing east. This extra room makes the building disproportionately long, so that there are fifteen columns along the sides instead of thirteen, as is normal at this period when there are six columns across the ends.

The side walls of the cella were extended in the usual way to provide porches, and between the ends of the walls *(antae)* stood two Doric columns, slightly smaller than those of the colonnade. They supported an architrave and a Doric frieze of triglyphs and metopes across the front of the porch. The metopes were sculptured, but only a few fragments survive and most of them are so shattered that their subjects cannot be certainly identified. Those exhibited show a woman holding castanets (Sculpture 512) and another woman being seized by a man whose hand appears behind her neck (Sculpture 517).

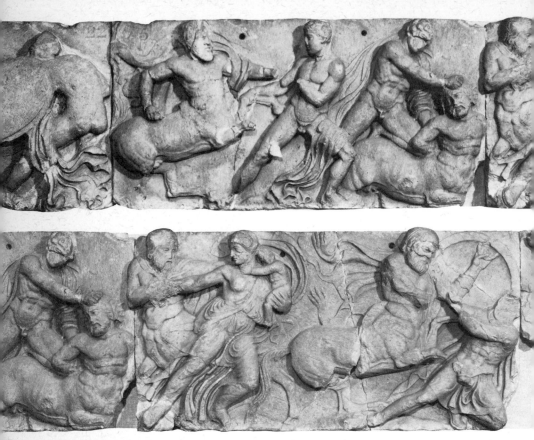

**68, 69** Frieze from the temple of Apollo at Bassae showing Lapiths and Centaurs at the wedding of King Peirithous. *Below*: one of the Centaurs attempts to abduct a Lapith woman, and a fight ensues. Ht 64.2 cm.

The inside of the cella shows several unusual features that attest the presence of an architect of great originality. In place of the superimposed rows of Doric columns that were used in some temples to help support the ceiling, we find Ionic half-columns engaged to short spur-walls. They have an unusual spreading base and the capitals are of a new design. The last spur-wall on each side projects at an acute angle, and a single column stands between these two on the central axis of the temple. The remains of a Corinthian capital, the earliest known example of the type, were found on the site. This is usually assigned to the central column, and

modern scholars dispute whether the columns flanking it also had Corinthian capitals or Ionic capitals like the rest.

The interior colonnade was surmounted by an Ionic architrave and frieze, the latter carved in high relief. This was the first sculptured frieze on the inside of a Greek building. Placed about seven metres above the floor and lit only by diffused light from below, the frieze must originally have been difficult to see. It portrays two subjects, the fight of the Lapiths and the Centaurs and a battle between Greeks and Amazons. The parts of the frieze allotted to each subject are of unequal length, and while some of the corner slabs may be recognised by the rebates cut in them, the arrangement of the rest has been the subject of much controversy. The numbering of the present arrangement begins on the right at the top of the stairs, on what was originally the west wall of the cella.

The fight of the Lapiths and Centaurs occupies the first ten slabs 68, 69 (Sculpture 520–522 and 524–530). The Centaurs, here represented in the classical manner with the upper part of a man growing from the body of a horse, were invited to the wedding of Peirithous, King of the Lapiths. At the wedding feast they drank too much and when they tried to carry off the Lapith women, the Lapith men naturally resisted the attempt. The ensuing fight became a favourite subject for Greek sculptors and painters. It came to symbolize the triumph of civilization over barbarism, of order over chaos; and its increasing popularity in the fifth century suggests that it was associated with the Greek victories over the invading Persians in 490 and 480–479 BC. Slab 6 shows a particularly popular episode: Kaineus, whom Poseidon had made invulnerable, is killed by being driven into the ground. On Slab 11 Apollo and Artemis are shown in a chariot drawn by deer (Sculpture 523).

The remaining slabs (12–23) show the expedition of Herakles against the Amazons at Themiskyra (Sculpture 531–542). Herakles himself may be identified by his lionskin and club on Slab 21, which was probably placed in the centre of the south wall, opposite the main door. The battles between Greeks and Amazons also seem to have been associated with the Persian Wars: the legendary home of the Amazons was in Asia Minor, they were also said to have invaded Attica, and in art at least their similarity with the Persians was often emphasised by giving them dress and weapons of Persian type. Both subjects provided the artist with contrasts of anatomy and dress, and in particular allowed them to portray Amazons and Lapith women only partly clad at a time when the female nude was not yet socially acceptable as a subject for large-scale free-standing sculpture.

The date of the temple has been disputed, but the available evidence suggests that construction of the building started after 430 BC and that the frieze was carved towards the end of the century.

# Room 7
# The Nereid Monument

The Nereid Monument originally occupied an imposing position on the brow of a steep hillside just outside the city of Xanthos. It is the largest of the monumental Lycian tombs brought to London by Charles Fellows, and the only one to use Greek rather than Lycian architectural forms. Fellows had found two blocks of the carved friezes on the site in 1838 and 1840, and in 1841–42 he accompanied the naval expedition that recovered the remaining sculptures from the slope down which they had fallen, probably as the result of an earthquake. At first Fellows thought that the four sculptured friezes belonged to four distinct 'temples', but he soon realised that all four came from the same building. Various attempts have been made to determine its original design and the position of the various friezes. The present reconstruction of the east façade is based on the researches of a team of French archaeologists who between 1950 and 1967 made a new examination of the base of the monument, which still stands *in situ*, and of the individual blocks in Xanthos and in London.

As Fellows himself eventually realised, the monument is in the form of a small Ionic temple standing on a tall base. This base is a Lycian feature, reminiscent of the tall pillars that supported the Lion Tomb and the Harpy Tomb. Around its top run the two largest friezes. The lower of these, just over one metre high, shows a battle between Greeks and barbarians, the latter supported by cavalry and archers (Sculpture 850–865). Both sides include light-armed and heavy-armed troops, but some of the Greeks are portrayed as fighting nude, in accordance with the artistic convention of the time, while the barbarians may be recognized by their oriental dress and weapons, including trousers, Persian caps and battle-axes. On the upper frieze, which is 62 cm. high, are scenes of actual warfare, including the siege of a walled city (Sculpture 866–884). On the front of the base a scaling party assails the walls (Sculpture 872); on the north side (around the corner to the right) the besieged are summoned to a parley (Sculpture 878). More slabs from the frieze are mounted on the wall to the right as you face the monument. They include episodes from the battle around the besieged city as well as a scene showing two old men in civilian dress standing before a man who is seated on a throne with an attendant holding a sunshade over his head (Sculpture 879). The old men seem to be representatives of the city seeking terms of surrender

70

71

72

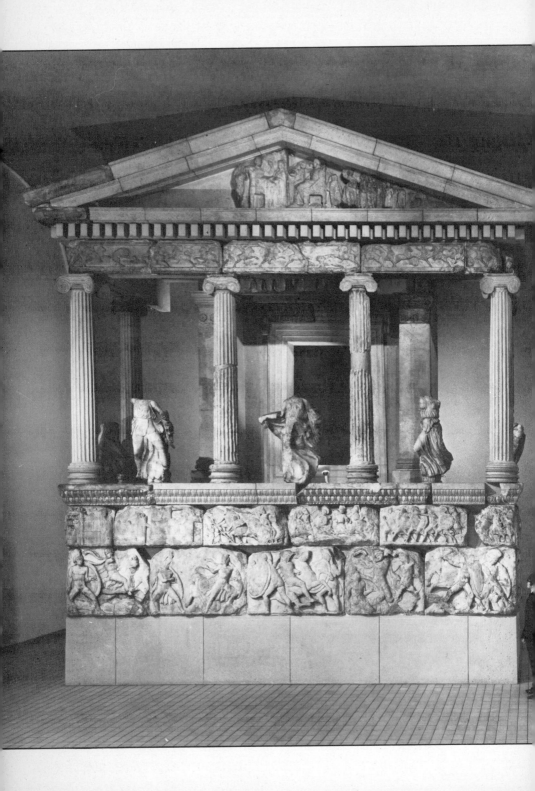

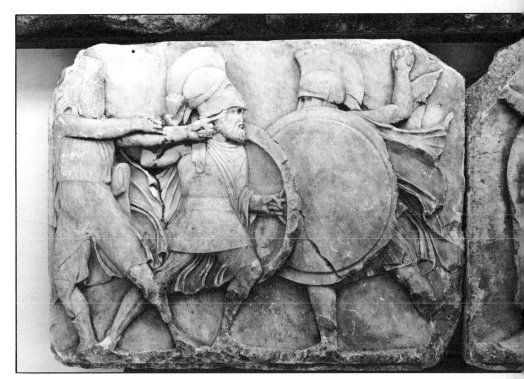

71 Detail of the lower frieze: an archer and two infantrymen. Sculpture 859, ht 1.02 m.

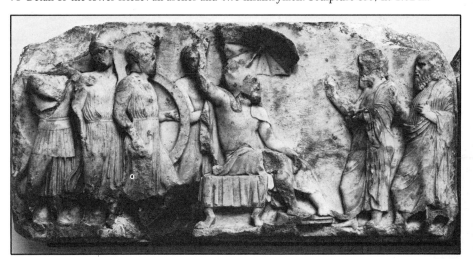

72 Detail of the upper frieze: a parley between besieger and besieged. Sculpture 879, ht 62 cm.

70 Reconstructed façade of the Nereid Monument from Xanthos in Lycia, c.400 BC. Ht 8.3 m.

73 Marble statue of a
'Nereid' running over the
sea; beneath her a water
bird floats on the waves.
Originally placed between
the columns of the Nereid
Monument. *c.*400 BC.
Sculpture 909, ht 1.41 m.

from the victor. The remaining slabs of the first frieze are mounted below.

The top course of the base is decorated with two rows of 'egg and tongue' moulding. Above it stood the columns, four at front and back and six along the sides (counting the corner columns twice, as usual).

When an Ionic building has a carved frieze it is normally placed above the architrave (the course that rests directly on the columns) in place of the small rectangular projections (dentils) below the cornice. Here the dentils remain, since it is the architrave itself that is carved in low relief (Sculpture 885–897). The scenes represent typical activities of the tomb's aristocratic owners. On the front are hunting scenes: a bear hunt on the left (Sculpture 889) and a boar hunt on the right (Sculpture 887). A battle scene, which again involves foot soldiers and horsemen but lacks the compact composition of the battles on the podium, is divided between the south (left) flank of the building and the wall near the other end of the gallery. Other slabs of this frieze mounted on the wall show a procession

of men bearing a variety of gifts, including hares, birds, and smaller objects in trays and baskets.

Inside the colonnade was the actual tomb chamber with a porch at either end. The fourth frieze is carved on the architrave of the porches and continues around the outside of the walls. The principal subjects are a sacrifice (Sculpture 905, placed on the building over the east doorway) and a banquet (Sculpture 898, etc., mounted on the wall at the opposite end of the gallery).

In addition to the four friezes the monument had relief sculpture in the pediments, the low triangular gables at the ends of the roof. In the east pediment the principal figures, a man and a woman, are seated near the middle, surrounded by standing figures (Sculpture 924). A hound lies in the angle on the right. No attempt has been made to keep the scale of the figures uniform by varying their posture to fit the diminishing height of the pedimental triangle, although the larger scale of the seated figures, in accordance with the normal convention in Greek funerary sculpture, probably indicates that these represent the dead for whom the tomb was built. The surviving portion of the west pediment is mounted on the wall to the left of the monument (Sculpture 925). It shows a group of soldiers, again of varying scale, facing to the right. Their leader is collapsing before the onslaught of a horseman, who was represented on the adjacent block (now missing) with only a forehoof of his horse overlapping on to this one. This rider may well have been another representation of the tomb's occupant.

Various identifications have been proposed for the female figures placed between the columns, including the Breezes (*Aurai*) and the Nereids, 73 daughters of Nereus, the Old Man of the Sea. The latter interpretation has given the tomb its conventional name, the Nereid Monument. Their position on the monument is shown by setting-marks between the columns, but three of the best preserved are exhibited on a separate plinth at the other end of the gallery. They are evidently meant to be visualised as skimming over the surface of the waves, since various sea-creatures are represented below them, including a fish and a sea-bird. One of the figures (Sculpture 909) is wearing a billowing mantle of fairly heavy material and a tunic of finer texture, which is closely pressed against the body to reveal its form and is apparently transparent, as if wet with spray. The drapery of the other figures is rather heavier, and they were evidently carved by different hands.

Near this plinth on the right wall of the gallery are placed the remains of the sculptured groups that originally surmounted the pediments. (Sculpture 926, 927). Each represents a nude youth holding a female figure. The lions, which have been placed here flanking the door to Room 8, seem to have been associated with the tomb in some way, but their original location is not known (Sculpture 929, 930).

# Room 8
# The Sculptures
# of the Parthenon

After the Persian invaders withdrew from Greece in 479 BC, the Greeks swore not to rebuild the sanctuaries that they had destroyed, but to leave the ruins as a memorial of their sacrilege. Thirty years later Pericles persuaded the Athenians to cancel the oath and to initiate a vast building programme on the Acropolis, financing it with surplus funds accumulated in the treasury of the Delian League. The first phase, which was completed during the lifetime of Pericles, included a monumental gateway, the Propylaea, and a new temple of Athena to replace one that had still been unfinished when the Persians sacked it in 480.

The Parthenon, as the temple has been known since Roman times, was the work of the architects Ictinus and Callicrates. Begun in 447, it must have been substantially complete by 438 when the statue of the goddess was dedicated in it. The building accounts, which were inscribed on marble slabs and are still in part preserved, show that work continued until 432, but in these later years this must have consisted largely of carving the pedimental sculpture. The builders had meanwhile moved on to the Propylaea, designed by Mnesicles and constructed between 437 and 432.

The Parthenon was always meant to be imposing. Built on the highest point of the Acropolis, it was considerably larger than most Doric temples and had eight columns across the front and seventeen along the sides instead of the more usual six and thirteen. Inside the colonnade the central structure was divided by a cross wall into two rooms of unequal size, each having a porch of six columns. The smaller chamber, on the west, served as a treasury, while the larger eastern room housed the gold and ivory statue of Athena, some twelve metres high, made by the sculptor Pheidias. The temple was constructed of marble throughout and was remarkable not only for the refinement of its design and the quality of its workmanship but also for the unprecedented quantity of sculpture that adorned it.

The sculptures are of three types, each appropriate to a different position on the building. The ninety-two metopes of the Doric frieze above the colonnade were carved with figures in high relief. The metopes must have been set in position some years before 438, perhaps as early as 442, and the carving was presumably complete by then. There was no Doric frieze above the porches of the cella; instead a continuous Ionic frieze, sculptured in low relief, was placed over the architrave and continued along the sides

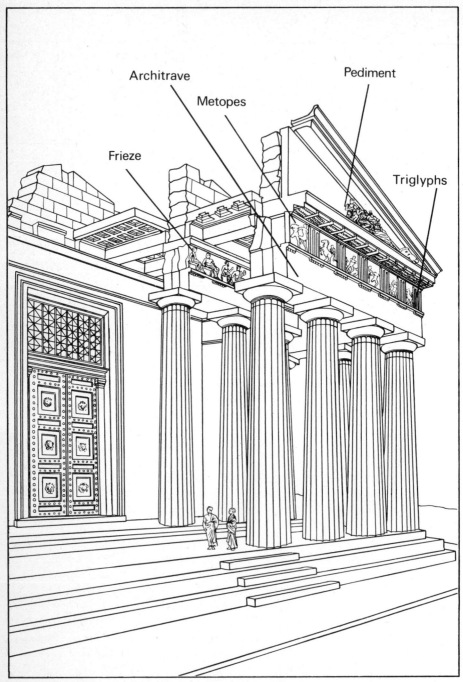

Architrave

Metopes

Pediment

Frieze

Triglyphs

**74** Sectional diagram of the Parthenon showing the positions of sculptural and architectural elements.

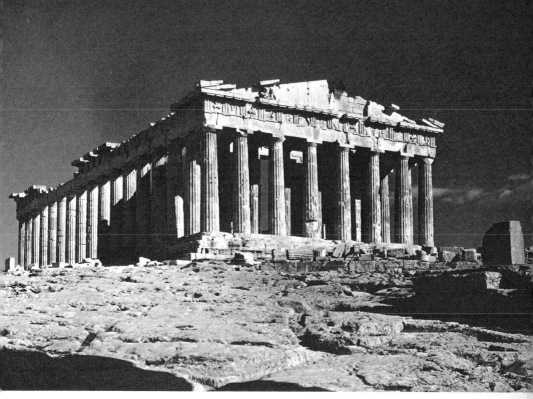

75 The Parthenon seen from the north-west

of the building for a total length of about 160 metres. Since it was masked
by the upper part of the colonnade until the spectator was almost directly
underneath, and was then about ten metres above his head and illuminated
only by reflected light, the frieze must have been quite difficult to see,
even with its background painted to set off the figures. The pediments at
each end of the temple were filled with groups of figures sculptured in the
round. These must have been carved on the ground before being hoisted
into position towards 432 BC. A considerable number of sculptors must
have been employed to complete all this work in so short a time, but the
unity of the overall scheme suggests that it was planned by a single in-
dividual. This can hardly have been anyone but Pheidias, the sculptor of
the gold and ivory image of Athena, who supervised the whole of the work
for Pericles.

The Parthenon stood virtually intact for over two thousand years,
although it was transformed into a Christian church and later into a mosque.
Disaster struck in 1687, when a Venetian shell exploded the gunpowder that
the besieged Turkish garrison had stored in the building. From then on
the condition of the temple and its surviving sculptures gradually de-
teriorated, so that their survival is largely due to Lord Elgin, who rescued
them from destruction by vandals and religious bigots in the days before
Greece became independent. He brought the sculptures to England at his
own expense, and they were acquired for the nation by Parliament in 1816.

The gold and ivory statue of Athena has long perished, but it was de-
scribed by Pausanias and has been recognized in reduced marble copies

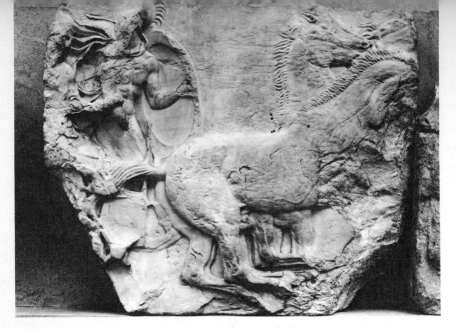

made in Roman times. A fragment of a copy of the shield, showing the battle of Greeks and Amazons (Sculpture 302), is exhibited in the South Slip Room (on the left before you enter the main gallery). Here also are models, drawings and photographs of the temple and its sculptures, as well as an idealized portrait of Pericles that once belonged to Charles Towneley (Sculpture 549).

### The Frieze

The dimensions of the frieze (about 160 metres long but only one metre high) posed a problem of composition. This was ingeniously solved by the choice of a subject that provided many participants, including a large number of animals as well as several classes of people. Each summer Athena's birthday was commemorated with a festival, including a procession, a sacrifice, and games for which the prizes were jars of oil from Athena's sacred olive trees. Every fourth year the festival was celebrated with particular pomp as the Great Panathenaia, and on this occasion the procession to the Acropolis escorted a new robe (the peplos) for the ancient olive-wood image of Athena. It was this procession that was chosen as the subject of the Parthenon frieze.

Opposite the entrance to the gallery are three long slabs, originally placed over the east door of the Parthenon, on which the culmination of the ceremony is represented. A magistrate and a girl hold the folded peplos, while two girls bring forward to the priestess stools for the gods. The gods themselves dignify the occasion with their presence, seated in groups on either side and adding the only mythological touch to the frieze. On the far left sits Hermes, the messenger of the gods, with his travelling hat on his knees, ready to depart at short notice; the staff in his right hand was added in metal and has not survived. On his shoulder leans the wine-god Dionysos, often portrayed as somewhat soft and effeminate, and here seated on an extra cushion. Facing him is the corn-goddess Demeter, holding a torch, and next to her the war-god Ares lounges comfortably with his spear beside

76 Chariot drawn by four spirited horses. Marble, low relief. South frieze of the Parthenon, Slab xxx, ht 1.1 m.

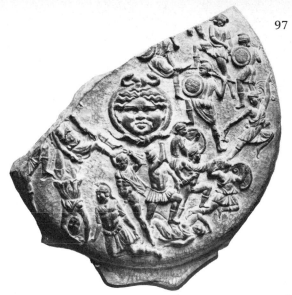

77 Reduced marble copy of the shield of the statue of Athena Parthenos by Pheidias. Sculpture 302, ht 45.8 cm.

him (a small part remains near his left ankle). Iris, the winged messenger, stands in the background near Hera, whose veil identifies her as the bride of Zeus. Zeus himself, the only god to have a throne rather than a stool, has the place of honour near the centre. In the corresponding place on the other side sits Athena. She has her snake-fringed aegis in her lap, and holes remain to show where her spear was attached. Next to her sits Hephaistos, and on the adjacent slab (now in the Acropolis Museum in Athens) are Poseidon, Apollo and Artemis. Aphrodite and Eros originally completed the company of the gods.

Near the gods stand groups of bearded men, magistrates perhaps or legendary heroes of Attica. The actual procession is seen to approach from both sides, led by groups of maidens with vessels for sacrifice, including jugs of wine and libation-bowls (phialai).

Beyond the corners of the temple the procession moved eastwards along both the north and south sides of the building, as if seen from opposite sides of the street. Near its head were the sacrificial victims, sheep and heifers on the north side, heifers alone on the south. These were followed by boys carrying trays of offerings or pitchers of water, and then by musicians and elders. These parts of the frieze were damaged or totally destroyed in the explosion but are known in part from drawings made by earlier visitors. Next in the procession are chariots, each manned by a charioteer and a soldier in armour, and these are followed by the cavalry. The riders are shown in overlapping ranks, sometimes as many as six or seven abreast on the north frieze, an extraordinary achievement in view of the overall shallowness of the relief. The north frieze is particularly remarkable for the variety of movement and posture.

The west frieze, most of which is still in place on the Parthenon but sadly deteriorated, shows other riders preparing to mount and to join the procession. One slab, with horsemen riding up under the eye of a marshal, is exhibited at the right of the entrance to the gallery. The marshal is carved on the return of the first slab of the north side.

76

78

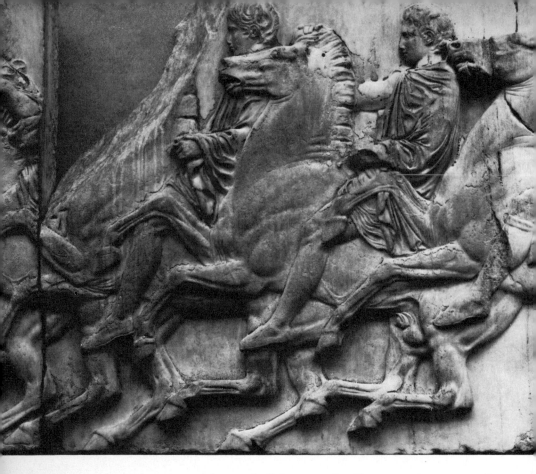

The transepts at either end of the central gallery contain metopes from the south side of the temple and sculptures from the pediments.

### The Pediments
The pedimental sculptures are very fragmentary and we are fortunate that Pausanias recorded the subjects: in the east pediment the birth of Athena, and in the west the contest between Athena and Poseidon for the land of Attica. He did not, however, name the individual figures, and the identification of some of them remains in doubt.

The west pediment was almost complete until an unsuccessful attempt was made to remove some of the figures as spoils of war while the Acropolis was in Venetian hands after the siege of 1687. Seven fragmentary statues are exhibited in the south transept (on the left of the entrance), and the general lines of the composition may be seen in a copy of a drawing that was made some years before the siege and is usually attributed to Jacques Carrey. In the centre are Athena and Poseidon, who have arrived for the contest in two-horse chariots, led by the divine messengers Hermes and Iris. The identity of many of the onlookers is not known, but the reclining figure from the left angle is usually interpreted as a personification of one of the rivers of Attica, the Ilissus or Cephisus.

In the north transept are sculptures from the angles of the east pediment. The central section, which showed the actual birth of Athena and com-

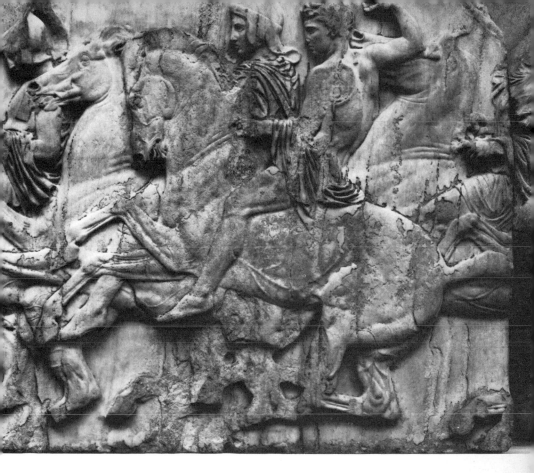

**78** A group of young horsemen from the North Frieze of the Parthenon, Slabs xxxvii–xxxviii. They ride abreast although the sculptor shows the line at an angle, skilfully fitting the overlapping figures into the very low relief. Ht 1.1 m.

prised almost half the total length, was probably destroyed when the Parthenon was turned into a church. Although Pausanias did not name the individual figures, most of those that survive may be tentatively identified. A running messenger brings news of the birth to two goddesses, probably Demeter and her daughter Kore (or Persephone). The reclining figure near them may be Herakles, or perhaps Dionysos. The three goddesses on the right are perhaps Hestia, patron of the hearth, and Aphrodite reclining in the lap of her mother Dione. Their postures are adapted to the diminishing height of the pediment, and while there is a balance between the seated and reclining figures at either side, a strictly symmetrical arrangement has been avoided in the grouping. There is a further contrast in dress: Demeter and Kore are soberly clad in heavy material that falls in deep folds, while Aphrodite's voluptuous form is clearly visible under her light and clinging drapery. The action takes place at dawn: on the left the sun (Helios) and his eager chariot-horses are rising from the eastern horizon, while on the right the moon (Selene) dips in the west. Her team is here represented by a single horse's head, its weariness apparent in its flaring nostrils and drooping jaw.

79

80

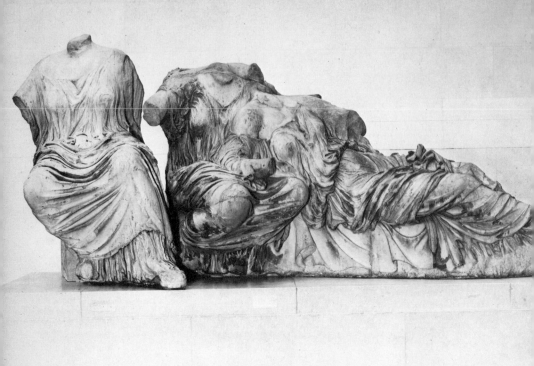

**79** Three goddesses from the East Pediment of the Parthenon, formerly called 'The Three Fates', but now identified as Hestia, Dione and Aphrodite. Carved between 438 and 432 BC. Overall length 3.15 m.

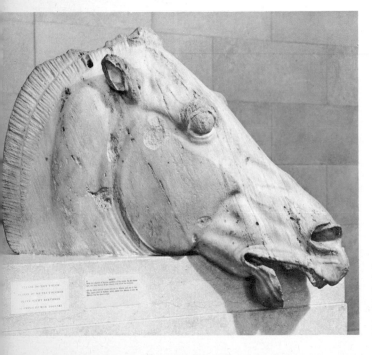

**80** Head of one of the horses that drew the chariot of Selene (the Moon) in the East Pediment of the Parthenon. 438–432 BC. Length 79 cm.

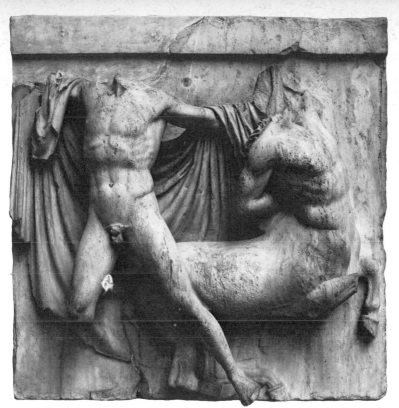

81 Marble relief of a Lapith overcoming a Centaur. 445–440 BC. Parthenon South Metope xxvii, ht 1.34 m.

## The Metopes

On the walls of the transepts are mounted some of the metopes of the south side of the Parthenon, which tended to escape the deliberate defacement suffered by those on the other, more conspicuous sides. Some of those in the middle were destroyed in the explosion, and the fifteen that Lord Elgin acquired portray excerpts from the fight between Lapiths and Centaurs at the wedding feast of the Lapith king, Peirithous, when the Centaurs got drunk and tried to carry off the Lapith women. Each metope shows a Centaur either seizing a victim or engaged by a Lapith. The quality of the carving sometimes fails to match the inventiveness of the composition. Among the finest are two adjacent metopes (xxvii and xxviii) that show a Lapith using a left-handed tackle to arrest a wounded Centaur in flight while raising a weapon in his right hand to deliver a decisive blow, and a Centaur leaping in exultation over a fallen Lapith. Their verve and high technical skill are lacking in the stiff poses and conservative anatomical treatment of some other metopes (e.g. xxxi). This uneven quality reflects the urgent need to finish the metopes for insertion in their proper place on the building, a necessary preliminary to the installation of the cornice and the roof. The team of sculptors that produced them was still being sifted, their common style refined and developed for the carving of the frieze and pediments.

In the North Slip Room, on the left as you leave the main gallery, is an exhibition of fragments of sculpture and architectural details, including the capital and upper drum of a column (Sculpture 350).

Room 10

84

85

92

94
96

93
91

86

95

89

88    90

87

83

Room 7

# Room 9
# Architecture and Art in the Later Fifth and Fourth Centuries
## (entrance behind Nereid Monument in Room 7)

The Parthenon was scarcely finished when war broke out between Athens and the Peloponnesian cities, a war that was to drag on at intervals from 431 to 404 BC, when Athens suffered a final, crushing defeat. Pericles died in 429 BC, and the Peloponnesian War, far from establishing Athens as the undisputed mistress of all Greece, as the Athenians had hoped, put an end to the Periclean Age, the golden age of Athenian democracy. Among the terms of peace imposed on her by Sparta was the dissolution of the Athenian Empire. Deprived of her imperial revenues, Athens could no longer maintain her military and naval power nor continue to spend vast sums on public works.

During the fourth century Sparta, Thebes and Athens tried in turn to dominate the rest of Greece, and in turn all failed. The military weakness of Greece's independent cities left them at the mercy of a powerful ruler from the north, Philip of Macedon, father of Alexander the Great. Philip pursued his imperial ambitions with a skilful mixture of warfare and diplomacy. By his victory at Chaeronea in 338 BC he gained control of Greece, depriving her cities of their political independence.

These political and military developments inevitably affected Greek economic and social life and influenced the development of literature and the arts. The outbreak of the Peloponnesian War interrupted Pericles's building programme. Work on the monumental gateway to the Acropolis (the Propylaea) was halted and apparently never resumed, but at intervals during the long drawn out conflict work was carried out on two Ionic buildings, the temple of Athena Nike and the Erechtheion.

### The Erechtheion

The Erechtheion has been so named since Roman times after Erechtheus, a legendary king of Athens, who was venerated there along with Athena and several other deities. It stands near the north side of the Acropolis, replacing an earlier temple nearby that was ruined by the Persians. Its sloping site and diversity of use imposed an asymmetrical plan with two interior floor levels, four entrances, and three porches that differ in shape, size, decoration and relative position. Nevertheless the skill of the men who planned and built the Erechtheion made it a model of harmonious design, rich decoration and near perfection of workmanship.

82

Drawings of the Erechtheion having been published by J. Stuart and N. Revett in 1787, its exceptionally ornate details, especially the floral bands below the capitals of the Ionic columns, were frequently imitated during the Classic Revival. The overall design was copied in the church of St Pancras in Euston Road, London.

Among the parts of the building acquired by Lord Elgin were a complete Ionic column from the east porch (Sculpture 408) part of the decorative moulding that crowned the side walls (*epicranitis*; part of Sculpture 409) and one of the six statues of maidens *(korai)*, sometimes called Caryatids, that served instead of columns in the smallest of the porches (Sculpture 407). These are exhibited in Room 9, and more fragments of the building may be seen in the Room of Greek and Roman Architecture.

Construction of the Erechtheion perhaps began about 421 BC but was later suspended for a time. In 409 BC a Commission was appointed to survey the building and to superintend its completion. A long extract from this Commission's first report, inscribed on a marble slab, is also exhibited in Room 9 (Inscription 35). Since the Porch of the Maidens was

83

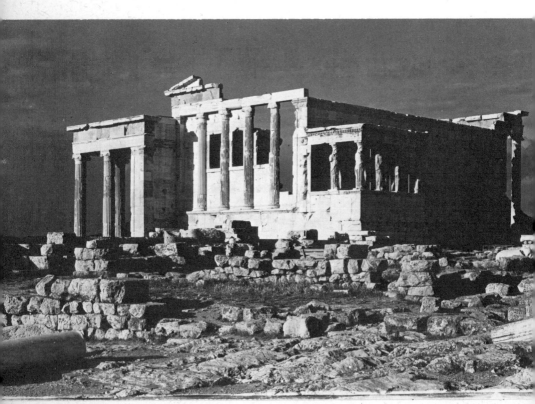

82 The Erechtheion with the Porch of the Maidens on the Acropolis at Athens

reported to be almost finished we know that the figures must have been carved before 409 BC. Like her companions the Caryatid stands with her arms by her sides and with one knee slightly bent. Her clothing is so fine in texture that it tends to cling where it touches the body, revealing rather than hiding its contours. Over the right leg it hangs in deep, straight folds, reminiscent of the fluting of a column.

## The Temple of Athena Nike

The temple of Athena Nike, Athena as the goddess of victory (sometimes called the temple of Nike Apteros or Wingless Victory) stands on a projecting bastion at the south-western extremity of the Acropolis. Designed by Callicrates and probably built in the years following 427 BC, it has four Ionic columns at each end of a small square cella. The frieze is sculptured in relief all around the building. It remained standing until the eighteenth century, but was later partly demolished by the Turkish garrison, who used the blocks to build a battery on the site. The four blocks of the frieze exhibited here (Sculpture 421–424) were acquired by Lord

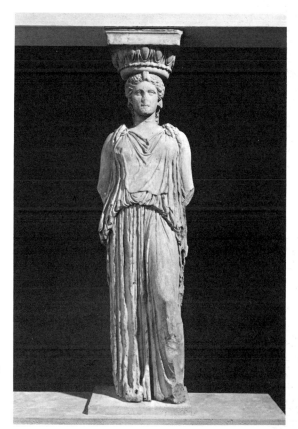

**83** Marble statue of a Caryatid, one of six statues that served as columns in the Porch of the Maidens at the south-west corner of the Erechtheion. *c.* 415 BC. Sculpture 407, ht 2.31 m.

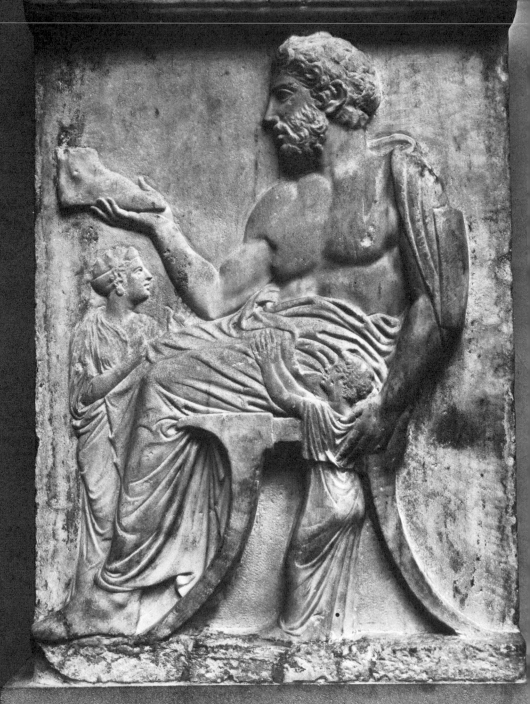

Elgin; most of the other blocks were found when the Turkish fortifications were dismantled, and the temple has since been carefully re-erected.

Since the slabs of the frieze are only 44.5 cm. high, the individual figures are small in scale and could be represented in relatively high relief. Some of them are carved almost in the round. The subjects are battles of Greeks against Greeks and of Greeks against Persians, the latter recognizable by details of dress and armour: long tunics worn over close-fitting trousers, leather caps and crescent-shaped shields. These are historical, not mythological scenes, but it is not clear what battles the sculptor had in mind.

### Classical Grave reliefs

The archaic series of monumental grave reliefs came to an abrupt end in Attica about 500 BC, perhaps because extravagant expenditure on funerals was curbed by legislation. The tradition of sculptured gravestones survived in other parts of Greece and was revived in Athens around the time when the sculptures of the Parthenon were finished.

Unlike their archaic fore-runners, which were tall and slender and usually showed single standing figures of warriors or athletes, the shorter classical grave *stelai* were frequently wide enough to accommodate several figures. The dead person was often represented seated and surrounded by relations and servants. There are no scenes of wild lamentation: the mourners' grief is tempered by dignity and the dead themselves appear aloof, as now beyond pain and suffering. On an early example of about 430 BC a bearded man, named in the inscription as Xanthippos, is seated on a high-backed chair (*klismos*) holding a model of a foot. His two daughters are represented as miniature adults rather than with correct childish proportions (Sculpture 628). Another inscribed stele, carved about a generation later, shows a woman, Glykylla, sitting on a backless stool and adorning herself, while a servant stands by with a trinket box (Sculpture 2231). Especially poignant is the relief of a woman who sits and gazes off, as a nurse holds the baby she has left behind (Sculpture 2232). While the other stelai are surmounted by a pediment without supports, this relief has an *anta* on each side to complete the architectural frame.

An elaborate finial from a more slender stele, with a palmette springing from a double row of acanthus leaves, dates from the fourth century (Sculpture 438). It was found at Eleusis and collected by Lord Elgin. A reclining bull, brought from Greece in the early nineteenth century by the architect C. R. Cockerell, was also originally a grave monument (Sculpture 680).

### Sculpture

Among the most important and influential sculptors of the fourth century was Praxiteles, who, in the words of Diodorus, 'in his works of marble

84

**84** Marble gravestone of Xanthippos. *c*.430 BC. Sculpture 628, ht 83.3 cm.

incomparably embodied the passions of the soul'. The statue of Aphrodite that Praxiteles sold to the city of Cnidus was the first life-sized free-standing female nude in the history of Greek sculpture. It was very celebrated in antiquity and inspired many imitative works, but it is now known only from descriptions in ancient literature (notably by Pliny and Lucian), from representations on coins of Cnidus and from copies made in Roman times. The soft, fleshy contours, the protuberant forehead and the free treatment of the hair that are hallmarks of his style may be recognised in a youthful head, perhaps of Herakles, which is probably the work of one of his followers in the later years of the century (Sculpture 1600). It was originally adorned with a metal diadem, and once belonged to the Earl of Aberdeen.

85

At a humbler level of sculpture, marble reliefs dedicated to various deities are a rich source of information on religious beliefs and practices. A relief dedicated to Bendis was found in the Piraeus, where the cult of this Thracian goddess was established about 430 BC (Sculpture 2155). Plato's *Republic* begins with Socrates returning from the first celebration of the festival, which included a mounted relay-race using a lighted torch as baton. The relief shows a team of eight young competitors approaching the goddess led by their trainer and patron, one of whom carries the torch. The goddess, who wears Thracian costume including leather knee-boots, cloak and hood, is on a larger scale than her worshippers. They are represented in a variety of relaxed postures that reflect the influence of Praxiteles.

### Vases

The idealistic qualities of the Parthenon sculptures continue to be reflected in contemporary vase-painting. On a red-figured cup attributed to the Codrus Painter (Vase E 84), the dignified postures and unemotional expression adopted by Theseus as he deals with a succession of villains and monsters belie the fact that he is fighting for his life. In the next generation new trends can be seen. Faces may now express intense emotions and are more frequently seen in oblique view, drapery is richly decorated or clings to the body with fine folds represented by a multitude of short strokes, and increasing use is made of relief, gilding and of added white. Among the leading exponents of this style is the Meidias Painter, so called from a hydria (Vase E 224) signed by Meidias as potter, on which he painted one of his most ambitious compositions: the Dioscuri abducting the daughters of Leucippus. The cult statue in the centre of the scene is in low relief and was originally represented as chryselephantine, with added white for the ivory of the flesh and gilding, now almost entirely lost, for the drapery and other details. This refined style is particularly appropriate to the feminine themes that formed a large part of the vase-painter's repertoire from now on. Aphrodite with her entourage and scenes of life in the women's

86

87

85 Marble head of Herakles. Fourth century BC. Sculpture 1600, ht 29.9 cm.

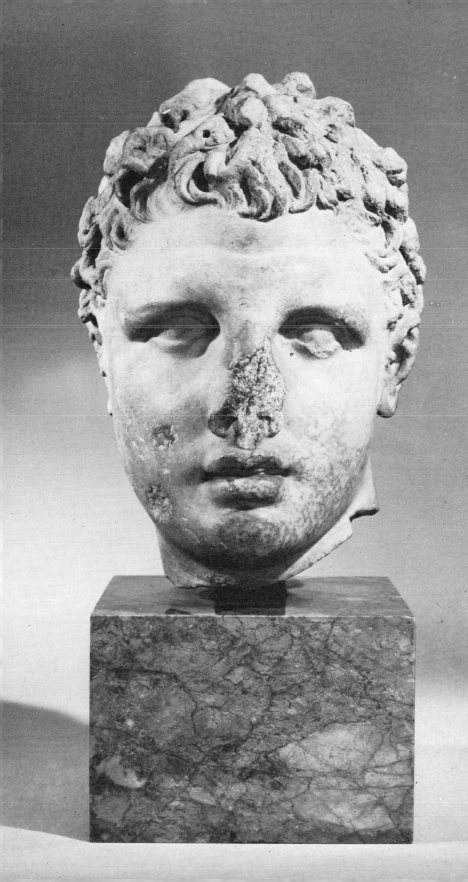

quarters are popular subjects on cosmetic boxes (pyxides, e.g. Vase E 775) and perfume bottles (lekythoi: now usually of the round-shouldered or squat form, e.g. Vase E 697).

White-ground lekythoi were decorated by specialist painters, who no longer worked also in the red-figure technique. Funerary subjects are standard and matt paint was regularly used not only for coloured details but also in place of dilute glaze for the outlines of figures. Taking full advantage of the medium these artists developed a fluid style of pure draughtsmanship that has scarcely been equalled in its capacity to represent rounded forms within a simple contour. A woman seated on the steps of a tomb, on a lekythos attributed to one of the painters of Group R, is characteristic (Vase D 71). Her expression of intense emotion is quite alien to the dignified restraint shown on contemporary grave stelai.

A certain light relief is provided by a group of small Corinthian vases with figures sketched in outline technique with a blithe disregard for anatomical accuracy (E 813, E 814, 1969.12–15.2).

During the fourth century Attic vase-painting suffered a general decline as talented artists increasingly sought other fields. The industry must have been badly hit when the rich markets of southern Italy were taken over by locally produced vases. Exports continued to other areas, including the Greek colonies on the Black Sea, where Kerch (ancient Panticapeum, in the

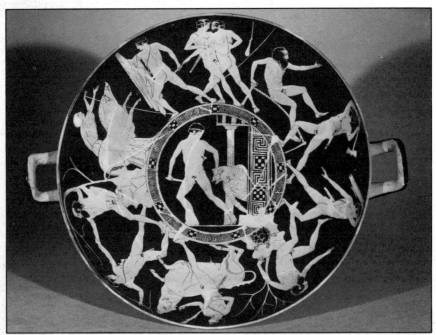

**86** Interior of a red-figured cup showing the Deeds of Theseus. Attic, 440–430 BC. Vase E 84, diameter 32.3 cm.

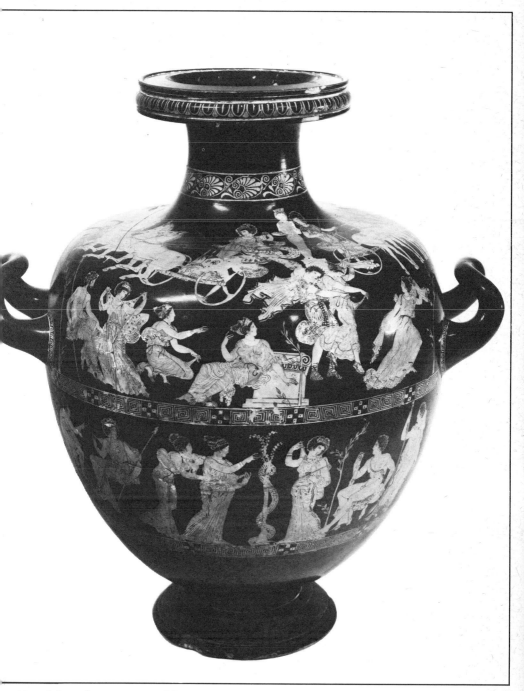

**87** Red-figured water-jar signed by the potter Meidias. Attic, c.410 BC.
Vase E 224, ht 52.2 cm.

Crimea) has given its name to a style of vase-painting that was practised around the middle of the fourth century. A storage-jar (pelike) showing Peleus wrestling with Thetis is a good example of the Kerch style (Vase E 424): the figures are sketched with short, broken strokes; added colours, green and blue as well as white, are extensively used to emphasise the important figures, but relief has been abandoned and gilding is now rare; the composition is crowded and complex, with languidly posed figures leaning away from the centre as though moving over the surface of the vase. This new emphasis on overall surface texture heralds the decline of red-figure and its eventual replacement by patternwork and relief decoration.

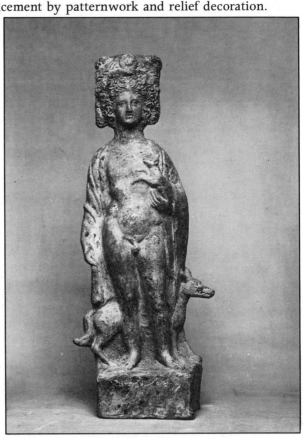

88 Statuette of a young man with a bitch at his heels and her puppy in his arms. Boeotian, c.400 BC. Terracotta 871, ht 32 cm.

## Stone Vases

Vases made of stone are relatively uncommon, probably because clay was both cheaper and more easily worked. One of the marble pyxides exhibited in Case 3 (TB 611) is related in shape to the red-figured and white-ground vases already discussed (see page 74). A rather more elaborate example on a tall stem, decorated with a series of delicate flanges, was evidently turned on a lathe (1906.3–10.2).

## Terracottas

In the early years of the fourth century, enterprising potters began to produce a series of perfume bottles in a mixed technique, a typical example being a lekythos in the form of a bust of Athena (Terracotta 1701). The bust itself was made in a mould and decorated after firing with matt colours, just like a terracotta statuette. The rest of the vessel was wheel-made or added freehand, and then decorated with black glaze and red-figure palmettes in the normal vase-painting technique. Later examples incorporate whole figures, usually religious subjects with a feminine appeal, Aphrodite, Eros (Terracotta 1716), or Dionysos as an infant.

Terracotta sculpture was made in many parts of the Greek world during the late fifth and fourth centuries and in a wide range of types, which showed increasing uniformity as the fourth century went on. A character-istic product of Halicarnassus in the late fifth century is a standing man wearing a cloak (himation) that leaves his chest bare. A good example (Terracotta 433) comes from a rich votive deposit excavated by C. T. Newton in 1856. The standing youths made in Boeotia wear their himatia at the back and have ornate, almost effeminate, hairstyles. They usually hold a bird or an animal: a cock, a hare (Terracotta 852), or a puppy (Terracotta 871). Busts in low relief (*protomes*), frequent in the archaic                **88**

89 Late Corinthian cup
showing Artemis with a
torch and a bow approaching
an altar. 450–400 BC.
1969.12–15.2,
diameter 9.2 cm.

period, long retained their popularity in Boeotia. The type of a goddess with a polos on her head (Terracotta 857) survived to about the end of the fifth century, and in the fourth century Dionysos appears in this form hold-ing appropriate attributes, an egg and a cock (Terracotta 874) or a kantharos.                **90**
The seated goddess (Terracotta 889) is a rarer type. Her ornate throne, polos and phiale all imply divine status. With her left hand she hugs a fawn to her breast, and she must therefore be identified as Artemis.

The original colours are particularly well preserved on a piece that is said to have been found at Olbia in southern Russia but is probably of Corinthian manufacture (Terracotta 970). It shows Aphrodite dancing while Eros beats time on a tambourine. His relaxed pose reflects the influence of Praxiteles, and the sweet expression on Aphrodite's face is also characteristic of this period. The treatment of her drapery points the way to the Tanagra style of the late fourth century.

91

**90** Bust of Dionysos holding a cock and an egg. Boeotian, c.370 BC. Terracotta 874, ht 31 cm.

**91** Statuette of Aphrodite dancing while Eros plays a tambourine. Corinthian, *c*.350 BC.
Terracotta 970, ht 16.5 cm.

### Bronzes

Among the surviving works in bronze of the late fifth and fourth centuries a prominent place is held by reliefs. As usual hardly any large statues have survived, and in this period statuettes are relatively rare, probably because they were no longer so frequently dedicated in sanctuaries, while the demand for them as *objets d'art* had scarcely arisen.

Bronze naturally remained in use for utilitarian objects like armour (helmet, 1919.11–19.6), mirrors and vessels (jug, Bronze 2474). Reliefs were frequently attached by way of decoration, for example below the vertical handles of hydriai. On a hydria from Chalke in Rhodes (Bronze 312) the relief portrays Dionysos and his bride Ariadne, a favourite subject that is also seen in a relief now detached from its original setting, no doubt also a hydria (Bronze 311; Case 2, no. 9).

A further stimulus to the development of bronze reliefs arose late in the fifth century, when a new type of mirror came into fashion. Instead of being supported on the head of a statuette the mirror was placed in a circular box with a hinged lid, rather like a modern powder compact. The outside of the lid was a suitable place for a decorative relief, and the bronzeworkers responded to the challenge of composing groups of figures to fit the circular field with the same enthusiasm that archaic vase-painters

92 Water-jar with a relief showing Dionysos and Ariadne. The vessel and the relief were hammered from metal sheets, the handles were cast.
c.350 BC. Bronze 312, ht 47.1 cm.

had brought to the corresponding problem in the interior of drinking cups.

Many of these compositions consist of two figures, and combats naturally bulk large in the repertoire. An extract from the Battle of Gods and Giants, with Dionysos (or perhaps Artemis) about to deal the death blow to a fallen giant shows all the artist's skill in composition and his great technical ability in such details as the extreme foreshortening of the giant's right leg (1906.4–25.1; Case 2, no. 5).

A more complex composition shows Aphrodite and the Trojan Anchises (the parents of Aeneas) reclining on Mount Ida (1904.7–2.1; Case 2, no. 12). Aphrodite is accompanied by two winged erotes, Anchises by his dog. Silver inlay was used for the whites of the eyes and for Aphrodite's necklace. Silver inlay was similarly employed on a relief of a woman's head (Bronze 299; Case 2, no. 4). Heads in frontal or profile view were frequently attached to mirror-cases, but this example is in unusually high relief.

Some mirrors were further embellished with a scene engraved on the inside of the lid. A particularly pleasing example shows Aphrodite playing at knucklebones with Pan (Bronze 289). The technique is more akin to drawing than to sculpture: the flowing line recalls the draughtsmanship of the later white-ground lekythoi, but here the effect of roundness is partly achieved by groups of lines that suggest shading.

93

93 Aphrodite playing at knuckle-bones with Pan, delicately drawn with a graver on the inside of a bronze mirror-cover. c.350 BC. Bronze 289, diameter 18.5 cm.

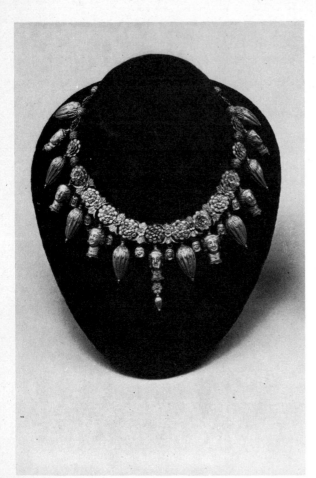

95 Three seal-impressions: women playing the harp and writing, and a heron. Gems 529, 533 and 553, about actual size

94 Gold necklace with filigree decoration and with pendants hammered from sheet gold. The goldsmith who made this masterpiece between 400 and 360 BC probably worked at Taranto, a Greek colony in the heel of Southern Italy. Jewellery 1952

96 Gold earring from Eretria with a siren on a boat-shaped pendant. The upper rosette masks the suspension hook. Greek, about 400 BC. Jewellery 1653, ht 6 cm.

## Seals and Jewellery

During the fifth century the plain-backed scaraboid replaced the true scarab (with its back carved to represent a beetle) as the standard shape for sealstones. Pale coloured stones like chalcedony became popular but did not completely oust old favourites like cornelian. Seated women and animals are particularly frequent subjects. On a rock-crystal scaraboid a seated woman plays the harp (Gem 529; Case 6, no. 16), and on a scaraboid of      95 chalcedony a young woman sits writing (Gem 533; Case 6, no. 3). Other chalcedony scaraboids show a lion attacking a horse (Gem 536; Case 6, no. 1) and a particularly graceful heron that has an antler in place of a crest (Gem 553; Case 6, no. 14). A four-sided chalcedony bead has both beasts of prey and domestic animals (Gem 605; Case 6, no. 15). All these stones have longitudinal string-holes and could be mounted either as pendants or as swivels in rings. About the end of the fifth century some rings were made with engraved metal bezels in place of sealstones. Early subjects include Victory in a four-horse chariot (Ring 42; Case 5, no. 26) and a head of Athena (Ring 68; Case 5, no. 20). Other rings with relief decorations, which were unsuitable for sealing, must have been purely ornamental items of jewellery (Rings 218,219; Case 5, nos 18 and 25).

During the sixth and much of the fifth centuries gold was in short supply in Greece, and most jewellery was made in more perishable materials like silver and bronze, so that little has survived. Towards 450 BC, however, gold became more readily available to private individuals in some parts of the Greek world, though remaining rather scarce on the mainland itself. Decorated ear-studs from Rhodes include an example from Camirus that shows a Nereid on a dolphin bringing a new helmet to Achilles (Jewellery 2067; Case 5, no. 3). From Eretria come a pair of late fifth-century earrings, each with a siren on a boat-shaped pendant suspended from a rosette      96 (Jewellery 1653–54; Case 5, no. 15). The decoration is in delicate filigree, now more extensively used than granulation, with enamel filling. Enamel, long a favourite technique in Cyprus, may also be seen on the collars of a pair of griffin-head earrings from Amathus (Jewellery 1846–47; Case 5, no. 28).

One of the finest extant products of a fourth-century goldsmith is a neck-      94 lace found at Taranto and probably made there (Jewellery 1952; Case 5, no. 13). Acorns and female heads are suspended from three-layered filigree rosettes, which are separated by spherical beads and other spacers with floral decoration. Comparison of the heads with those on Tarentine coins suggests a date of 400–360 BC. The filigree is remarkable both for the richness of its design and the precision of its execution.

Greek goldsmiths also worked for foreign clients, including the Scythians of southern Russia. Characteristic products include plaques to be sewn on clothing with animals and Scythian archers in low relief (Jewellery 2106 a–d; Case 5, no. 5).

# Room 10
# Fourth-century Sculpture and Vase-painting

### Fourth-century Grave Reliefs

While women and old men are usually shown on their grave reliefs seated, younger men, whether athletes or warriors, normally stand. A stele of a young man and his attendant (Sculpture 625), although found on Delos, is of Attic workmanship of not long after 390 BC. The architectural frame is now normal, with antae supporting a low entablature including a pediment. Some later monuments even have the figures set into a separately constructed framework, as if it were a small shrine (*naiskos*). The classical series of elaborate grave monuments in Attica was brought to an end by the sumptuary legislation of Demetrios of Phaleron in 317/6 BC.

### The Tomb of Payava (Sculpture 950)

Discovered at Xanthos by Sir Charles Fellows in 1838, the Tomb of Payava combines relief sculpture of Greek style with a characteristically Lycian architectural form, which frankly imitates a wooden structure. The relief sculptures include themes that had become traditional on the tombs of the Lycian aristocracy.

On either side of the roof, in low relief, is a four-horse chariot with a charioteer and a soldier in armour. Projecting from the roof and cutting through this relief are the foreparts of lions, guardians of the tomb. Other guardians, seated sphinxes, are carved in very low relief in the upper panels of the gables. Along the ridge are reliefs that presumably depict the exploits of the tomb's owner in war and peace: a cavalryman riding down foot-soldiers on one side, and a mounted hunter of wild boar on the other. An incription in Lycian on the military side, now partially obliterated, should probably be read: 'Payava built this monument'. The same inscription is cut above another military scene in the lower register, which shows Payava taking a prominent part in a cavalry engagement. As before, his equipment includes a long leg-guard, perhaps made of leather. On the shorter ends at this level are scenes that echo each other. In one of them a young man, naked and therefore presumably an athlete, receives a victor's crown from an older, bearded man. The gesture of crowning is repeated on the other end, but here both men are maturely bearded and both wear military dress: greaves, a cuirass over a short tunic, and a cloak over all. A long Lycian inscription includes the information that Payava was him-

97 Relief from the side of the Tomb of Payava from Xanthos. The Persian Satrap Autophradates grants an audience to Payava. This composite photograph includes on the left a fragment found at Xanthos in 1952. Sculpture 950, height of relief 1.05 m.

self a Lycian. It is no doubt Payava who is being crowned for valour, and the incident that merited the honour could well be that shown on the adjacent side. The victorious athlete probably represents Payava himself as a young man.

97     The fourth side shows four men standing before an obviously important personage, who wears Persian costume and is seated on an ornate stool. Behind him stands an attendant with folded arms, and the scene was completed by a second attendant on a fragment that was overlooked by Fellows but found on the site by French excavators in 1952. The inscription above seems to contain the name of Autophradates, the Persian satrap of Lydia, whose career spanned the years 390–354 BC. The scene evidently records an audience granted to Payava, who must have regarded it as one of the great moments of his life.

## South Italian Vase Painting

The beginning of red-figured pottery in southern Italy has been plausibly connected with the foundation of Thurii in 443 BC, when potters trained in Athens could have been included among the new settlers. Certainly the style of vases made in southern Italy at this period is very close to that current in Athens. When the supply of Attic pottery was interrupted by the economic collapse of Athens at the end of the Peloponnesian War, demand for red-figured pottery in Italy was met by the expansion of local production. As the fourth century progressed, the influence of local taste

and the isolation of the Italian potters from the Attic tradition led to an increasing divergence of style between the various local schools.

*Lucanian*

The divergence from Attic standards of both style and taste is already apparent in a Lucanian bell-krater (wine-bowl) of about 390–380 BC (Vase F 157). Its subject, taken from Homer's *Iliad*, is the ambush of Dolon, and has given this artist his conventional name, the Dolon Painter. The treatment of an epic subject in a rather burlesque manner, acceptable in the theatrical tradition of South Italian vase-painting, would scarcely be admitted in Athens.

*Apulian*

Many of the potters and vase-painters of the Apulian school, which was probably centred in Taranto from about 420 BC, show a marked predilection for monumental shapes and elaborate decoration. There was also a less flamboyant Plain Style, which may be seen on a pail (*situla*) by the Painter of Perseus and Athena, so named from the subject of this vase (Vase F 83). Athena is holding the sickle (*harpe*) with which Perseus severed the Gorgon's head.

The Ornate Style is found on vases of all sizes, but it is most at home on large volute-kraters (wine-bowls with volutes on the handles) that allow scope for rather grandiose compositions. These are frequently in several tiers, in a manner no longer fashionable in Athens. The subjects are chiefly funerary and mythological, with some emphasis on uncommon myths and scenes from Greek tragedies. Scenes from the Trojan War are also popular. The namepiece of the Iliupersis (Destruction of Troy) Painter shows several incidents from the fall of the city: the seizure of Polyxena

98

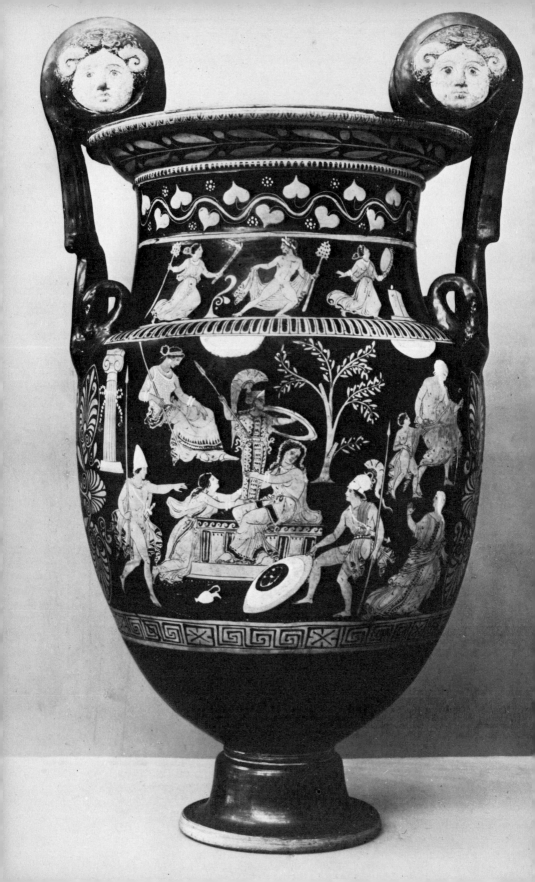

for sacrifice, Cassandra vainly seeking sanctuary at the statue of Athena, and the departure of Anchises and Ascanius (Vase F 160). Liberal application of extra colours gives a polychrome appearance that is particularly striking on a volute-krater from the Hamilton Collection (Vase F 284). The main scene features a large grave monument, related in concept to the more elaborate Attic stelai, where white paint distinguishes the statue in the shrine (*naiskos*) from the living mourners who surround it. The painter has made a noteworthy attempt to represent the roof in perspective.

Vases with an admixture of sculpture include a drinking cup *(rhyton)* in the form of a mould-made ram's head with an added lip (Vase F 425) and a perfume-bottle (squat lekythos) with relief decoration showing Ajax seizing Cassandra during the capture of Troy (Vase G 23).

*Paestan*

A very distinctive school of vase-painting was located during the fourth century at Paestum (Poseidonia) on the west coast of Italy. Here too theatrical subjects were popular, and a lost play by Euripides was the source for the scene on a large bell-krater (Vase F 149). On the right, Amphitryon     99
applies blazing torches to a pile of logs in front of an altar on which his wife Alcmene has taken refuge, her right arm raised in supplication to Zeus. Two female figures pouring water out of jars represent the Clouds, sent by Zeus to quench the pyre. A rainbow behind Alcmene serves as a frame for the falling rain. Above the scene is the signature of Python, one of only three South Italian vase-painters known to have signed their work.

*Campanian*

Red-figured vases were produced in various parts of Campania from the early fourth century, perhaps at first by potters from Sicily. The clay often fires to the rather pale yellowish colour seen on a situla of Capuan manufacture showing the abduction of Helen by Paris (1928.7–19.3).     100
This vase was formerly in the Dillwyn Parrish collection, and the artist has been named the Parrish Painter after it. A perfume-bottle (squat lekythos), probably made at Cumae slightly later, retains extensive traces of the red ochre that was used to counteract the yellowness of the clay (Vase F 241). Its scene of a warrior departing for battle is a favourite in Campanian vase-painting, and the lavish use of white, especially for women's flesh, is characteristic. The warrior wears Oscan armour, including the distinctive breastplate consisting of three connected discs of metal.

*Lipari Ware*

Around 340 BC there was a revival of red-figured pottery in Sicily, with a particularly distinctive school on the island of Lipari off the northern coast. A perfume-bottle (alabastron) showing two women (Vase F 251) has details in white and blue, but other colours including green are often used. The effect is reminiscent of Attic vases of the Kerch style and leads on to the fully polychrome vases that were produced after the red-figure technique had been abandoned.

**98** Apulian volute-krater with scenes from the Destruction of Troy. 380–370 BC. Vase F 160, ht 88.4 cm.

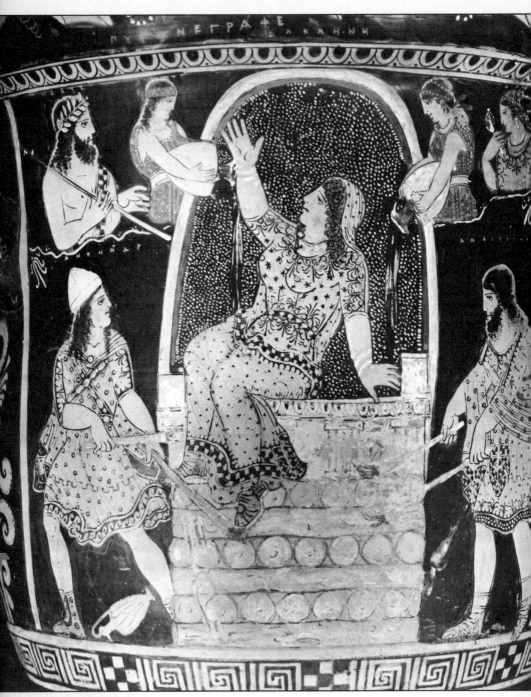

**99** Paestan bell-krater with Alcmene appealing to Zeus. 350–325 BC. Vase F 149, ht of picture 26 cm.

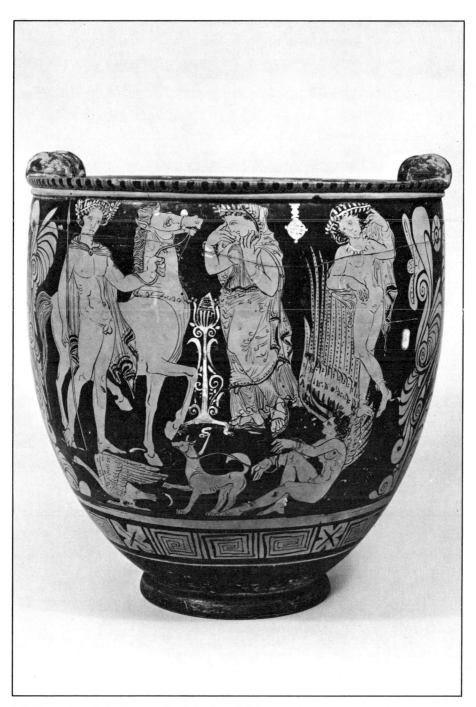

**100** Campanian situla showing the abduction of Helen. *c*.350 BC. 1928.7–19.3, ht 27.8 cm.

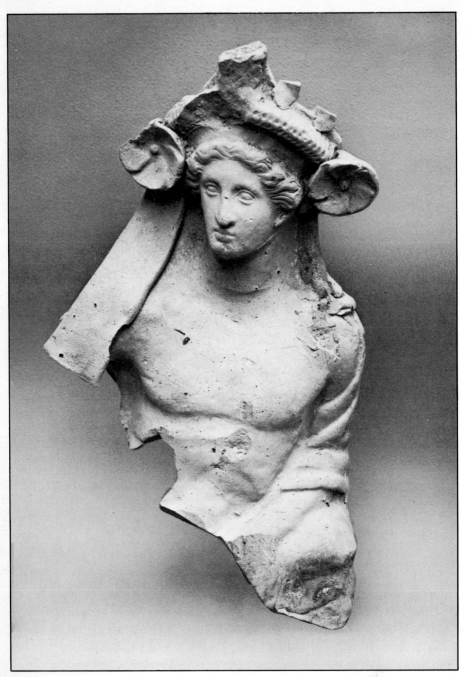

**101** Fragmentary relief from Taranto, showing Dionysos reclining. *c*.380 BC. Terracotta 1315, ht 25 cm.

## Gnathian

Another technique that survived the end of red-figure is that of the so-called Gnathian ware. Early finds around Gnathia (modern Egnazia) in Apulia were responsible for its name, but it is now known to have been manufactured in several areas from about the middle of the fourth century. The vases are covered completely in black glaze and designs are added in white and various subsidiary colours. Vases with figured scenes are exceptional, the decoration consisting chiefly of floral or geometric patterns. Among the subjects that occasionally appear are vases, animals, figures of Eros and theatrical masks. A comic mask of an old man may be seen on a wine-bowl inscribed with the name of Zeus the Saviour (Vase F 548).

## Terracotta Sculpture

Apart from a seated goddess of Paestan type, probably to be identified as Hera (1956.7–19.2), most of the terracottas exhibited here were, like the Apulian vases, probably manufactured in Taranto. Among the many thousands of known Tarentine terracottas the most common type shows Dionysos reclining on a couch (Terracotta 1315). Complete examples show the god holding a drinking cup in his left hand, and they frequently include near the foot of the couch a standing woman with a child, perhaps best identified as Persephone and Iacchos (Terracotta 1354 bis). These were made without backs and supported on struts, rather like plaques in very high relief. Another frequent type is a statuette of a seated woman or goddess that also requires support and was probably in antiquity provided with a wooden throne (Terracotta 1305). A less formal representation of a goddess shows Aphrodite accompanied by Eros seated on a swan (1308).

101

A group consisting of two girls crouching to play a game of knuckle-bones is of disputed provenance (Capua or Canosa), but it was probably made in Taranto about 330 BC (Terracotta D 161). Its freedom of pose and graceful style look towards the Tanagra figurines that are so typical of the early Hellenistic period.

102

## Bronze Sculpture

Among the fourth-century bronze statuettes are two from the Woodhouse collection representing warriors, one from Corfu and the other perhaps found in southern Italy. Both wear crested conical helmets, but their moods and actions are totally unlike. The first (Bronze 1454) is aggressively posed with left leg and shoulder advanced, left knee flexed, and body protected by a shield (now missing) on his left arm. Having drawn his right arm back he is about to lunge forward with his sword (also missing), but even now can sway to avoid a counterthrust by straightening his left leg. The second (Bronze 1074) is at ease, with a spear at the slope over his left shoulder and his right hand negligently placed on his hip.

103

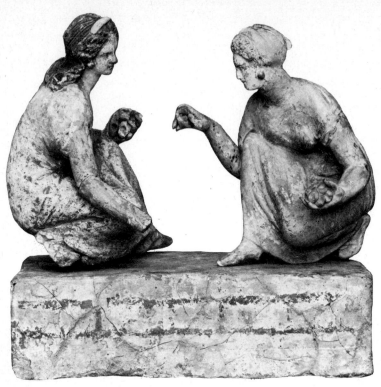

**102** Two girls playing a game with knuckle-bones. *c.*340–330 BC. Terracotta D 161, ht 21 cm.

104     A pair of shoulder-flaps from a cuirass (Bronze 285) rank among the masterpieces of fourth-century bronze relief work. Each shows a Greek warrior in close combat with an Amazon. The compositions are balanced but subtly different in detail. The depth of the relief is emphasised by bold foreshortening, the vigour of the action by swirling drapery. The flaps were hinged at the top to the back plate of the cuirass and hooked to the front plate below, where lions' heads formed part of the attachments.

105     A rare example of life-size sculpture in bronze is the head of a North African excavated by Smith and Porcher in the temple of Apollo at Cyrene in 1861 (Bronze 268). It was cast hollow and the hairs of the eyebrows, moustache and beard were later individually chased. When new it must have been extremely lifelike, with the bronze not corroded green but freshly polished to the colour of lightly sun-tanned skin. Copper inlay gave a reddish hue to the lips, behind them was a flash of silver for the teeth, and glass paste in the eyes produced a proud, realistic stare.

Room 11, approached by the staircase and balcony in Room 10, is used for temporary exhibitions. From the balcony a good view may be obtained of the upper part of the Tomb of Payava and of the roof of another Lycian tomb, that of Merehi (Sculpture 951).

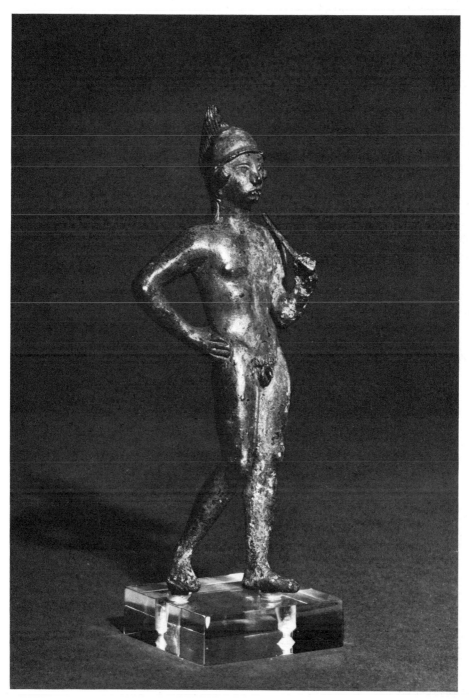

**103** Statuette of a warrior carrying a spear. *c.*350 BC. Bronze 1074, ht 13.1 cm.

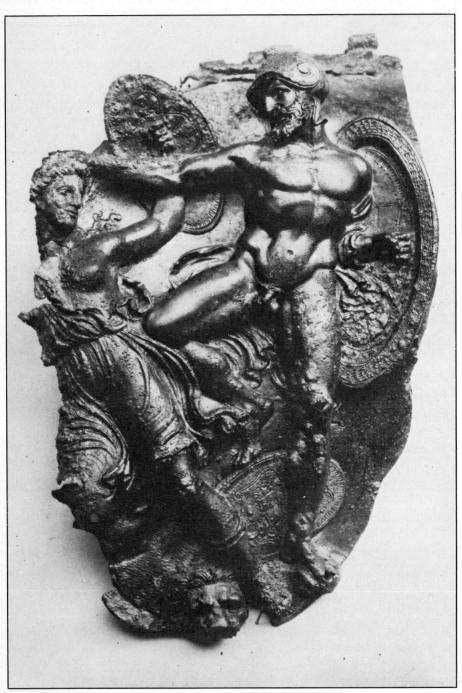

**104** Shoulder-flap from a breastplate showing a Greek fighting an Amazon. 400–350 BC. Bronze 285, ht 16.5 cm.

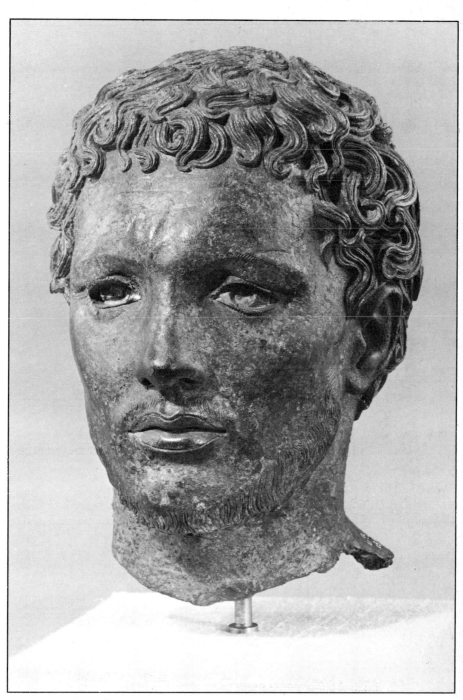

**105** Portrait of a North African, found at Cyrene. c.350 BC. Bronze 268, ht 30.5 cm.

# Room 12
# Architectural Sculpture from Asia Minor

**The Mausoleum**

The Mausoleum was the tomb of Mausolos, Satrap of Caria, who died about 353 BC. It stood in the centre of Halicarnassus, the city that for economic and military reasons Mausolos had chosen to be his capital. Celebrated in antiquity as one of the Seven Wonders of the World, its name has been used since Roman times to designate any monumental tomb. It may have been planned during the lifetime of Mausolos, but the chief credit for building it belongs to his sister and queen Artemisia, who died before it was actually completed. Having remained standing for many centuries, the Mausoleum eventually collapsed, probably some time before 1402 when the Knights of St John built their Castle near the harbour. The ruins of the Mausoleum served as a quarry when the Castle was repaired and extended in 1522. Thirteen blocks from the friezes, which the Knights had used to decorate the walls of the castle, were removed with the Sultan's permission in 1846 and brought to the British Museum.

The earliest attempts to reconstruct the appearance of the Mausoleum were based on the brief descriptions by ancient authors, especially Pliny and Vitruvius. A version by the architect Nicholas Hawksmoor can be seen near the British Museum in the elegant tower of St George's Church, Bloomsbury, which was consecrated in 1731. New evidence became available when the actual site of the Mausoleum was rediscovered early in 1857 by an expedition under C.T. Newton. Neither Newton, who continued excavating until 1858, nor Biliotti, who worked there in 1865, was able to clear the whole site, but this was eventually accomplished in the years following 1966 by a team of Danish archaeologists led by Kristian Jeppesen. Although many fragments of the building and its sculptures have been found, only traces of the foundations remain in place. From these remains and the ancient descriptions we now have a good general idea of the appearance of the Mausoleum, with only a few details remaining uncertain. It consisted of an Ionic colonnade, which stood on a tall base and was surmounted by a stepped pyramid, with a four-horse chariot in marble on the apex. It is likely that the thirty-six columns mentioned by Pliny were so arranged as to give nine across the ends and eleven along the sides. The chariot-group was the work of Pythios, who together with Satyros was also the architect of the building and wrote a book about it. Various frag-

**106, 107** *Left*: a chariot-horse (Sculpture 1002, ht 2.38 m.); *right*: a portrait statue
(Sculpture 1000, ht 3.01 m.), both from the Mausoleum, *c*.350 BC

ments of the chariot-group survive, including the head and forehand of a
majestic horse with parts of its bronze bridle still preserved (Sculpture
1002).

   The Mausoleum was richly decorated with sculptures, including statues
of men and women, several of them on a colossal scale, a number of lions
and other animals, and three friezes. Among the statues are two that have
been thought to portray Mausolos himself (Sculpture 1000) and his queen,
Artemisia (Sculpture 1001). The figure called Mausolos, standing three
metres high and reconstructed from over seventy fragments, is the most
complete of the colossal male statues from the Mausoleum. The head was
made separately and fits into a socket between the shoulders. Its subject is
clearly a hellenized Asiatic: the facial features, the cut of moustache and
beard, the long hairstyle and the ankle-length tunic are not at all Greek, but
the cloak seems to be a Greek himation and the sculpture is Greek in style.
It doubtless portrays a member of the ruling family, but attempts to identify
it with Mausolos himself are no longer universally accepted.

106

107

The best preserved lion (Sculpture 1075) turns his head to the right. Others face left, and the whole group originally stood around the base of the pyramid.

108

Of the three friezes two depict battles, Greeks against Amazons and Lapiths against Centaurs, and the third shows racing chariots, recalling the tradition of chariot-racing at funerals that goes back as far as Homer. Each chariot was drawn by four horses, but while the existing fragments show various postures for both the charioteers and their teams, this frieze has been so thoroughly shattered that no single figure survives complete.

Only the Amazon frieze survives in sufficient quantity to permit an appraisal of the style and composition. Twelve blocks were recovered from the castle in 1846, and Newton found four more together with a large number of fragments at the site of the Mausoleum itself. According to a tradition preserved by Pliny, each of the four sides of the building was decorated by a different sculptor, and it has been something of a game among art-historians to attribute the surviving reliefs to the four sculptors he names: Scopas, Bryaxis, Timotheos and Leochares. The arguments for these attributions are largely subjective and the opinions of different scholars tend to be mutually contradictory. The whole process has been rather discredited by the recent discovery that two blocks, previously thought to be distinct and usually assigned to different sides of the building, actually join at the back and originally formed a single long slab (Sculpture 1008 + 1010).

Together with an adjacent slab on the left (Sculpture 1007) this gives an unbroken sequence of twelve figures. At the left is a group of three: a Greek pulling his spear from the body of a fallen Amazon while another Amazon attacks him with bow and arrow. The weapons were originally indicated in paint. Then come three single combats between Greeks and

108 Marble lion, one of several that stood around the base of the pyramid that surmounted the Mausoleum at Halicarnassus. c.350 BC. Sculpture 1075, ht 1.5 m.

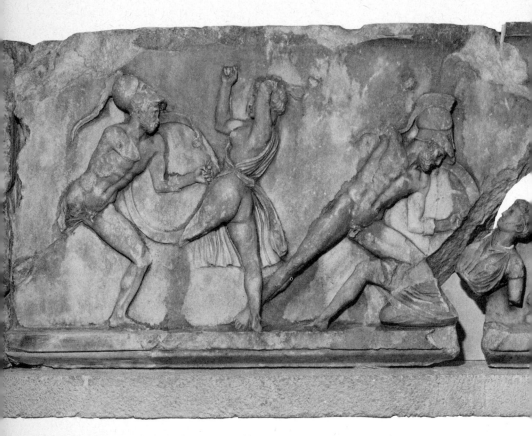

Amazons. In the centre Herakles may be recognised by his club and lion-skin, and at his side is probably his henchman Iolaos. The third Greek, who takes on a mounted Amazon, may be Theseus. At the right another Greek strides forward, sword in hand, over the body of a booted Amazon, and was probably confronted by another Amazon. The symmetrical placing of the groups is characteristic of the composition of the Amazon frieze.

109      The same principle may be observed in another group of adjacent slabs (Sculpture 1013–1015). Between two Amazons on rearing horses are three single combats: a Greek and an Amazon on equal terms in the centre, an Amazon overcoming a Greek on the left and a Greek victorious on the right. Bodies and limbs, sometimes boldly foreshortened, form a pattern of intersecting diagonal lines that binds the composition together. These slabs were found by Newton near the north-east corner of the foundations and have been most frequently assigned to Scopas, who was said by Pliny to have been responsible for the east side of the building, but on stylistic grounds they have been attributed to all three other sculptors.

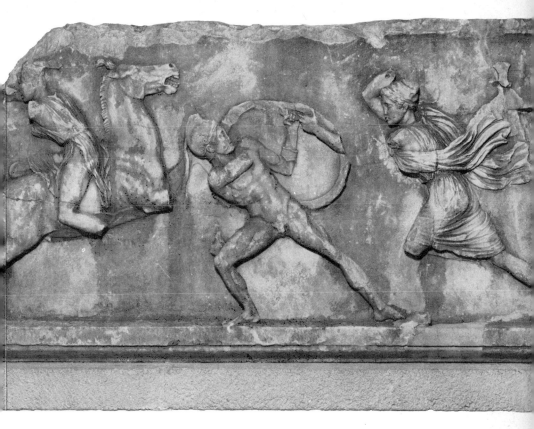

**109** Part of the frieze that crowned the base of the Mausoleum at Halicarnassus: the battle of Greeks and Amazons. *c.*350 BC. Sculpture 1013–1015, ht 90.2 cm.

Several fragments of the Centaur frieze were found by Newton and Biliotti, and more have been found by Jeppesen, but the only complete block was recovered from the castle (1032). In the centre a Lapith woman is running in alarm, and on either side Lapiths pursue fleeing Centaurs, carved for the most part on the adjacent blocks.

The original position of the Amazon and Centaur friezes has been much disputed. The Amazon frieze was once thought to have been part of the main entablature, but Jeppesen has now proved that it ran around the top of the base. This position corresponds to that of the battle friezes of the Nereid Monument, from which part of the Mausoleum's design is no doubt derived. Among the various positions proposed for the Centaur frieze, the most likely seems to be Jeppesen's conjecture that it decorated the plinth of the chariot-group. The chariot frieze was perhaps inside the building.

### The Temple of Artemis at Ephesus

The archaic temple of Artemis at Ephesus, of which fragments are exhibited in Room 3, was destroyed by fire in 356 BC. Reconstruction began at once with funds provided at great personal sacrifice by the citizens of Ephesus. The floor level was raised by about three metres and the new temple was built in the developed Ionic style of the later fourth century, but the basic ground-plan of the older temple was retained and some of the columns – thirty-six according to Pliny – were again embellished with drums and pedestals sculptured in relief. Representations of the temple on Ephesian coins prove that the lowest drums of the eight columns of the west front were sculptured, but the location of the other sculptured columns is uncertain. The sculptured pedestals were perhaps placed under the columns in the porches, where shorter and therefore more slender shafts would be appropriate.

After its destruction by the Goths about AD 263 the temple served as a quarry for other buildings in the neighbourhood of Ephesus and its site was eventually forgotten, buried under several metres of alluvial sand. It was eventually rediscovered in 1869 by John Turtle Wood, who had searched for the temple on behalf of the Museum's Trustees for six years.

110

Wood found but meagre remains of the temple and of its sculptured columns, which had made it one of the Seven Wonders of the World. The best preserved drum (Sculpture 1206) has substantial remains of five figures and traces of a sixth out of an original total of eight. At the right a seated man and a standing woman observe the departure of another woman, who is adjusting her outdoor cloak (himation) as if for a journey. She is ushered away by Hermes, the guide of the dead, and by Thanatos (Death) himself, who beckons her to follow. Hermes is identified by his herald's staff, Thanatos by his wings and by the sword that distinguishes him from his brother Hypnos (Sleep). The identity of the other figures and the event portrayed remain uncertain. It has been plausibly suggested that the departing woman is Iphigeneia being led away for sacrifice. The theme would be appropriate to the temple since it was Artemis who rescued her at the last moment.

110 Sculptured marble column-drum from the Temple of Artemis at Ephesus. Thanatos (Death) beckons a woman, who is escorted also by Hermes. The woman cannot be identified with certainty. She may be Iphigeneia, led away to be sacrificed to Artemis, who subsequently spared her; or Alcestis, who volunteered to die in place of her husband, but later returned from the Underworld. c.340 BC. Sculpture 1206, ht 1.82 m.

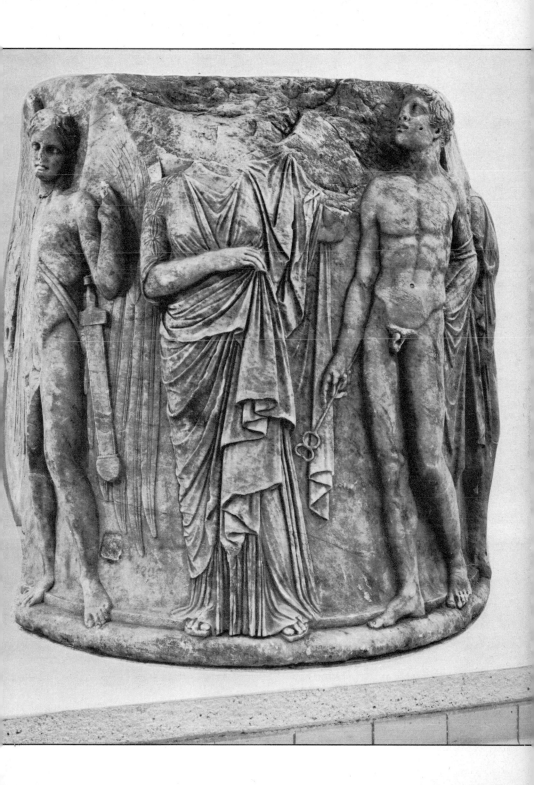

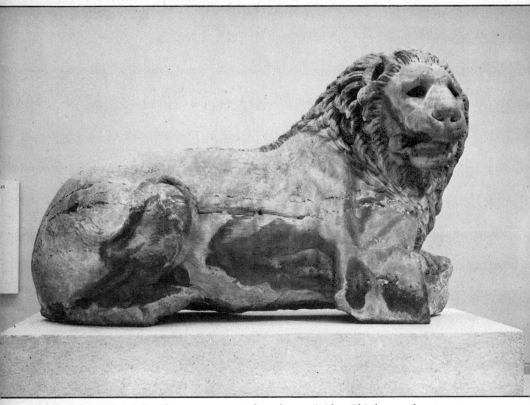

111 Marble lion from a monumental tomb near Cnidus. Third–second century BC.
Sculpture 1350, length 3 m.

### The Lion Tomb

111 The Mausoleum set a fashion in Asia Minor for monumental tombs with a
stepped pyramid supported by a colonnade. A colossal recumbent lion
(Sculpture 1350), three metres long and almost two metres high, was
originally set on the apex of such a tomb, which was built on a high
promontory overlooking the sea near Cnidus. It was much smaller than
the Mausoleum, about 19 metres high overall, and its Doric columns were
engaged to the walls instead of standing free. The style of the Doric
architecture suggests a date in the third or second century BC.

112 A staircase in the corner of the Mausoleum Room (Room 12) leads down to
the Room of Greek and Roman Architecture. Here are exhibited architec-
tural details of several buildings that are represented by sculpture in the
main galleries, including the Temple of Apollo at Bassae (Room 6), the
Erechtheion (Room 9), the Mausoleum (Room 12) and the temples of
Artemis at Ephesus (Rooms 3 and 12).

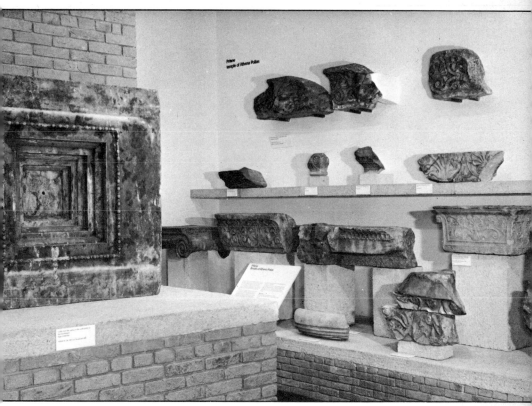

112 Part of the Room of Greek and Roman architecture. In the foreground is a coffer from the Erechtheion, Athens (see *Ill.* 82). The other fragments come from the temple of Athena Polias at Priene in western Turkey.

Room 12

114

113

Room 14

119          125          120

124          123          121

117          118          122

116      127        126      115

# Room 13
# Art in the Hellenistic Age

A new period in Greek history was inaugurated by the conquests of Alexander the Great. Alexander's father, King Philip of Macedon, had conquered the Greek cities, once so proudly independent, but it was as allies rather than as subjects that the Greeks joined Alexander in his crusade against the Persian Empire. Alexander's conquests eventually embraced Asia Minor, Egypt, Persia, and the rest of western Asia as far as the Indus. When he died in 323 BC, no single heir was able to establish a claim to this enormous empire, and it was carved up by his generals into a series of independent kingdoms.

Although the new rulers were themselves Macedonians, many Greeks found in these kingdoms scope for their talents as soldiers and administrators, as colonists and traders. The diffusion of Greek culture throughout the conquered territories was deliberately fostered as a means of uniting subject peoples of differing ethnic, religious and cultural backgrounds. The Seleucid kings, who ruled the eastern territories from their capital at Antioch in northern Syria, founded many new cities and reorganised others on the Greek model.

Alexandria, founded by Alexander himself on the Nile delta, was adopted by Ptolemy I as the capital of his Egyptian kingdom. Under the patronage of his successors it became also an important centre of learning and culture.

One by one these great kingdoms succumbed to a new power: Rome. Macedonia became a Roman province in 148 BC. In 133 the last King of Pergamon bequeathed his kingdom to Rome, and by 70 the rest of Asia Minor was in Roman hands. In 64 BC Pompey the Great annexed the Seleucid kingdom, and in 31 BC the defeat of Antony and Cleopatra at Actium brought Egypt under Roman rule.

The period between the death of Alexander the Great and the final triumph of Rome over the kingdoms of his successors is usually known as the Hellenistic age. It was marked not merely by the spread of Greek culture far to the east and south of Greece itself, but also by new developments in government, literature and the arts.

## New Developments in Art
By about the middle of the fourth century Greek sculptors had perfected both their knowledge of anatomy and their mastery of materials. No

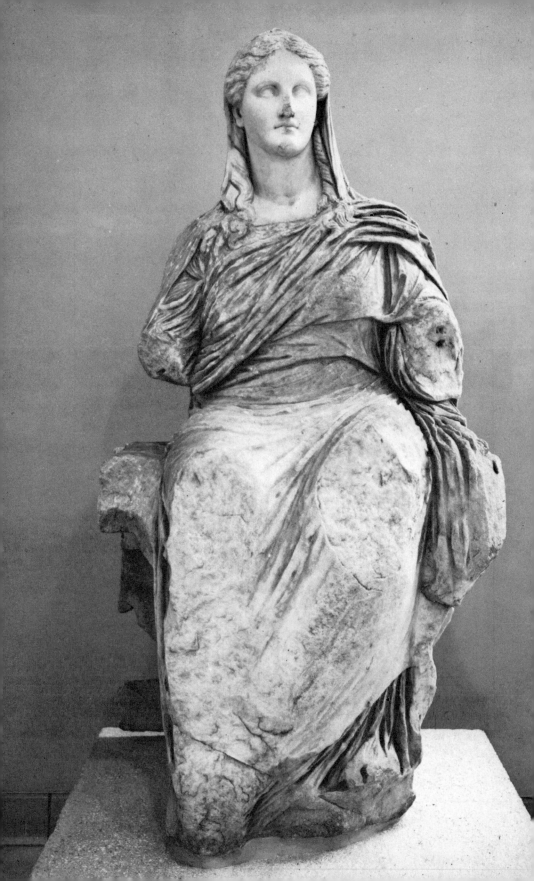

longer restricted by technical difficulties, Greek art was ripe for a change. A powerful factor for change was the new political and social situation in the Hellenistic world.

The building programmes of the Hellenistic monarchs gave architects and sculptors new opportunities for work on a grand scale. At the same time, the virtual end of a broad-based democratic government turned men's minds to the affairs of the individual, while the general decline of the old Olympian religion encouraged a new stress on humanity.

A new trend towards realism in art found expression both in portraiture and in the representation of commonplace subjects from ordinary life: infancy, old age, deformity, ethnic differences of physiognomy and dress – all were closely studied and accurately represented. Technical virtuosity was demonstrated in complex poses and in the detailed treatment of drapery; group compositions were designed that were no longer restricted by architectural forms like the pediment.

There are not many monuments that can be accurately dated by external evidence. Stylistic changes no longer represent advances of knowledge or technique, and some artists consciously imitate the styles of earlier periods. Consequently the chronological development of art in the Hellenistic period is not always clear.

## Sculpture

A marble statue of Demeter, excavated at Cnidus in 1858 by Sir Charles Newton, was probably carved about the beginning of the Hellenistic period (Sculpture 1300). The goddess is heavily draped and sits on a cushioned throne. Her head, made of a separate piece of marble and set into a socket on the shoulders, has largely escaped the weathering and damage suffered by the body. A high polish gives the skin a smoother texture than the hair and drapery. Two lamps excavated in the sanctuary of Demeter are exhibited in Case 2 (Lamp 384, 388).

A bearded head with a benign expression, found in the shrine of Asklepios on the island of Melos in 1828, is probably from the cult image of the god (Sculpture 550). The complete statue must have been nearly four metres high. Known to Homer as a mortal physician, Asklepios was later elevated to the rank of a divine healer. His cult became especially popular from the fourth century onwards, since it required the participation of individual worshippers, so satisfying a need for personal involvement that was no longer met by the state cult of the Olympian gods.

A popular group composition, to judge from the many surviving copies of individual figures, portrayed the Nine Muses. The types were used on a reduced scale in a relief representing the Apotheosis of Homer, which was probably carved about 150–120 BC by Archelaos, son of Apollonios, of Priene (Sculpture 2191). The composition is arranged in tiers. At the top is Zeus, and below him are the Muses with their mother, Mnemosyne,

113

114

113 Marble statue of Demeter from Cnidus. c.330 BC. Sculpture 1300, ht 1.47 m.

and Apollo. A statue of a victorious poet, doubtless the dedicator of the relief, stands at the right. Inscriptions identify the figures of the lowest tier: the World and Time are crowning Homer, who sits on a throne flanked by small figures representing the *Iliad* and the *Odyssey*; in front are personifications of literary concepts and the virtues inculcated by the Homeric poems: Myth, History, Poetry, Tragedy, Comedy, Nature; and Courage, Memory, Trustworthiness and Wisdom.

A large statue of a standing Muse demonstrates its sculptor's pre-occupation with drapery at the expense of the forms of the body beneath it (Sculpture 1684). With a mannerism typical of the later Hellenistic period the outer garment (himation) is so thin that the folds of the chiton beneath are seen through it.

Portraiture in the Hellenistic period followed two paths: realistic and imaginary. Realistic portraits of public figures and wealthy private individuals became more frequent. A head of a man found in Rhodes was made to fit into a statue, which was probably of a rather conventional type (Sculpture 1965). A continuing demand for portraits of famous men

115

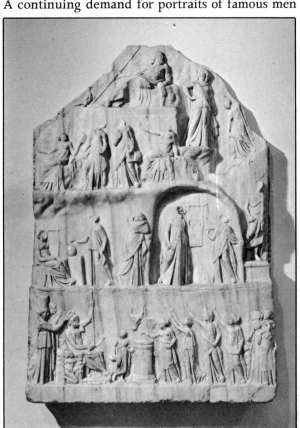

114 Marble relief, the Apotheosis of Homer, by Archelaos of Priene, whose signature is just below the figure of Zeus at the top. c.150–120 BC. Sculpture 2191, ht 1.15 m.

of the past was met, when no authentic portrait existed, by inventing a suitable type. A bronze portrait-head brought from Constantinople in the early seventeenth century for the collection of Thomas Howard, Earl of Arundel, is characterized as a poet by the fillet that binds the hair; it was long thought to represent Homer, but has more recently been identified as a portrait of Sophocles in his old age (Bronze 847). 116

## Terracottas

Among the most typical products of the early Hellenistic period are terracotta figurines in the Tanagra style, named after the Boeotian town where large numbers were found in the 1870s. In spite of the name, the style probably originated in Athens. As in full-sized sculpture, the trend towards greater realism finds expression not only in complicated poses and drapery but also in the portrayal of everyday subjects. Characteristic examples include women in indoor or outdoor dress. Indoors (Terracotta c295) a woman wears a long tunic (chiton) and a loosely draped mantle (himation); before going out she draws the mantle more closely around 117

115 Marble portrait of a man, from Rhodes. A new emphasis on the individual can be seen in the increasingly realistic portraits of the Hellenistic period. c.100–50 BC. Sculpture 1965, ht 45 cm.

116 Imaginary portrait of a poet, perhaps Sophocles. Third century BC.
Bronze 847, ht 30 cm.
117 Two statuettes of women, from Tanagra. Third century BC. Terracottas C 263
(left, ht 25.9 cm.), C 295

118 Two women seated on a couch, from Myrina. *c*.100 BC. Terracotta C 529, ht 20.3 cm.

herself, covering her arms completely, and adds a sun-hat (Terracotta
c 263, c 312). Men and boys did not protect themselves from the sun so
rigorously: a boy dressed for travel wears boots, a cloak (chlamys), and a
cap (1906.10–19.1). The boy has been given the proportions appropriate
to his age, and the old were also portrayed with equal realism. Types like
the old nurse (1911.4–16.1) would not be out of place in the newly
fashionable domestic comedies. The influence of Praxiteles may be seen
in the sweet expressions on the women's faces; that of Lysippos in the
reduced size of the head in relation to the body.

Myrina in Asia Minor has been a particularly prolific source of terra-
cottas. Like other centres it produced statuettes of Tanagra type until
about 200 BC, but in the later Hellenistic period it gradually developed
its own distinctive types and style. Figures of Eros and Victory were
frequent, and some statuettes bear the maker's signature. In the later
second century groups of figures appear: two women seated on a couch        118
are usually interpreted as a matron advising a young bride (Terracotta
c 529). Towards the end of the Hellenistic period the style becomes
coarser and signatures more common. A statuette of Victory (Terracotta
c 533) made in the first century BC is still recognisably Hellenistic in taste,
but an Aphrodite (1906.3–10.1), made about AD 20 and signed by
Meno(philos), shows a harsher modelling and a more conventional style
of drapery.

## Bronze and Ivory

A large bronze mirror with silver inlay, found at Locri in southern Italy,
continues the decorative tradition long established there of placing an
open-work relief between the disk and the handle (Bronze 303). The figures
probably represent Aphrodite and Adonis.

Miniature copies of well-known statues were produced both in terracotta
and in bronze. A bronze statuette of Aphrodite is perhaps derived from        119
a statue by the fourth-century sculptor Praxiteles showing a woman
putting on a necklace (Bronze 1084). With the Aphrodite of Cnidus
Praxiteles introduced the life-sized female nude into Greek sculpture and
inspired several versions of the type during the Hellenistic period. The
influence of another fourth-century sculptor, Lysippos, may be seen in
the attention to anatomical detail and the proportionately small head of a
statuette of Hermes (Bronze 1195).

In portraiture realism might be tempered by political propaganda,
the features and leonine hairstyle of Alexander the Great being frequently
adopted in official portraits of his successors, leaving the actual identity
in doubt. A portrait-statuette of a Hellenistic ruler (Bronze 799), typically        120
represented in heroic nudity, bears some resemblance to Alexander, as
does a larger statuette of a hunter made some 200 years after Alexander's
death (Bronze 1453).

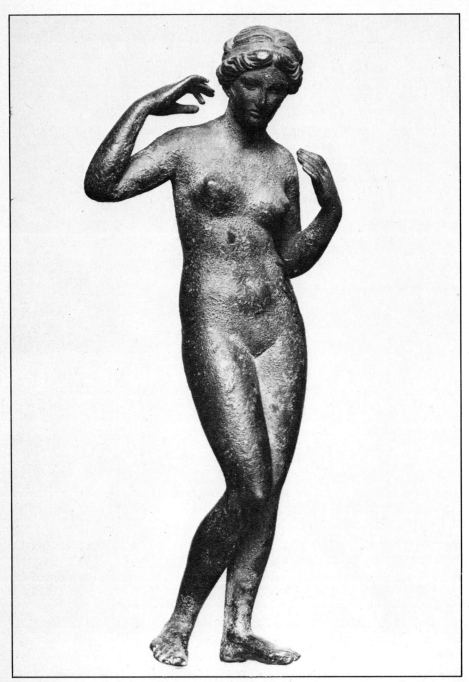

**119** Statuette of Aphrodite adorning herself. Third-second century BC. Bronze 1084, ht 26 cm.
**120** Huntsman about to plunge a spear into his quarry. *c.*100 BC. Bronze 1453, ht 47.5 cm.

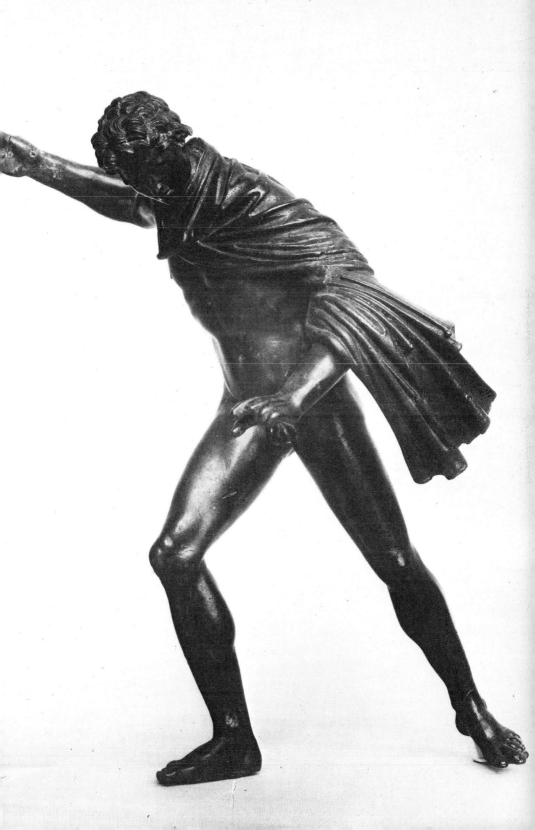

In other respects realism was given a freer rein. A scent-bottle in the
122     form of the head of a young African woman is so precisely observed and
so accurately modelled that she may be plausibly identified as a member of
a particular north-eastern tribe (1955.10–8.1). Hellenistic taste even
encouraged the realistic portrayal of deformities. A dancing dwarf from
Damanhur in Egypt, a typically grotesque figure, was perhaps made in
121     Alexandria (1926.4–15.32). An ivory statuette from the Towneley
Collection portrays a hunchback in such detail that it is possible to diagnose
his condition as Pott's disease (1814.7–4.277).

**121, 122** *Left*: an ivory hunchback. First century BC. 1814.7–4.277. *Right*: bronze
scent-bottle, *c.*100 BC. 1955.10–8.1

## Vases

As the red-figure technique declined and finally died out, the great days
of Greek vase-painting were over. Pottery was still of course needed for
everyday use, and other decorative techniques came into fashion. The
technique of painting in ceramic colours on a black background lingered
for a while, but it was eventually superseded by decoration in a wider
range of colours that were added to the vase after firing, sometimes on
a ground of whitewash. The whitewash tends to flake off, and little
remains of the painted wreaths on an urn from Athens, which has on the
shoulder gilded foreparts of lion-griffins sculptured in the round
(Terracotta C 12).

The white-ground technique was practised also in Alexandria, especially
for cinerary urns, since the friable surface was unsuitable for daily use.

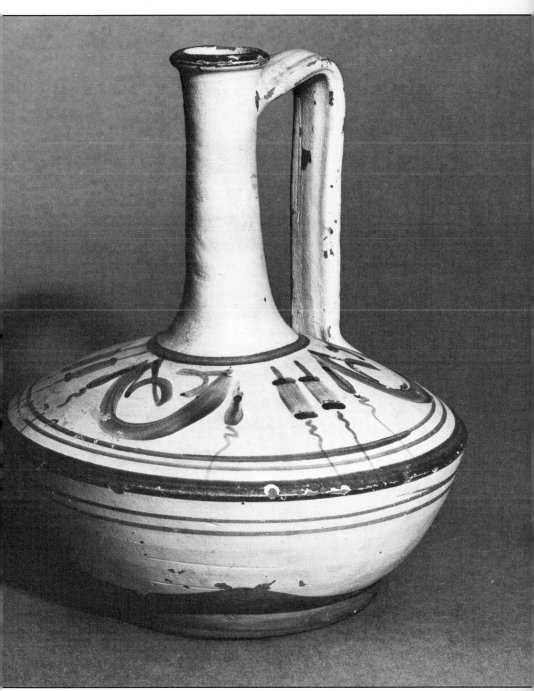

**123** Narrow-necked flagon *(lagynos),* decorated with garlands. 230–180 BC. Vase F515, ht 20.1 cm.

An ancient cemetery in the modern Alexandrian suburb of Hadra has yielded them in large numbers and has given its name to the ware. Other Hadra vases have decoration in dark glaze against the light background of the fired clay. These sometimes include scenes in a late survival of the black-figure technique, but they are more frequently restricted to simple floral and geometric patternwork (1927.3–17.5). The latter technique was used also on flagons of a newly fashionable shape, the so-called Lagynoi. These have a wide but shallow body and a tall, almost cylindrical neck (Vase F 515).

123

    With the decline of painted decoration relief work became more popular. Small reliefs were sometimes separately moulded and applied to the vase before firing, but in many places hemispherical bowls were formed in moulds into which the design had already been impressed. The floral patterns on many examples resemble those of contemporary metalwork. Mythological scenes are rarer: the exhibited example shows a group of Herakles and Auge alternating four times with a figure of Pan (Vase G 103).

**124** Faience jug with Queen Arsinoe III at an altar. *c.*210 BC. Pottery K 76, ht 29.2 cm.

125 Glass bowl decorated with gold leaf. 220–200 BC. 1871.5–18.2, diameter 19.3 cm.

## Faience

Faience is the term conventionally used for a glazed material that was manufactured in Egypt. It is not in fact a type of pottery, since its raw material is quartz sand rather than clay. Natron, a compound of sodium carbonate and sodium bicarbonate that occurs naturally in the desert, was used as a binding agent, together with a mineral pigment for colouring.

A jug (Pottery K 76), coloured blue with copper, has in relief a represen-    124
tation of Arsinoe III, sister and Queen of Ptolemy IV Philopator (221–204 BC). Hellenistic rulers often received divine honours during their lifetime, and jugs like this may have been connected with the cult.

The same material was used with a different pigment for a jug in the form of a duck with a small Eros seated on the neck (Pottery K 1). Although found in Tanagra it was probably made in Egypt about 200 BC.

## Glass

Another industry established at Alexandria was glassmaking, and a bowl of gold sandwich-glass was almost certainly made there although it was found at Canosa in southern Italy (1871.5–18.2). It consists of two thin    125
bowls of glass, carefully ground and polished to fit snugly one inside the other. A complex floral design of gold leaf was placed on the outside of the inner bowl, and with the outer bowl in position heat was applied to fuse the two bowls together at the lip.

A shallow bowl found in the same tomb has a row of raised bosses around the outside and a wheel-cut design of leaves radiating from a central rosette underneath (1871.5–18.7). This bowl was first cast in a mould and then ground to shape, cut and polished.

Another glass-making technique, that of millefiori ('thousand-flower') or mosaic glass, was invented in Mesopotamia, practised also in Egypt, and probably introduced to the Hellenistic world by Alexandrian craftsmen. Rods of glass with coloured spirals or other patterns running through them were cut into sections, and these were placed side by side on an upturned convex mould. With an outer casing in place, heat was applied to fuse the glass into a single piece, which on cooling was ground and polished to its final shape. This technique was in use from before 300 BC and continued into Roman times. The examples exhibited in Case 3 date from the first century BC (s 87 and 1849.11–21.1).

## Jewellery

Alexander the Great's conquest of the east brought vast quantities of booty to the Greek world, so that for about a century there was a fairly plentiful supply of gold for the manufacture of jewellery. The skill of the goldsmith in the Hellenistic period is in no way inferior to that of his predecessors, but changes of fashion added new forms and new techniques to his repertory.

Diadems were no longer made solely for funerary use but were strong enough to be worn by the living. An example from Santa Eufemia (Jewellery 2113; Case 4, no. 16) employs traditional techniques: embossed decoration in low relief, and filigree for a complex floral design. Another (Jewellery 1607; Case 4, no. 17), which is said to be from Melos, is decorated in the traditional techniques of filigree and enamel but includes in its design a newly introduced motif, the 'knot of Herakles' (reef knot). On either side are twisted ribbons of gold; similar ribbons could be turned into bracelets (Jewellery 1991–2; Case 4, no. 18). The knot of Herakles from another diadem (Jewellery 1608; Case 5, no. 7) employs a striking new technique that remained popular into Roman times: the addition of colour by inlaying glass or semi-precious stones, in this case garnets.

126

126 Gold diadem with a 'knot of Herakles'. The decoration includes an inset garnet and filigree scale-pattern with green and blue enamel. Jewellery 1607, length of central section 4.2 cm.

Earrings of the disk-and-pendant type remained fashionable. The pendants still include inverted pyramids or cones with filigree decoration, but the design tends to be more elaborate, with tiny figures of women (Jewellery 1670–1; Case 5, no. 9), Nike (1672–3; Case 5, no. 11) or Eros as subsidiary pendants. Slightly larger figures may replace the pyramids altogether. Eros is particularly popular, no longer represented as the adolescent boy of the Classical period but as a rather chubby infant (Jewellery 1872 and 1876; Case 4, nos. 4 and 6). Amphoras also serve as pendants, sometimes constructed in part of coloured stones and glass; one pair is joined with a plaited gold chain (Jewellery 2331; Case 5, no. 22).

127

A new type of earring consists of a tapering hoop, often ending in the head of an animal. At first these are usually made entirely of gold, and lion-head finials are especially frequent (Jewellery 1774–5; Case 5, no. 2). Later they remained popular only in areas like Syria and Egypt; the heads are often now of dolphins (Jewellery 2426–7; Case 5, no. 19), and the bodies could be made of stone or glass.

A new type of necklace consists of a woven strap of gold wire with a row of spear-heads or jars suspended from it (Jewellery 1947; Case 4, no. 26). Finger-rings often have stones fixed on the bezels, either left plain (Case 5, nos. 12–15) or engraved for use as seals (Case 4; nos 12–15 and 31–34); massive rings with oval stones were particularly fashionable in early Hellenistic times when gold was fairly plentiful. A rare and splendid item is a sceptre from Taranto that has a Corinthian capital surmounted by a sphere of green glass in a cup of acanthus leaves (Jewellery 2070; Case 5, no. 16).

127 Gold earring. The pendants, which hang from a disc with filigree rosettes and scrollwork, include a woman, two dolls, and a pair of Erotes. c.300 BC. Jewellery 1670, ht 6.1 cm.

138

143

◁ Room 13

129

135  136

128                    130/131          142          Room 15 ▷

Frontispiece →

137

132/133                                                      141

134          140      139              144

# Room 14
# First Roman Room

Around 500 BC Rome was a small but independent republic in control of the Tiber valley; five centuries later she was mistress of the Mediterranean and most of the lands around it. The battle of Actium in 31 BC was a turning point. When Julius Caesar's great-nephew and adopted heir Octavian defeated the combined forces of Cleopatra VII and Mark Antony, he not only broke the power of the last of the Hellenistic dynasties and brought Egypt under Roman rule, he also put an end to a series of civil wars that had wracked Rome for a century and made himself the undisputed master of the Roman world.

This mastery, theoretically at variance with the republican constitution, was in part disguised by Octavian's tenure of traditional magistracies. The name 'Augustus', conferred on him by the Senate in 27 BC, confirmed his pre-eminence and, as seen in retrospect, defined his position as the first of the Roman Emperors. His successors during the following three centuries were of varied calibre. Many were men of great military and administrative ability; some were even men of learning and culture; others were little more than ambitious ruffians, whose talents sufficed only to attain Imperial rank, not to discharge its responsibilities.

Frontier defence was an almost constant problem, but within the Empire peace was secured. This *Pax Romana* provided the opportunity for economic development and for the progressive Romanization of the provinces. It also provided a background of public order and the freedom of movement that allowed the rapid spread, in spite of intermittent persecution, of the Christian faith.

The Roman genius found its expression in administration and law, in engineering and warfare, rather than in literature and art. It was in the latter areas that 'Captive Greece led its captor captive'. Most of the artists of the Roman world were actually Greeks or orientals trained in the artistic traditions of the Hellenistic period. The Roman contribution to art was principally as patrons, and art is only truly Roman when conditioned by their distinctive and austere taste. This is naturally most evident in Rome itself. In the eastern provinces of the Empire the Hellenistic spirit remained strong. In other provinces that were never part of the Hellenistic kingdoms, local styles expressing local tastes may be observed.

### Glass

Towards the end of the first century BC the technique of glass-blowing
was invented, probably by Phoenician craftsmen working on the coast of
Syria. This revolutionary new technique soon spread to other parts of the
Roman world, and was eventually to dominate and transform the entire
industry. During the second and third centuries AD it made possible an
enormous increase in production, so that glass became an everyday
product instead of the luxury that it had been in the Hellenistic period
and the early years of the Roman Empire.

Among the finest glass vessels to have survived from Roman times
is the Portland Vase, so called because it was acquired by the Dowager
Duchess of Portland in 1784 and remained the property of her family
until 1945 (Gem 4036). The vase was made in two main stages. First it was
blown to shape, with an opaque white layer over the translucent cobalt-
blue body. Then, after the handles had been applied, the outer layer was
partly cut away like a cameo to leave a frieze of white figures against the
blue background.

Among many different interpretations of the scene, the most likely

128

128 'The Portland Vase'
with scenes from the
story of Peleus and
Thetis carved from blue
and white cameo-glass.
c. AD 30. Gem 4036,
ht 24.8 cm.

seems to be the story of Peleus and Thetis. On one side is Peleus, guided by Eros and encouraged by two sea-divinities (the parents or grandparents of Thetis); on the other side, Thetis herself is falling asleep on a rock by the sea-shore, flanked by Hermes in his capacity as a marriage-god and by Aphrodite, the goddess of love. Although each composition is balanced and complete, the two scenes are linked both by the subject-matter and by the far-off gaze of the figures at either end: Peleus seeking his bride in the distance, and Aphrodite observing the bridegroom's approach.

The lower part of the vase is missing. A disk of cameo-glass that was formerly fitted underneath is now exhibited separately.

During the first century AD glass was still often coloured and worked in a variety of techniques. A boat of blue glass (1869.6–24.20) was cast in a mould and brought to its final shape by grinding and polishing. Glass-blowing was practised, both with and without moulds. An amber-coloured jug decorated with white blobs (s85) is an example of free-blowing; the blobs were applied individually and embedded by rolling on a smooth surface (marvering) before the final shaping. A conical jug 129 blown from clear glass has a carved ring-handle and surface decoration of

129 Glass jug. The conical body was shaped by the glass blower and the hexagonal facets were cut after the glass had cooled. First century AD. WT 1203, ht 12.2 cm.

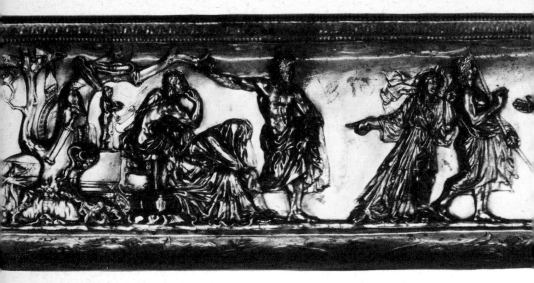

cut hexagonal facets (WT 1203). Similarly decorated vases have been found at Pompeii, showing that this technique was already in use by AD 79, when Pompeii was buried by the eruption of Vesuvius.

Mould-blown vessels include a beaker with six rows of almond-shaped knobs (1913.5–22.18) and another of bluish-green glass with four figures that may be identified as Mercury, a personification of Winter, Hercules, and Hymen or another Season (1878.10–20.1). An unusual beaker has a cobalt-blue liner blown into a silver case with rows of oval openings, through which the glass bulges out (1870.9–1.2).

In the second and third centuries, most glass was blown and colours were almost abandoned. An innovation was the decoration of the surface of blown vessels with threads of coloured glass applied when still hot and pliable. This 'snake-thread' technique was used in both eastern and western parts of the empire. A small jug with blue and yellow threads from Urdingen (1868.1–5.49) and a similarly decorated flask found at Cologne (S 257) are both typical products of the Cologne factories. Also from Cologne is a very rare vessel in the form of a gladiator's helmet with a bird in thread decoration on each side (1881.6–24.2).

### Silver and Gold
Silver was scarce in Rome before the second century BC, but in late Republican and Imperial times the possession of a set of silver vessels, for use at the table or purely for display, was for the Romans a necessary sign of wealth and status. With changes of taste and fortune much of this silverware must eventually have found its way back to the melting-pot, but some splendid sets have survived, either as the result of a natural

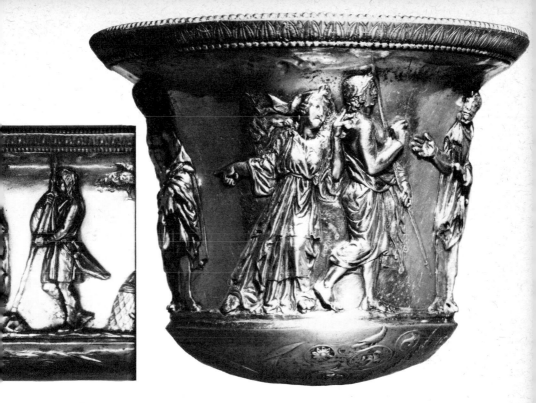

130, 131 Silver cup with Orestes and Iphigeneia among the Tauri. The figures were raised by hammering and details were added by chasing and gilding. Handles and foot were made separately and are now missing. First century BC. 1960.2–1.1, ht 9.8 cm.

disaster like the eruption of Vesuvius, or because their owners buried them in times of danger and were subsequently unable to retrieve them.

One such hoard from Arcisate in northern Italy included a jug, a ladle and a strainer (Silver 126, 128, 129), the last with holes arranged in intricate floral and geometric patterns. Comparison with other finds in various parts of the Hellenistic world suggests a date around 75 BC. These particular pieces are known to have belonged to Romans because the owners' names and the weights are inscribed in Latin on the jug and ladle.

A late republican date has also been assigned to three silver cups with relief decoration each, unfortunately, lacking the foot and handles. Two are decorated with a formal arrangement of the fruit and foliage of many different trees and plants (1960.2–1.2 and 3). The third (1960.2–1.1) has a mythological scene, perhaps derived from a lost tragedy: Iphigeneia, 130, 131 Orestes and Pylades seek sanctuary in a precinct of Apollo, while Chryseis urges her son Chryses not to surrender them to Thoas, King of the Tauri.

A small silver amphora of the first century AD has vine and ivy tendrils in relief on the handles and body (Silver 79). A plain gold vase of similar shape, the handles now missing, was found in the sea off the coast of Asia Minor (Jewellery 3168). Its weight is inscribed underneath.

A specifically Roman contribution to the silversmith's repertory is a kind of deep bowl with a straight handle, rather like a saucepan in shape. Its ancient name is unknown, and its purpose remains uncertain.

Perhaps originally a domestic utensil, the figures and scenes usually portrayed on the handle suggest that it eventually served a religious function. The goddess Felicitas (Prosperity) holding a horn of plenty appears on a second-century example (Silver 136), together with a small shrine and a woman making a sacrifice. Baskets of fruit, goats and Pan-pipes decorate the curving arms, which were soldered to the bowl.

A complete table-service of thirty-nine pieces was discovered in 1883 in a field at Chaourse in France, where, to judge by the associated coins, it had been buried some time after AD 260. The high quality of the workmanship may be appreciated in some representative pieces: a slender jug, partially gilt (Silver 147); a deep basin with a swinging handle and a band of floral ornament (Silver 48); a bowl with a flanged rim, also decorated with a floral scroll (Silver 170); and a fluted bowl with a six-pointed star in the centre (Silver 168). (Other items from the Chaourse Treasure are exhibited in the Room of Greek and Roman Life on the First Floor.)

## Fluorspar

A drinking-cup (kantharos) of fluorspar is a very rare example of a class of vessel that was rare and expensive even in antiquity (1971.4–19.1). This attractive and rather soft mineral, which the Romans called *murra* and obtained from near the Persian Gulf, is seldom found in pieces large enough to carve into such cups. It is recorded that the Emperor Nero once bought a cup made of *murra* for a million sesterces (equal to about 2500 ounces of gold).

## Pottery

The regular use of silver and glass vessels caused earthenware to be held in rather low esteem, especially in Rome itself. Coarse wares were needed everywhere for trade and other menial uses, but it was chiefly in the provinces that demand for finer wares was maintained. With the virtual disappearance of painted decoration during the Hellenistic period, pottery had now to rely for its appeal partly on other forms of decoration such as relief, and partly on shape and surface texture.

Among many different types of pottery the most characteristically Roman are the various red wares. The preference for a red finish in place of the Greek 'black glaze' developed from the second century BC onwards around the eastern Mediterranean, where there was a long indigenous tradition of red pottery.

Hellenistic mould-made bowls with relief decoration were imitated in Italy as early as the second century BC (1839.11–9.23). In the early years of the reign of Augustus, that is not long after 30 BC, the manufacture of a fine relief ware with a good red gloss finish began at Arretium near Florence. An Arretine bowl decorated in low relief with personifications of the four Seasons (Pottery L 54) is shown by a stamp to come from the

132

**132, 133** Bowl of Arretine ware with the four Seasons. The bowl has lost its tall foot; the original shape is shown in the drawing. *c.* 10 BC. Pottery L 54, height as preserved 14.2 cm.

workshop of Atei(us). The decorated part of the bowl was made in a mould, the undecorated lip was drawn up by hand, and the foot (now missing) was made separately and added before firing.

133

    Arretine ware dominated the Mediterranean market for some years, and was imitated in Italy, Asia Minor and particularly in southern Gaul. Production of Arretine relief-ware ceased about AD 30, although the manufacture of plain wares continued for a while. By about AD 50 the Gaulish wares, which were of a stouter make with a high gloss finish, had captured the market. A bowl with moulded floral decoration was made at La Graufesenque in southern Gaul (Pottery M 4). Where such decoration was not required, the entire pot was thrown by hand: a bowl with a pouring channel in the rim was so made in southern Gaul (1910.10–11.1). Another bowl, of marbled ware produced by applying a yellow slip unevenly over the red body, bears the stamp of the potter Cestus, who worked at La Graufesenque in the years around AD 50 (Pottery M 124).

    The glossy finish of these red wares was, like the Greek 'black glaze', produced by a specially prepared coating of clay (slip) applied to the pot before firing. True glazes contain other substances that cause them to melt at certain temperatures, and these are applied to pots that have already been fired once. The use of a glaze containing lead, which fuses at a fairly low temperature, was developed during the first century BC, probably in northern Syria. The technique was practised also in Egypt and Asia Minor, and spread to Italy and Gaul.

**134** Three lead-glazed vases. First century BC to first century AD. 1931.5–14.1, Pottery K 29 and K 25

134 Lead glazes are easily coloured with oxides of other metals. Copper, for example produces the rich green seen on the outside of a two-handled cup with moulded scale decoration (1931.5–14.1). The inside is yellow. Pottery with this combination of colours has been found mainly around the eastern Mediterranean and was no doubt made somewhere in that area. Probably of Italian manufacture are a cup with applied reliefs (Pottery K 29), said to have been found in southern Italy, and a pourer *(askos)* decorated with olive branches (Pottery K 25). The lead-glazed products of Gaul included small moulded bottles in the form of rabbits and other animals (Pottery K 40).

From about AD 100 a new type of red pottery, made in North Africa, begins to take over the Mediterranean market, confining the Gaulish wares to the northern provinces of the Empire. This African Red-Slip Ware usually has a rather matt surface, but sometimes has a gloss comparable to that of the Gaulish products. A characteristic jug of the later second century comes from the Towneley Collection and may well therefore have been found in Italy (1814.7–4.676). A pear-shaped jug with applied reliefs belongs to a special class that was exported less frequently (1972.9–27.1). The reliefs include a plaque with a victory slogan. This shape has already been seen in glass of the late first or early second century; in pottery it occurs in the third century and appears to have been taken over by the potters from the glassmakers.

Applied reliefs are uncommon on the Gaulish red wares. Other decorative techniques used there from the second century include incised patterns imitating the effect of cut glass (Pottery M 156), and reliefs formed freehand on the vase itself with a thick slip of rather creamy consistency, rather as icing may be piped on to a cake. This technique, sometimes called barbotine, has been used for the floral patterns of a third-century cup of east Gaulish manufacture (1920.11–18.27).

Many of the decorative techniques of red-gloss pottery were employed on other provincial wares that do not have a glossy finish, illustrating an interesting interaction of Roman styles and techniques with provincial taste. The cut-glass technique was used on Gaulish ware of the fourth century (Pottery M 155, M 158). A black-ware jug with a trailed design in white pipe-clay (Pottery M 146) is one of a class often inscribed with convivial mottoes, in this case VITA (long life). The decorative effect is not unlike that of contemporary 'snake-thread' glassware.

## Jewellery (Case 3)

Although the Greek colonists of southern Italy and the Etruscans north of Rome had plenty of jewellery, in Rome itself the wearing of jewellery was inhibited in Republican times by legal restrictions on the use of gold. It was only after Pompey's conquest of the East that gold became plentiful in Rome. The Roman goldsmiths themselves were chiefly immigrants from such centres as Alexandria and Antioch, and in their hands Roman jewellery followed the developments begun in the Hellenistic period.

Filigree and granulation played a smaller part than before in surface decoration. They are still used on a first-century bracelet with a large drinking-cup (kantharos) in relief at the clasp (Jewellery 2823; no. 4), but they yield in decorative effect to the broader expanse of smooth gold, to the openwork strips of leaves and berries, and to the inlay of green glass. Another first-century bracelet in the form of a snake (1946.7–2.2; no. 9) and a second-century necklace of gold chain with a Medusa-head medallion (Jewellery 2373; no. 5), rely for effect on sculptured detail and the gleam of the metal itself.

Coloured stones and glass had already been used extensively in the jewellery of the Hellenistic period, and they seem to have appealed strongly to Roman taste. A necklace with emeralds and amethysts in alternate settings is directly derived from Hellenistic models (Jewellery 2749; no. 6) but an earring consisting of a round cluster of small emeralds represents a new type (Jewellery 2622–3; no. 2). In both cases the emeralds are used in their natural form of six-sided crystals.

After about AD 200 coloured stones, including hard stones like sapphires, emeralds and even uncut diamonds, were used in greater profusion. Gold began to take second place to them, serving as little more than a rich setting. A hair-ornament, worn vertically over the middle of the forehead

(Jewellery 2866; no. 7), and a matching bracelet found with it near Tunis (Jewellery 2824; no. 8) are typical of the new taste. They are embellished with pearls as well as with sapphires and emeralds. The influence of this style of jewellery was to remain strong in Byzantine and medieval times.

**Cameo (Case 3)**
The art of cameo-cutting also developed in the Hellenistic period, and continued under Roman patronage. For effect it requires a stone such as sardonyx with uniform layers of contrasting colours, or a piece of glass manufactured with similar layers. The design is cut in relief, usually with a dark layer as the background. In a cameo-portrait of the Emperor Augustus (Gem 3577) a second dark layer is skilfully used to define the details of the *aegis* (the goatskin fringed with snakes and bearing the head of Medusa, normally the attribute of Athena).

136

135 Gold hair-ornament set with emeralds and pearls; a sapphire and two pearls are suspended below. Third century AD. Jewellery 2866, ht 10.8 cm.

## Sculpture

After the sack of Corinth (146 BC) and of other Greek cities, many Greek statues were brought to Rome, some to adorn public buildings, others for the collections of wealthy individuals. As the demand for sculpture outstripped the supply of original works, a flourishing trade in copies arose. Many famous sculptures described by Pliny and other ancient authors perished in later centuries and are now represented only by copies made in Roman times.

Greek artists too came to Rome, attracted by the prospect of Roman patronage. The most talented among them were employed in the further development of realistic portraiture and of sculptured reliefs that presented a continuous narrative of important contemporary events. Narrative friezes had been carved in the Hellenistic period, but they illustrated mythological subjects. Roman taste for realism and the demands of Imperial

136 Cameo-portrait of the Emperor Augustus (27 BC–AD 14) carved in sardonyx. The diadem is a medieval addition. Gem 3577, ht 12.8 cm.

propaganda encouraged the sculptors to turn from mythology to history. Realism was further served by the addition of topographical detail and the use, albeit halting, of linear perspective. The most impressive surviving example is the frieze showing episodes from the Dacian Wars that runs in a spiral up the outside of Trajan's Column in Rome.

### Small-scale Sculpture

Sculpture on the grand scale was always expensive and there was a continuing demand for smaller works of art. Small statuettes, being both cheaper than large sculptures and more portable, have been found in many parts of the Roman Empire. In subject matter and stylistic development they sometimes follow the same trends as larger works, and sometimes reflect local needs and provincial taste.

Portraits of famous men of the past were always popular, often at life size but sometimes in miniature. A marble statuette of Socrates, said to have been found at Alexandria, was probably made in the second century AD but reflects a posthumous imaginary portrait created in the Hellenistic period (1925.11–18.1). A small bronze bust with inlaid eyes of silver and garnet portrays a Roman of the later second century (Bronze 834).

Interest was maintained in the representation of various ethnic types and of the deformed. A statuette of a dwarf from the collection of R. Payne Knight recalls similar works of the Hellenistic period (RPK xxxi.2). The elegant figure of an African youth that formed part of a domestic utensil, perhaps a candelabrum, shows how the modern distinction between fine and applied art was as alien to the Romans as it had been to the Greeks (1908.5–15.1). The illustration of contemporary events in narrative friezes probably influenced the production of such figures as a Gaulish prisoner (1913.4–16.1) and a Roman trooper (Bronze 821). The latter's uniform of chain mail, knee-length leather breeches and military sandals *(caligae)* is frequently to be seen on Trajan's Column.

The sculptural types of the various Greek gods were fully developed by the first century BC, and the Romans were content to make use of them, often with little variation. For Jupiter they adopted the Greek types of Zeus: a dignified, bearded figure, standing nude with one hand raised to grip a sceptre, the other holding a thunderbolt (1913.10–21.1 and Bronze 275), or half-draped and seated with the same attributes, which are now sometimes missing. A bust of Zeus-Serapis, whose cult began at Alexandria in Ptolemaic times, is perhaps derived from the original statue by Bryaxis (1970.2–16.1). Mercury takes over the type of Hermes, wearing the travelling costume appropriate to the messenger of the gods; to give him a purse as the god of trade is a Roman innovation (Bronze 825).

Such statuettes were made not only in bronze but also in silver. Several were included in a vast hoard that was found at Mâcon in France in 1764. On the evidence of the coins the hoard may be dated about AD 260. In

137

137 Bronze bust of Zeus-Serapis. First century AD. 1970.2–16.1, ht 19 cm.

addition to the standard types of Jupiter (Silver 27 and 35) and Mercury (Silver 29–32) there were others invented to satisfy the needs of Roman religion. A youth with a horn of plenty and a crown representing city walls is perhaps the patron spirit or *genius* of the city (Silver 34). A more elaborate figure (Silver 33) seems to be a personification of Tyche (Good Fortune). She too has a mural crown as well as two horns of plenty with busts of Apollo and Diana; above her are busts of Castor and Pollux, and of the seven patron deities of the days of the week.

Terracotta statuettes continued to be manufactured in various parts of the Empire. A statuette of Venus, found at Thapsus near Carthage and probably made locally, wears a great deal of jewellery, including on her necklace the *bulla* that the Romans had taken over from the Etruscans (Terracotta c 681). A group of a mother and child signed by Leonteus was made in Athens around AD 300 (1905.6–9.2). Of similar date is a charming figure of a little girl from Trapezus (Trabzon) on the Black Sea. She holds a pet bird and a bunch of grapes (1907.12–16.2).

138 Statuette of Tyche with busts of Apollo and Diana; Castor and Pollux; and Saturn, Sol, Luna, Mars, Mercury, Jupiter and Venus. Third century AD. Silver 33, ht 14 cm.

139 Wall-painting from a villa near Pompeii; the Death of Icarus. The rules of linear perspective were not fully understood in Roman times. Before AD 79. Painting 28, ht 35.5 cm.

### Painting and Mosaic

Wall-paintings and mosaic floors were extensively used as early as the Hellenistic period to decorate the houses of the wealthy. Roman taste in wall-painting favoured complex architectural schemes of increasingly fanciful design, often interspersed with scenes drawn from mythology or daily life. Some examples have survived in Rome itself, but many more have been preserved in the elegantly decorated houses of Pompeii and its neighbourhood, which were buried under volcanic debris from the eruption of Vesuvius in AD 79.

One of a pair of paintings from a house in Pompeii shows Ulysses tied to the mast of his ship as his men row past the rocky and skeleton-strewn coast of the Sirens (Painting 27); the other shows Icarus falling headlong into the sea after flying too close to the sun, while Daedalus his father flies safely at a lower altitude (Painting 28). In both pictures the horizon is set at the top of the panel. This allows the artist to depict more distant objects as if they were above those in the foreground and leaves room for

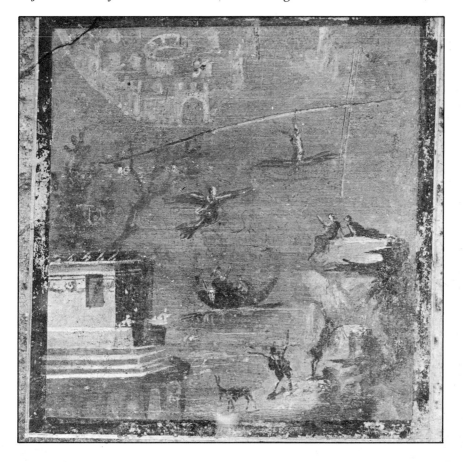

139

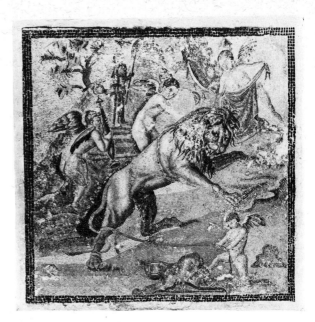

**140** Mosaic with four
Cupids harassing a lion;
one has roped the lion's
right hind leg, another
waves a cloth to distract
it. First century BC.
Mosaic 1, ht 37.2 cm.

many topographical features: rocks, trees and, in the background of
the Death of Icarus, a walled city with an amphitheatre.

Greek artists had already used the 'bird's eye view' to represent more
distant subjects, but they had concentrated on human figures to the
almost complete exclusion of topographical detail. This interest in
landscape, to be seen also in narrative friezes, is characteristic of the Roman
taste for factual detail. It finds further expression in scenes of town,
country and seashore that must have been painted for their own sake
since they are lacking in mythological content.

Two such scenes come from a villa near the modern village of Boscoreale,
not far from Pompeii (Paintings 19 and 20). In the foreground a building
is seen from an oblique angle, but the principles of linear perspective are
not yet fully understood: there is no single vanishing-point. The diminution
in scale of the buildings in the background is an innovation, as is the use
of pale and shadowy tones to give an impression of the intervening
atmosphere and so to enhance the effect of distance.

Roman tombs were often modelled on the houses of the living and
similarly decorated with wall-paintings. A painting of a Bacchanalian
revel, found in a tomb in Rome, was evidently sketched quite rapidly in
red outline before flat washes of colour were added (Painting 24).
Bacchanalian subjects were popular in Roman funerary art as allegorical
representations of a happy after-life.

The earliest mosaic floors were composed of natural pebbles, but these
gave an uneven surface and were superseded as early as the third century

BC by flat-faced tesserae, small pieces of coloured stone cut especially for mosaic work. A small mosaic showing a lion beset by four Cupids, being composed of very small tesserae, is very like a painting in appearance (Mosaic 1). Such small pictures could be placed in the centre of a room, rather like a rug with a plain surround, but an overall, carpet-like scheme proved more acceptable to Roman taste. Floor mosaics have been found in most parts of the Roman world, and the north African provinces have been particularly prolific sources. From Carthage comes a mosaic head of a sea-god, perhaps Oceanus (Mosaic 15). Its tesserae are of the normal size for mosaic floors.

## Copies of Greek Sculpture
A winged bronze head of a youth (Bronze 267) is copied from the same original as a marble statue in the Prado Museum, Madrid, recognized as Hypnos, the personification of Sleep, from a description by the Roman poet Statius. The original was perhaps made as early as the fourth century BC, but the sculptor's name is not known.

141 Winged head representing Hypnos (Sleep). A copy made in Roman times of an earlier Greek original. Bronze 267, ht 21 cm.

The statue of Apollo that was excavated by Smith and Porcher in the temple of Apollo at Cyrene is one of a dozen surviving copies made in Roman times of a Hellenistic original, attributed to the second-century Athenian sculptor Timarchidas (Sculpture 1380).

## Portraits
The development of realistic portraiture during the Hellenistic period coincided with an increasing Roman exposure to Greek art. The Romans were predisposed to an interest in portraiture by the aristocratic tradition of displaying masks of ancestors in funeral processions, and this fortunate combination of circumstances led naturally to the highly realistic portraits of the late Republic.

A relief with two portrait heads in circular recesses was commissioned by two liberated slaves in memory of their late owners, Antistius Sarculo

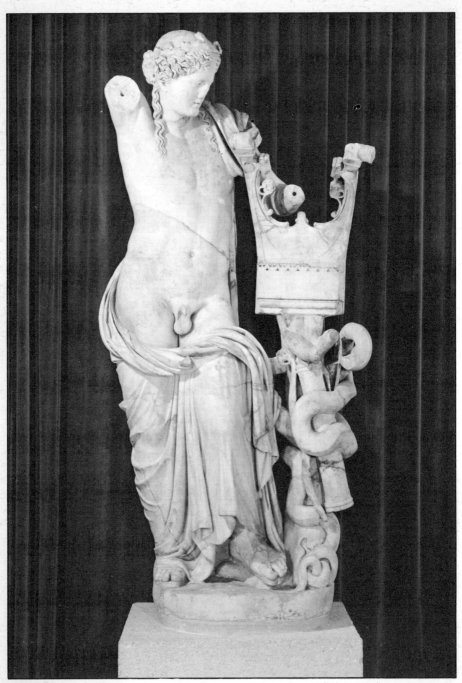

**142** Marble statue of Apollo from Cyrene. A Roman copy of a Hellenistic original. Sculpture 1380, ht 2.29 m.

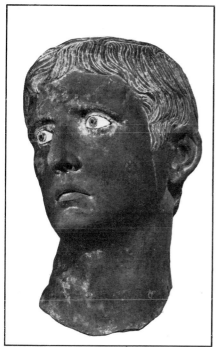
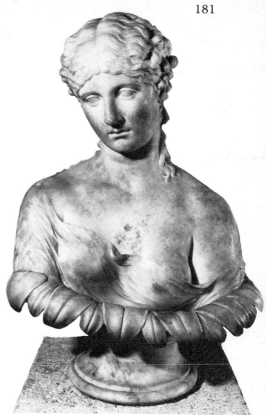

**143, 144** *Left*: bronze portrait of Augustus (1911.9–1.1, ht 47.1 cm.); *right*: marble portrait, perhaps of Antonia (Sculpture 1874, ht 68.5 cm.)

and Antistia Plutia (Sculpture 2275). As in many late Republican portraits the subjects are represented late in life, their age uncompromisingly revealed by the wrinkles of face and neck, their strength of character indicated by a proud and determined expression.

This rather severe and linear style, so typical of native Roman taste, is very different from the idealistic treatment evident in a bronze head of the Emperor Augustus (1911.9–11.1). This was found at Meroe in the Sudan, the ancient capital of Ethiopia, and was probably broken from a portrait-statue seized as booty when the forces of Queen Candace of Ethiopia captured Syene (the modern Aswan) in 24 BC. The whites of the eyes are inlaid with marble, the irises with glass. 143

A marble portrait of a woman, once the prized possession of Charles Towneley, exhibits the same idealising style (Sculpture 1874). Towneley identified her as the goddess Isis or as Clytie, a nymph who pined away for love of the sun-god Helios and was turned into a flower. The petals around the base, however, occur on other portrait-busts and have no mythological significance. Her true identity is uncertain, but she may be Antonia, the daughter of Mark Antony and mother of the Emperor Claudius. 144

Later Roman portraits are exhibited in the Second Roman Room (Room 15).

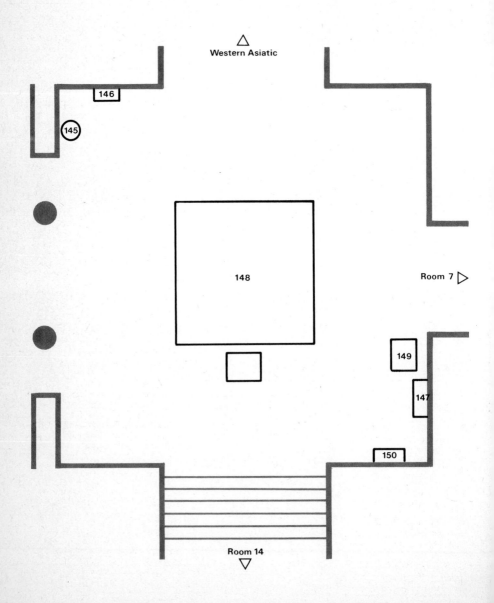

Western Asiatic

146

145

148

Room 7

149

147

150

Room 14

# Room 15
# Second Roman Room

## Portraits

In a portrait-bust of Trajan, Emperor from AD 98 to 117, something of the 145
severity of the Republican portrait style re-emerges, especially in the
expression and the linear treatment of the hair (Sculpture 1893). The bust
is now extended to include the shoulders and most of the chest. Trajan's
cultured successor Hadrian (117–138) preferred an idealistic style,
modelled on that of classical Athens, both in portraiture and in decorative
sculpture.

A bust from Cyrene portrays Antoninus Pius (138–161) in breastplate
and military cloak (paludamentum), and wearing the full beard that
Hadrian had brought back into fashion (Sculpture 1463). The striking
contrast between the highly polished surface of the flesh and the rougher
finish of the elaborately cut hair and beard may also be observed in the
portrait of an unknown private citizen of this period (Sculpture 1949). 146
In spirit the two portraits are very different. While the Emperor's is an
official portrait, which emphasizes his Imperial dignity and power but is

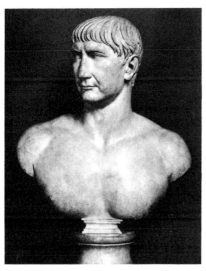 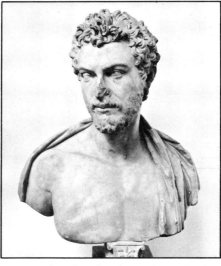

**145, 146** Two marble portraits: of Trajan (AD 98–117), and, *right*, of an unknown man
(c.AD 140–200). Sculptures 1893, 1949

only one copy of many distributed throughout the Empire, the sculptor of the other has worked from life: he knows his subject, and with such slight means as a raised eyebrow and a rather sardonic smile has managed to capture the personality of an intelligent and thoughtful individual.

A woman, whose portrait-statue was excavated at Cyrene, wore her hair in plaits coiled on top of her head, imitating the hairstyle favoured by Faustina, the wife of Antoninus Pius. The head is a true portrait, but the body is of a standard type that was already current in Trajan's time (Sculpture 1415).

### Decorative Reliefs

Although under Roman patronage striking innovations were made in relief sculpture illustrating contemporary events, purely decorative reliefs were more often copied, or at least derived, from works of earlier periods. Many of these reliefs were produced by Athenian sculptors, identified as such by their signatures and nowadays conveniently called 'neo-Attic' to distinguish them from their classical predecessors. On a fragmentary relief of a warrior standing before a tall shaft surmounted by an urn, the archaic style is deliberately imitated in the formally stacked folds of the drapery, but their curving outline is a mannerism typical of neo-Attic work (1905.10–23.1). The Bacchanalian relief with a maenad and two satyrs accompanied by the panther of Dionysos was perhaps carved around AD 100 or even a little later, but the figures themselves are derived from works of the fourth century BC (Sculpture 2193).

A relief showing the slaughter of Niobe's children by Apollo and Artemis (Sculpture 2200) includes several figures that recur elsewhere and are ultimately derived from a work of the fifth century BC, perhaps the frieze with this subject sculptured by Pheidias on the throne of his statue of Zeus at Olympia. In adapting the frieze to a circular frame the later sculptor has broken up the groundline and has added other figures from a Hellenistic illustration of the myth.

147    An attempt to imitate fifth-century sculpture may be seen in the relief of a youth restraining a horse (Sculpture 2206). This relief was found in the villa near Tivoli (the ancient Tibur) built by the Emperor Hadrian, and reflects his marked preference for the classical Greek style.

### Copies of Greek Sculpture

A marble statue of Apollo is one of several surviving copies of a work that was evidently much admired in antiquity (Sculpture 209). The severe frontality of the archaic *kouros* has been modified in various ways, including a twist of head and hips to the right and a slight bend in the left knee. The original was probably of bronze, lacking the tree stump that was added by the copyist to give greater strength and stability to the marble version.

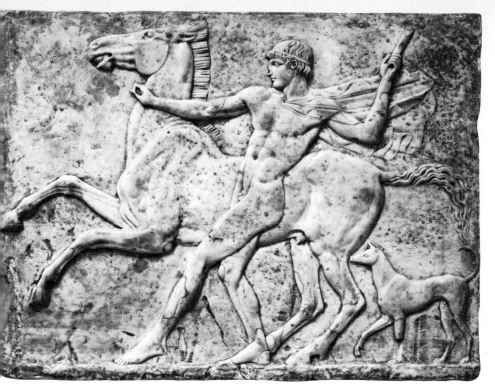

147 Marble relief of a youth and a horse. c.AD 125. Sculpture 2206, ht 75 cm.

Also derived from a bronze original is the marble statue of a young athlete binding a victor's fillet around his head (Sculpture 501). The original is likely to have been made about 440 BC.

Roman copies of works by the Argive sculptor Polykleitos have been recognized from descriptions in ancient literature. Stylistically related, especially in the treatment of anatomy and the curly but closely cropped hair, is the Westmacott Athlete, so called after its former owner (Sculpture 1754). It is perhaps a copy of the bronze statue of Kyniskos, attributed to Polykleitos, which Pausanias saw at Olympia. Although the statue itself is lost, the inscribed base survives, and the cuttings on its top show that the position of the feet of the two statues was similar. 149

The statue of Aphrodite crouching for her bath is one of many surviving versions of an evidently popular type that probably originated in the third century BC (1963.10–29.1). It has been attributed to Doidalses of Bithynia. This copy is known as 'Lely's Venus' since it once belonged to the painter Sir Peter Lely. Acquired for the Royal Collection by Charles II, it has been graciously lent to the British Museum by Her Majesty The Queen. 148

## Mosaic

The Mosaic, which is exhibited under water to bring out the colours of the tesserae, was found in 1912 at St-Romain-en-Gal in southern France (Mosaic 7). It is a good example of the overall design that was as popular in the provinces as at Rome itself. Five square panels are set into an interlocking design of cable-pattern and strips of triangles. The central panel shows

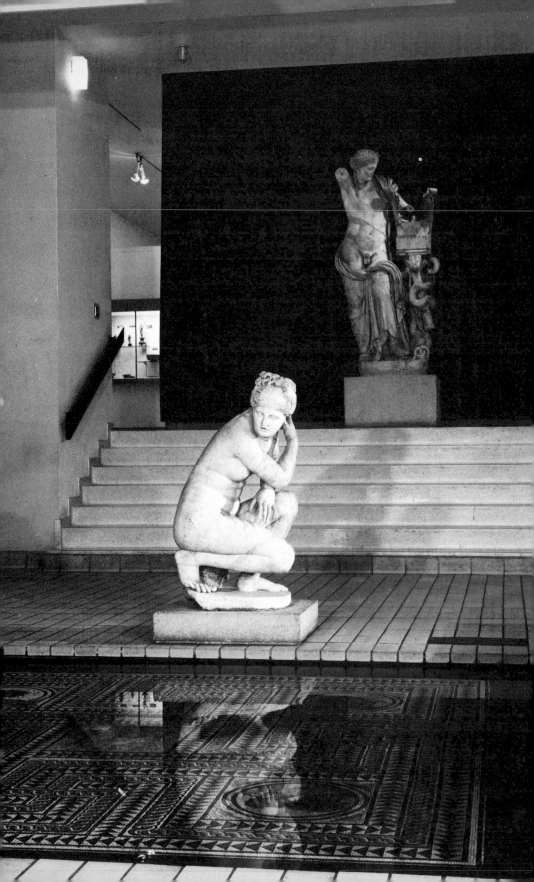

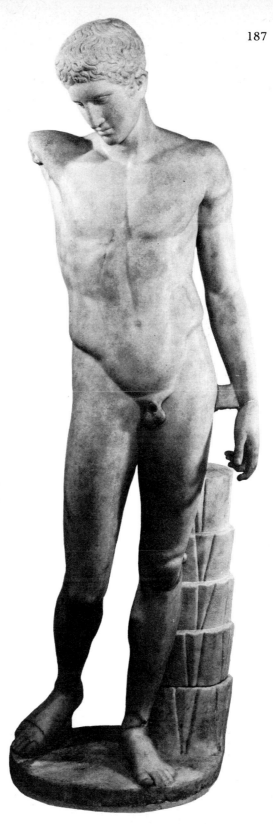

148 View of the Second Roman
Room including the Crouching
Aphrodite (1963.10–29.1) and the
Apollo of Cyrene (Sculpture 1380,
see *Ill*. 142)

149 The 'Westmacott Athlete', a
marble copy of Roman date of a
Greek work of about 440 BC,
perhaps the Kyniskos by
Polykleitos. Many lost Greek
originals are known only from
Roman copies and literary
references. Sculpture 1754,
ht 1.5 m.

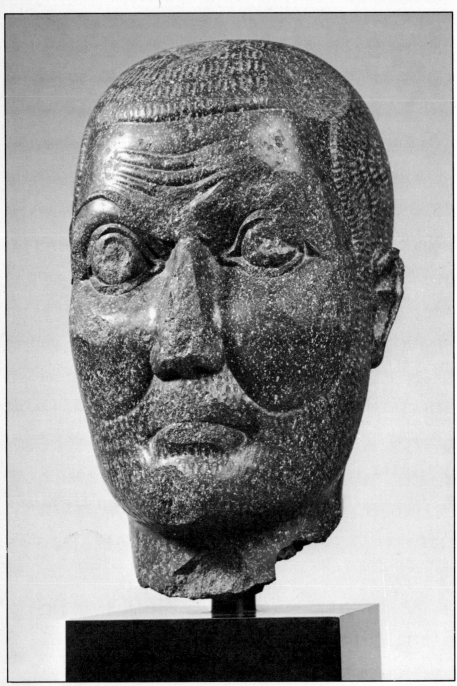

150 Porphyry portrait-head of a Tetrarch, perhaps Constantius I (AD 296–306). 1974.12–13.1, ht 43 cm.

Silvanus, a Roman rustic deity, and his dog; the others have birds in each corner around circular medallions with Bacchic subjects: Pan in one and an elderly satyr in another, each accompanied by a maenad; a younger satyr in the third medallion; and Bacchus himself in the fourth.

### The End of Roman Art

The Emperor Diocletian (284–305) attempted to reform the administration of the Empire by dividing it into four parts, two ruled by emperors with the title of Augustus, two by heirs-presumptive called Caesars. The ensuing period, known as the Tetrarchy, saw the rise of new local schools of art and new provincial styles.

A porphyry head from a statue of a Tetrarch, perhaps Constantius I (296–306), is characteristic of the new style of portraiture. The fashion for closely-cropped hair and beard, represented simply by light incisions, had been introduced by military emperors earlier in the third century. What is new is the extreme stylization of the features: the large, staring eyes, emphasized by strongly arching eyebrows, now dominate the rest of the face. The effect is powerful, but it is no longer realistic.

150

This new artistic movement maintained its momentum after the empire was reunited by Constantine. When in AD 330 he transferred the seat of government to Byzantium, renaming it Constantinople, the city of Constantine, he marked the end of Rome's political and military domination of the empire. The deliberate abandonment of naturalism had already marked the end of realistic portraiture and indeed of the Classical phase of Roman Art. The future of art, as of political power, lay in Byzantium.

# The Upper Galleries

The remaining galleries of Greek and Roman Antiquities are on the first floor of the Museum. On the right near the head of the main staircase is an exhibition of bronzes and terracottas from the Geometric to the Roman period. This leads to the Room of Daily Life, which has cases devoted to various aspects of life in the ancient world, including warfare, transport, agriculture, writing, music, the theatre and children's toys. The Roman silver in the wall-cases includes items from the Mâcon and Chaourse Treasures (in part exhibited in Room 14), while the rest of the Aegina Treasure, of which part is shown in Room 2, can be seen with other jewellery on the balcony. Below the balcony are eight cases of Greek and Roman glass. A corridor with cases illustrating various mythological subjects leads to a small exhibition of antiquities from Cyprus and to the reserve collection of Greek and Etruscan vases.

# Greek Vase Shapes

## Storage jars

Amphora

Neck-amphora

Pelike

Stamnos

## Water-jars

Hydria

Hydria

## Bowls for mixing wine and water

Volute-krater

Bell-krater

Dinos

## Jugs

Oinochoe

Olpe (Attic)

Olpe (Corinthian)

## Some Mycenaean vases

Alabastron                    Krater                    Goblet

## Perfume bottles

Aryballos (Protocorinthian)    Alabastron (Classical)    Lekythos                Squat lekythos

## Cosmetic pots

Pyxis (Geometric)              Pyxis (Classical)         Pyxis (Classical)

## Drinking cups

Kylix                    Stemless kylix            Kantharos

# Glossary

**Alabastron** a perfume-bottle made of alabaster or pottery; see *Ill.* 45 and page 191

**Amphora** a jar with two handles used for storing liquids, especially wine; see page 190 Neck-amphora: an amphora with the neck set off from the body; see *Ill.* 38 and page 190

**Anta** the end of a projecting wall, decorated with mouldings at capital and base

**Architrave** a horizontal beam supported directly by the columns; see *Ill.* 74

**Aryballos** a small jar for perfume or olive-oil; see *Ill.* 45 and page 191

**Askos** a vase with a loop-handle and a spout, for pouring oil; see *Ill.* 134

**Auloi** a pair of pipes, blown simultaneously but each fingered by one hand

**Cella** the main room of a temple

**Centaur** a mythological creature part man, part horse; see *Ills.* 43, 68

**Chiton** a Greek tunic, usually worn short by men and Amazons, but reaching to the ankle for women and charioteers; see *Ills.* 109, 117

**Chlamys** a Greek travelling-cloak, worn by men, often pinned on one shoulder; see *Ill.* 78

**Chryselephantine** made of gold and ivory

**Dinos** a round-bottomed bowl for mixing wine and water; see *Ill.* 37 and page 190

**Erotes** plural of Eros, the Greek winged god of love; see *Ill.* 57

**Filigree** surface decoration for jewellery using fine wire; see *Ills.* 94 and 96

**Fresco** painted decoration applied to plastered walls before the plaster was dry

**Frieze** the course above the architrave. In Ionic architecture it sometimes has sculpture in low relief; in Doric it consists of alternating triglyphs and metopes; see *Ill.* 74

**Granulation** surface decoration for jewellery using tiny spheres of gold; see *Ill.* 30

**Greave** a piece of armour protecting the leg from knee to ankle; see *Ill.* 38

**Griffin** a mythological creature, part lion, part eagle; see *Ills.* 22, 26, 27

**Himation** a Greek cloak: women wore it over a chiton, but men without; see *Ills.* 84, 117

**Hydria** a water-jar with two handles at the shoulder for lifting and a single handle behind the neck for pouring; see *Ills.* 87 and 92 and page 190

**Kantharos** a drinking-cup, often on a tall stem, with two handles that sometimes curve high above the rim; see page 191

**Klismos** a Greek chair with a high back; see *Ill.* 84

**Kore** the Greek word for a girl, used to describe a standing draped female figure (*Ill.* 41), and also as an alternative name for Persephone, the daughter of Demeter

**Kouros** the Greek word for a youth, used to describe a nude standing male figure; see *Ills.* 46 and 47

**Krater** a bowl for mixing wine and water. Various types have been given specialized names like BELL-KRATER (from the shape of the bowl) and VOLUTE-KRATER (from the volutes above the handles); see *Ill.* 98 and page 190

**Kylix** a shallow drinking-cup with two handles, often on a tall stem; see *Ill.* 60 and page 191

**Lagynos** a one-handled flagon with a wide body and a tall slender neck; see *Ill.* 123

**Lekythos** a bottle for perfumed oil, used especially at funerals, see *Ill.* 65; the later, round-shouldered form is sometimes called a SQUAT LEKYTHOS; see page 191

**Maenad** one of the female votaries of Dionysos

**Metope** a squarish panel between the triglyphs of a Doric frieze, sometimes decorated with sculpture in high relief; see *Ill.* 74

**Oinochoe** a one-handled jug for serving wine, the lip often pinched to form a spout; see page 190

**Olpe** a special type of oinochoe (wine-jug) with a slender body and circular mouth; see page 190

**Naiskos** a shrine in the form of a small temple

**Patera** a bowl with a single handle at right angles to the rim

**Pediment** the triangular gable below the pitched roof at either end of a Greek temple; see *Ill.* 74

**Pelike** a two-handled storage jar with a wide mouth and a wider body; see page 190

**Peplos** a long tunic worn by Greek women, usually pinned at both shoulders; see *Ill.* 57

**Phiale** a shallow bowl used by men for pouring drink-offerings (libations) and by the gods as a drinking-cup

**Polos** a tall head-dress worn by Greek goddesses; see *Ills.* 32, 54

**Protome** the upper part of a figure; see *Ill.* 90

**Psykter** a vessel for cooling wine; see *Ill.* 50

**Pyxis** a cylindrical box with a lid, for cosmetics or trinkets; see page 191

**Rhyton** a drinking horn often in the form of an animal or an animal's head

**Satyr** a mythological creature, largely human in form but with a horse's ears and tail; see *Ill.* 50

**Siren** a mythological creature with a woman's head and arms upon the body of a bird

**Situla** a pail; see *Ill.* 100

**Skyphos** a deep drinking-cup with two handles; see *Ill.* 52

**Sphinx** a mythological creature with a human head on a lion's body, often winged

**Stamnos** a two-handled storage jar; see page 190

**Stele** a free-standing slab of stone bearing a relief or an inscription; see *Ill.* 84

**Triglyph** a decorative feature of the Doric frieze separating the metopes, emphasized by vertical channels; see *Ill.* 74

# Bibliography

Suggestions for further reading: many of these books contain detailed bibliographies.

**Books published by The British Museum**
*Arretine and Samian Pottery,* by C. Johns (1971).
*Greek and Roman Pottery Lamps,* by D. M. Bailey (rev. ed. 1972).
*The Greek Bronze Age,* by R. A. Higgins (1970).
*Greek Gods and Heroes,* by P. E. Corbett and A. Birchall (1974).
*Greek Terracotta Figures,* by R. A. Higgins (1963, repr. 1969).
*An Historical Guide to the Sculptures of the Parthenon* (1962, rev. 1969).
*Jewellery from Classical Lands,* by R. A. Higgins (1965, repr. 1969).
*Masterpieces of Glass* (1968).
*The Portland Vase,* by D. E. L. Haynes (rev. ed. 1975).
*South Italian Vase Painting,* by A. D. Trendall (1966).

**Other books**
*Arms and Armour of the Greeks,* by A. W. Snodgrass (1967)
*Crete and Mycenae,* by S. Marinatos and M. Hirmer (1960)
*Greek and Roman Gold and Silver Plate,* by D. E. Strong (1966)
*Greek and Roman Jewellery,* by R. A. Higgins (1961)
*Greek and Roman Sculpture,* by A. W. Lawrence (1972)
*Greek Art,* by R. M. Cook (1972)
*Greek Gems and Finger Rings,* by J. Boardman (1970)
*Greek Painted Pottery,* by R. M. Cook (2nd edition, 1972)
*Greek Painting,* by C. M. Robertson (1959)
*Greek Pottery,* by A. Lane (2nd edition, 1963)
*Greek Terracottas,* by R. A. Higgins (1967)
*A History of Greek Vase Painting,* by P. E. Arias, M. Hirmer and B. B. Shefton (1962)
*Minoan and Mycenaean Art,* by R. A. Higgins (1967)
*Prehistoric Greece and Cyprus,* by H.-G. Buchholz and V. Karageorghis (1973)
*Roman Painting,* by A. Maiuri (1953)
*Roman Pottery,* by R. J. Charleston (1955)
*The Technique of Painted Attic Pottery,* by J. V. Noble (1965)

## Catalogue and Register Numbers

Objects that have not yet been listed in published catalogues are cited by their numbers in the departmental Register. A typical Register number, based on the date of registration, is 1839.11–9.23; but initials are sometimes substituted for the date, e.g. WT for William Temple and S for Slade. Objects that are listed in published catalogues are cited by the appropriate catalogue numbers, using the following scheme of abbreviations for the titles of the Catalogues.

| Abbreviation | Prefix | Title of Catalogue, with author and date of publication |
| --- | --- | --- |
| Bronze | none | *Catalogue of the Bronzes, Greek, Roman, and Etruscan in the Department of Greek and Roman Antiquities, British Museum,* by H. B. Walters, 1899 |
| Gem | none | *Catalogue of the Engraved Gems and Cameos Greek Etruscan and Roman in the British Museum,* by H. B. Walters, 1926 |
| Jewellery | none | *Catalogue of the Jewellery, Greek, Etruscan, and Roman, in the Departments of Antiquities, British Museum,* by F. H. Marshall, 1911 |
| Lamp | none | *Catalogue of the Greek and Roman Lamps in the British Museum,* by H. B. Walters, 1914 |
| Mosaic | none | *Catalogue of the Greek, Etruscan and Roman Paintings and* |
| Painting | none | *Mosaics in the British Museum,* by R. P. Hinks, 1933 |
| Pottery | K, L, M | *Catalogue of the Roman Pottery in the Departments of Antiquities, British Museum,* by H. B. Walters, 1908 |
| Ring | none | *Catalogue of the Finger Rings, Greek, Etruscan, and Roman, in the Departments of Antiquities, British Museum,* by F. H. Marshall, 1907 |
| Sculpture | none | *A Catalogue of Sculpture in the Department of Greek and Roman Antiquities, British Museum,* by A. H. Smith, 3 vols., 1892–1904 |
| Sculpture | A, B | *Catalogue of Sculpture in the Department of Greek and Roman Antiquities of the British Museum. Vol. I, Part I. Prehellenic and Early Greek,* by F. N. Pryce, 1928 |
| Silver | none | *Catalogue of the Silver Plate (Greek, Etruscan and Roman) in the British Museum,* by H. B. Walters, 1921 |
| Terracotta | A to E | *Catalogue of the Terracottas in the Department of Greek and Roman Antiquities, British Museum,* by H. B. Walters, 1903 |
| Terracotta | none | *Catalogue of the Terracottas in the Department of Greek and Roman Antiquities, British Museum,* by R. A. Higgins, 2 vols., 1954 and 1959 |
| Vase | | *Catalogue of the Greek and Etruscan Vases in the British Museum.* |
| | A | *Vol. I, Part I. Prehistoric Aegean Pottery,* by E. J. Forsdyke, 1925 |
| | B | *Vol. II. Black-figured Vases,* by H. B. Walters, 1893 |
| | C | *Vol. I. Part II. Cypriote, Italian, and Etruscan Pottery,* by H. B. Walters, 1912 |
| | D, E | *Vol. III. Vases of the Finest Period,* by C. H. Smith, 1896 |
| | F, G | *Vol. IV. Vases of the Latest Period,* by H. B. Walters, 1896 |

# ndex

Numbers in bold type refer to illustrations